IMPRESSIONISTS

BÉRÉNICE MORVAN

IMP

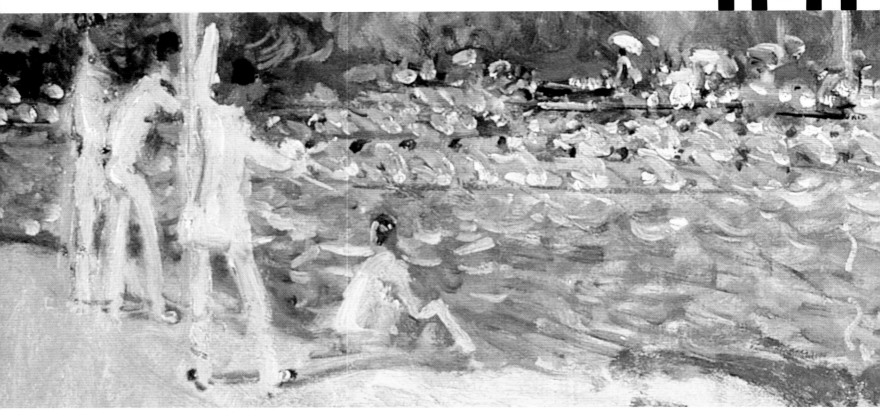

RESSIONISTS

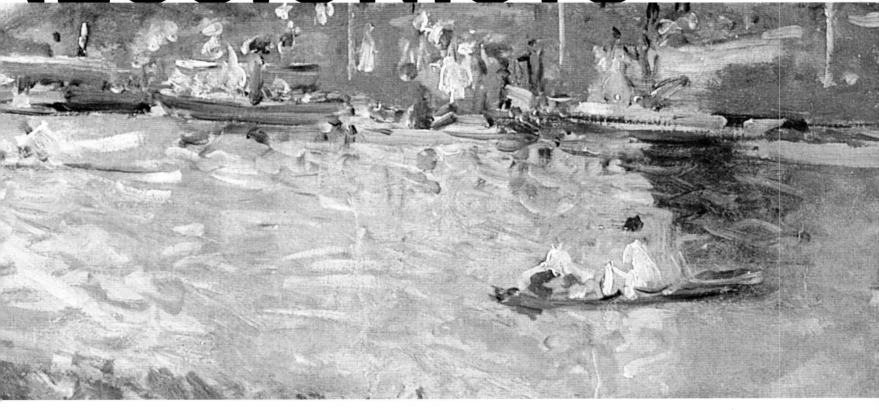

BARNES
&NOBLE

NEW YORK

Cover:
Auguste Renoir
The Umbrellas (detail)
1881-1885. Oil on canvas
180x115
London, National Gallery

Previous pages:
Alfred Sisley
Regattas at Moseley
Detail
1874. Oil on canvas
66x91.5
Paris, Musée d'Orsay

Auguste Renoir
The Bathers
Detail
1918-1919. Oil on canvas
110x160
Paris, Musée d'Orsay

Editorial Directors
Soline Massot
Layout
Emmanuel Bagot
Iconography
Hélène Orizet
Translation
Charle Penwarden
Copy editor
Marie-Paule Rochelois
Lithography
L'Exprimeur, Paris

ISBN-13: 978-0-7607-9007-6
ISBN-10: 0-7607-9007-8

Printed and bound in China

1 3 5 7 9 10 8 6 4 2

Contents

3 Bazille PAGE 66

2 Monet

3 Bazille

5 Renoir PAGE 88

6 Caillebotte PAGE 110

5 Renoir

6 Caillebotte

10 Morisot PAGE 190

9 Degas

10 Morisot

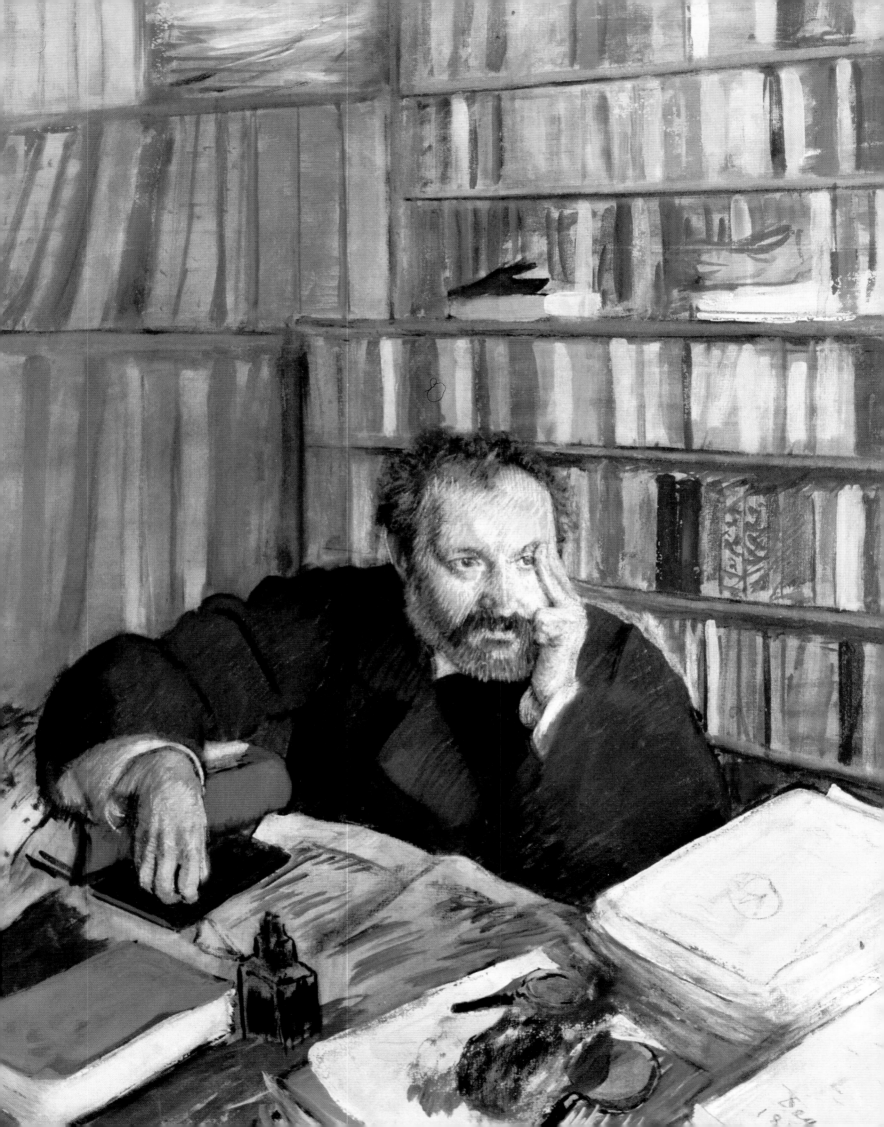

Edgar Degas
Portrait of Duranty
1879. Pastel
100.9x100.3
Glasgow, Art Gallery and Museum

Introduction

Whether or not they set out to be 'Impressionists'; whether or not they accepted that label, that name provided by the circumstances; whether or not they sought to merge into one movement; whether or not they managed to establish their genius beyond Impressionism itself, for us Cézanne, Degas, Monet, Morisot, Pissarro, Renoir and Sisley nevertheless form the first real movement in modern painting, and the words that Zola wrote in 1877 on the occasion of their third group exhibition still offer a perfect definition of its nature, concerns and limits:

'This is the third time these painters have submitted their works to the public, outside the official Salons. At first they wanted to avoid the judgment of the jury, which diverts any original efforts from the Salon. They thus found themselves forming a homogeneous group, with all of them having a more or less similar view of nature; and so they picked up the description that had been made of them, "Impressionist," and used it as a banner. They were called Impressionists in a spirit of mockery; Impressionists they remained out of pluck. Now, I do not believe there are grounds for trying to find out what exactly this word means. It is a good label, as all labels are. In France, schools make their way only once they have been baptized, even if the word is far-fetched. I think that by "Impressionist painters" we should understand painters who paint reality and pride themselves on conveying the impression of Nature itself, which they do not study in its details but as a whole. [...] But fortunately, there is something more than theory to this group. By which I mean that they are genuine painters, artists endowed with the greatest merits.'

The banner, the name and the provocation are of little importance, then, even if they do offer the advantage of placing the painting of the Impressionists alongside the explorations of some of their predecessors, such as Daubigny, Boudin or Jongkind, but above all of affirming these painters' independence of vision, their capacity to express their own worldview—which Zola, again, sums up in this definition of painting: 'A patch of nature seen through a temperament.' In fact, Monet was quick to play down the importance of the name. Interviewed by the journalist Émile Taboureux in 1898, he gave his version of the word's origins: 'I was asked for a title for the catalogue. You could not really call it a view of Le

Havre, so I said: "Put Impression." They turned it into Impressionism.' He then dwelt on what for him was the key part of the story: 'There were a few of us, my friends and myself, who were systematically rejected by Jury. It's all very well to paint, but you have to sell, you have to live. The dealers would have nothing to do with us. And yet we had to exhibit. Where? Should we rent a hall? But when we had a whip round, we barely had enough to take a box a the Théâtre de Cluny. Nadar, the great Nadar, who has a heart of gold, *lent* us these premises and now, this group that poor Duranty dubbed the School of the Batignolles made its appearance in the artistic firmament as independent stars.'

For Zola then, as for Monet, who was one of the main protagonists of the enterprise, the *raison d'être* for the movement was this absolute need to exhibit outside the jurisdiction of the Salon, that great machine which, because of the ever-greater number of submissions from a growing number of painters who were increasingly diverse in their training and production, had become uncontrollable and subject to inevitable crises. From the mid-1860s onwards, these artists bore the brunt of the despotic, capricious nature of this Salon which was, in fact, utterly deliquescent. Cézanne stated his position in a forthright letter to the superintendent of the Beaux-Arts, dated 1867: 'I shall simply tell you once again that I cannot accept the illegitimate judgment of colleagues to whom I have not entrusted the mission of accepting me… I wish to make my case to the public and be exhibited in spite of it all… let the Salon des Refusés be reestablished, therefore.' This request was repeated that same year in a petition signed by Bazille, Monet, Renoir, Manet, Pissarro and Sisley. Farsighted and perceptive, the artists who wrote the statutes of the 'Anonymous Cooperative Society of Painters, Sculptors and Print-makers,' published in the *Chronique des Arts*, specified that the aim of the association was, '1. The organization of free exhibitions, without juries or prizes, where each of the associates will be able to show his works. 2. The sale of the said works. 3. The publication, at the earliest possible opportunity, of a journal concerned exclusively with the arts.' For it was not enough just to show one's works; they also had to be shown properly. The deplorable hanging of so many paintings in the Salon was another of the artists' grievances. Unlike the Salon jury, they did not limit the number of submissions from participants and were careful to offer each one the best possible conditions of presentation.

With the works well displayed, the next step was to sell them. Hence, in 1875, the auction organized at Drouot in an attempt by some of the Impressionists to win over an ignorant and reluctant market. According to the account by the critic Philippe Burty, Drouot had, for some years now, been considered as 'a kind of permanent museum of the modern school.' But the sale was a catastrophe. Durand-Ruel speaks of a 'public that was exasperated with the rare supporters of these wretched exhibitors [who] tried to stop the sale and shouted and jeered with each new bid.' And yet the enthusiasts *were* there, and they were active. There was Ernest Hoschédé, a rich cloth merchant, Jean-Baptiste Faure, the opera singer, Ernest Chesneau, a naturalist and *Japoniste* critic, Henri Rouart, an industrialist and engineer specializing in iron and steel, Jean Dollfus, an industrialist, Georges Charpentier, a newspaper owner, and Gustave Arosa, a stockbroker who was also Gauguin's tutor and one of the most discerning

Edgar Degas
**Photo of Auguste Renoir
and Stéphane Mallarmé circa**
1895
Vulaines-sur-Seine, Musée Stéphane Mallarmé

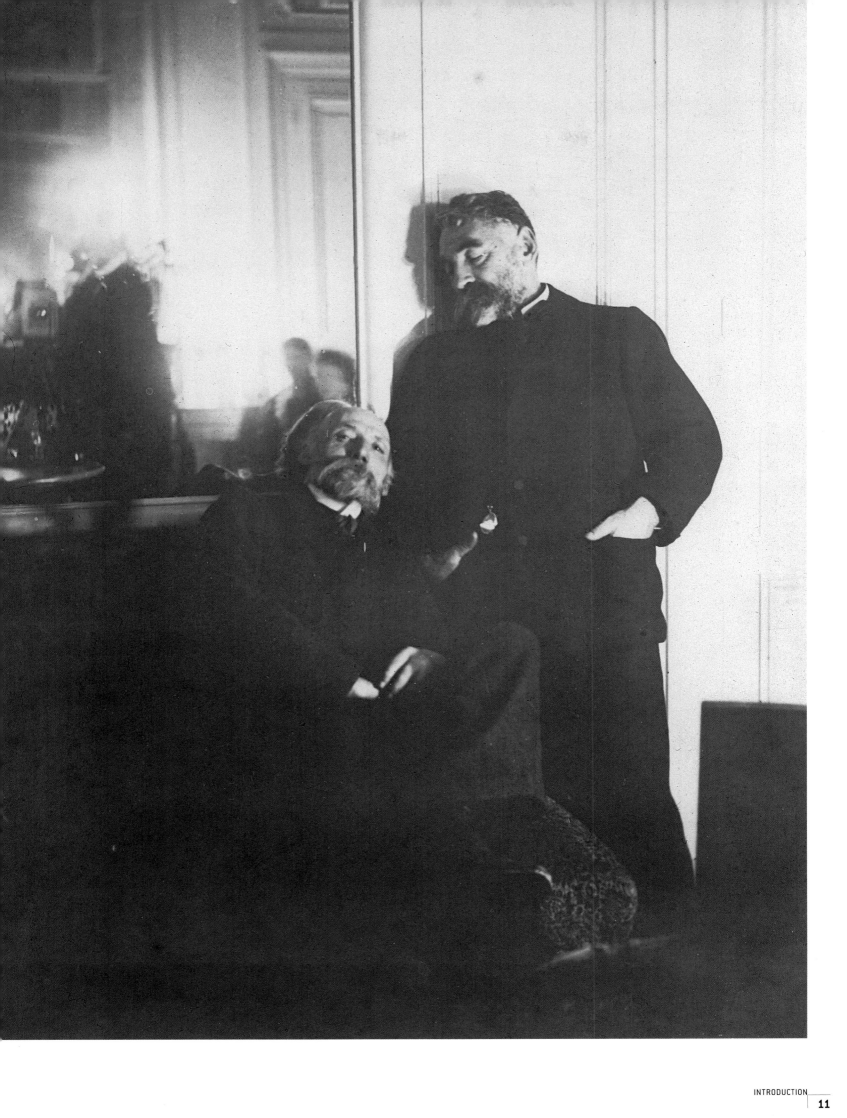

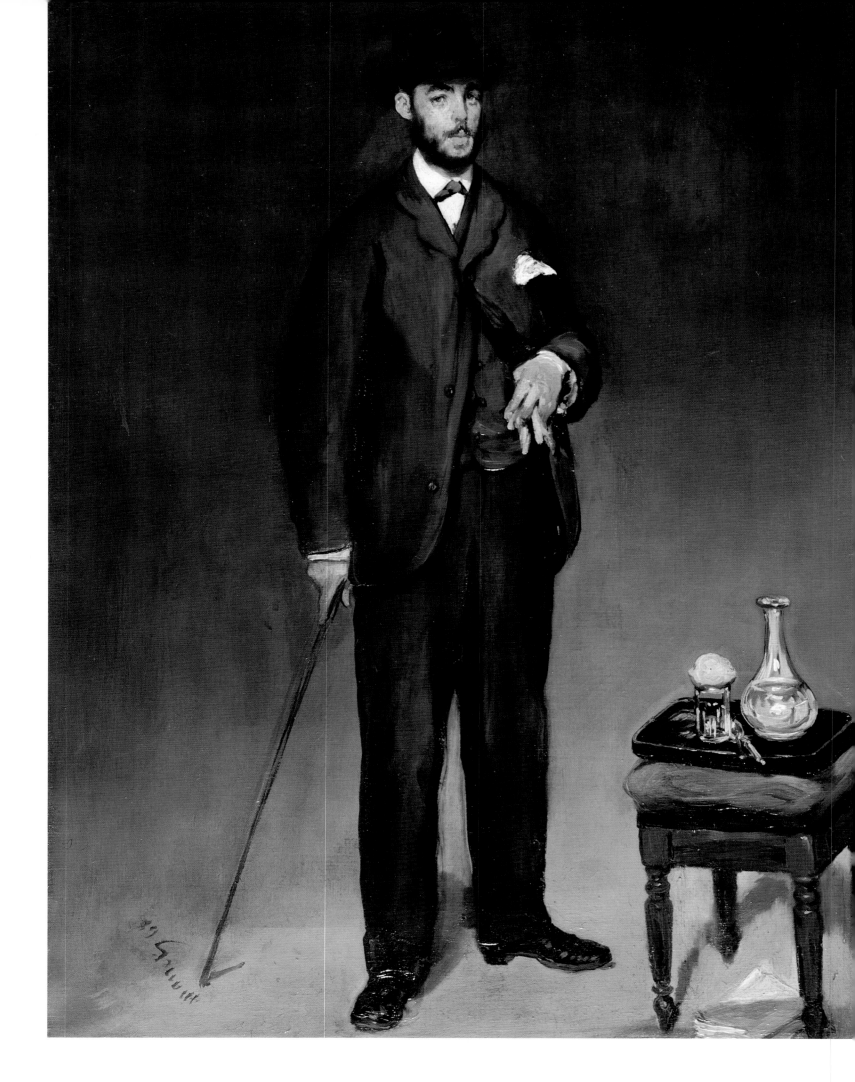

collectors of Impressionist paintings. Other, less wealthy admirers also collected valiantly, such as Victor Chocquet and Georges de Bellio, not to mention the painters themselves, starting with Caillebotte. And so, in 1878 Théodore Duret, now the owner of a fine collection, could write: 'The public that laughs so loud at the Impressionists has an even bigger surprise in store: this painting sells!' Nevertheless, in spite of these pioneers, prosperity came to the Impressionists mainly from the other side of the Atlantic. There ultra-rich American financiers were ready to buy paintings that were still disdained in France. In the 1880s, with the sound guidance of the American artist Mary Cassatt, for example, the Havemeyers began building up what would become one of the most prestigious collections of Impressionist art. It was later donated to the National Gallery in Washington.

Of course, the works also had to be talked about. The artists' methods to be explained. The public had to be won over. This was the role of the critics and the press. The Impressionists were well supported by Zola, but the writer was suspended by the editor of *L'Événement* in 1866 because of readers' hostility to his committed positions. Other champions were needed. They could count on occasional support from the critics who had supported the Realist school, and who saw them as the heirs of Courbet and the School of Barbizon. They also inspired others to become reviewers. There was Zola, of course, but also Mallarmé, who took up criticism in order to defend Manet when Zola—too much a writer, too much the author of the Rougon Macquart novels—threw in the towel. There was Georges Rivière, the main contributor to the short-lived journal *L'Impressionniste* published during the third exhibition of 1877—a real propaganda tool set up by the artists themselves. Rivière appreciated each one of the Impressionists, marveled at everything they exhibited and was the first to write a praiseful commentary on Cézanne. There was Huysmans who, before becoming a Symbolist, was an out-and-out realist. And there was Mirbeau, who was primarily a passionate devotee of the work of Monet. Finally, there were the critics Théodore Duret and Edmond Duranty who attended most of the group's exhibitions and never failed to remind readers of its ancestry: 'The origins of these efforts, the first manifestations of these temperaments, can be found in the studio of Courbet, between *Burial* and the *Young Ladies of the Village*. They are in the great Ingres and the great Millet… They are also in the great Corot and his disciple Chintreuil, who was constantly searching, and whom Nature seems to have loved so much that She vouchsafed revelations to him.' Duranty and Duret expounded the ideas of the two main tendencies that cohabited within the movement.

Duret championed the landscape painters, the lovers of light and the moment. He guided, counseled and supported Sisley and Pissarro. He delighted in the paintings of Monet ('Monet is the supreme Impressionist') and considered only the kind of Impressionist who 'sits on the river bank: in accordance with the state of the sky, the angle of vision, the time of day, the calm or agitation of the atmosphere, he unhesitatingly paints on the canvas all the different tones of the water.' He it was who developed the theory of *plein-air* painting. Duranty, for his part, analyzed the realists, the clinical portrayers of modern life. For while he admired the *plein-air* painters and their skill at rendering light ('Proceeding by

Édouard Manet
Portrait of Théodore Duret
1868. Oil on canvas
43x35
Paris, Musée du Petit Palais

intuition, they little by little succeeded in splitting sunlight into its rays, and then reestablishing its unity in the general harmony of the iridescent colors that they scatter over their canvases. Even the most learned physicist could find nothing to criticize in these painters' analysis of light'), Duranty's true passion drew him to those artists who dared and would dare to paint 'the railways, notion shops, construction scaffolds, lines of gaslights, benches on the boulevards and newspaper kiosks, omnibuses and teams of horses, cafés with their billiard-rooms, and restaurants with their tables set and ready.'

These two tendencies caused strains and rivalry within the movement but were reconciled in the imperious necessity of representing the world as it is. Here, indeed, is the other rift between the Impressionists and the Salon painters. For in the Salon one still saw nymphs and goddesses, allegories, ageless heroes, myths and battles. Realism may have existed, but it was either omitted or fed on the landscapes of another generation whose order had yet to be overthrown by the new revolution. Or otherwise it contented itself with small formats and small ideas. There was a considerable discrepancy between what the Salon painters depicted and what people in Paris and the provinces, in the town or in the country, were living through. 'Everything around is moving, getting bigger, increasing [...] Science is performing prodigious feats, industry working miracles and yet we are unmoved, insensitive, despicable, plucking at the out-of-key strings of our lyres, closing our eyes so as not to see, or insisting on looking towards a past that we have no reason to miss. We discover steam and we sing of Venus, daughter of the bitter wave; we discover electricity and we sing of Bacchus, friend of the bright red grape. It is absurd!' To illustrate the dizzying abyss decried here by the critic Maxime Ducamp in 1858, we need only refer to the Salon of 1863, which saw the triumph of Cabanel's *The Birth of Venus*. Zola described the painting thus: 'a goddess, drowning in a river of milk, rather like a delicious *lorette* [woman of easy virtue], not in flesh and blood—that would be indecent—but in a kind of white and pink marzipan.' The canvas was snapped up by Napoleon III for his private collection. On the other side of the turnstile separating the official Salon from the Salon des Refusés, there was Manet's *Le Déjeuner sur l'herbe*, with its naked woman in the foreground and another, in the background, pulling up her shift. These are definitely no nymphs. The painting was jeered at, mocked and vilified. The transition from hackneyed historical subjects to modern ones was not always smooth. Taking up Manet's cause, Zola justified the proximity of these naked women and clothed men on the grass by invoking the Louvre, where 'there are more than fifty pictures in which clothed people mix with the naked. But no one goes to the Louvre to be shocked.' For while the writer could not admit this, Manet was indeed steeped in the models at the Louvre. As for Degas, it took him years to liberate himself from classical painting, and Cézanne was literally obsessed with it to the end of his life. But this *Déjeuner sur l'herbe* is already something else, the death throes of an ideal and a historical period, and a window onto landscapes and mores that were undergoing a profound transformation.

For it was not just a matter of modern subjects. There was also technique, which had to be adapted to a new vision. A new visual language. This is what Zola was looking for in Manet's painting: 'What you have to

Édouard Manet
Portrait of Stéphane Mallarmé
1876. Oil on canvas
27.5x36
Paris, Musée d'Orsay

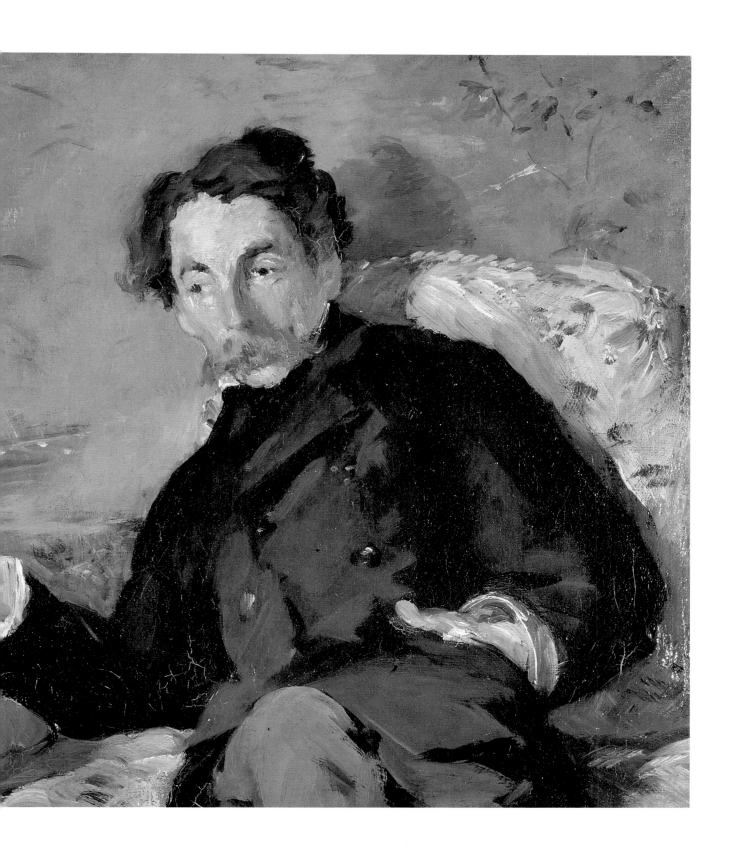

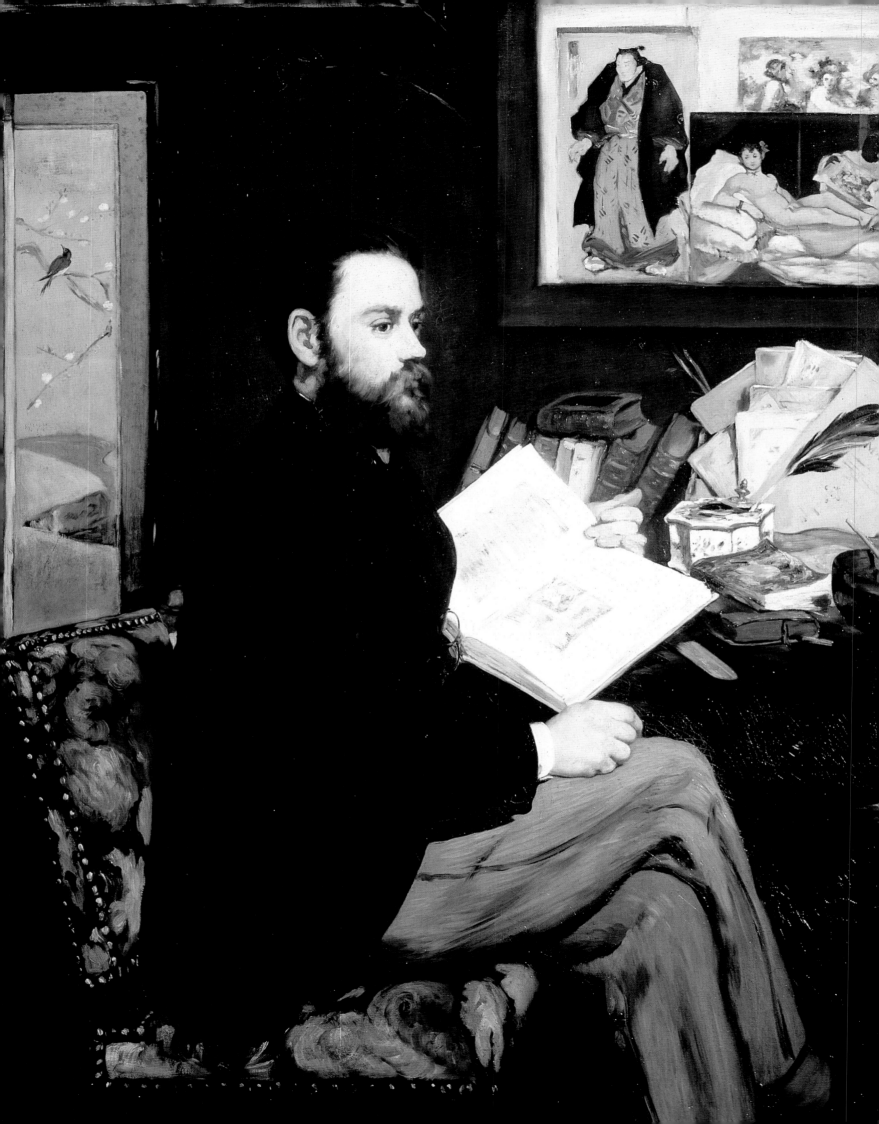

look for in the picture is not just a picnic on the grass, but the whole land-scape, with its bold and subtle passages, its broadly painted solid fore-ground, its light and delicate background [...] in fact [...] this vast airy composition [...] this attention to Nature, rendered with such accurate simplicity.' It was not enough simply not to paint a Venus; one had also to paint a modern Bather, at home or at the public baths, reacting to the caprices of the atmosphere around her, be it in the open air or in a con-fined interior saturated with moisture and warmth. One needed this 'sim-plicity' mentioned by Zola, this capacity to forget details in order to make a swift analysis of the overall scene. This is what the Impressionists were after, each in their own way. Contrary to the neo-Impressionists, who devised a scientific technique that erased individual particularities, the Impressionists all had their own personal pictorial languages. And although they painted side by side, their touches and viewpoints were rad-ically different. There can be no confusing Renoir's painting of the La Grenouillère pool with Monet's. Which is what Zola pointed out: 'beyond the theories [...] these are genuine painters, artists endowed with the greatest merits.' This addition of talents and individualities is what made the movement so strong but also fatally weakened it as an association.

The history of Impressionism is indeed inextricably bound up with the quarrels and power struggles that almost immediately threatened the very feasibility of the exhibitions for which, essentially, its members had come together in the first place. From 1874 to 1886 there were eight exhibi-tions, six of which revealed the artists' lack of cohesion and shared ambi-tion. In order to share the costs of organizing their exhibitions more widely, they were forced to admit painters who were less talented or more conservative, a fact regretted by the critic Chesneau in 1874: 'Inviting to take part in this exhibition certain painters who bring up the rear of the official Salon's banalities, and even artists of undoubted talent plowing a different furrow from their own, such as Messrs. De Nittis, Boudin, Bracquemond, Brandon, Lépine and Gustave Colin, is a capital logical and tactical mistake.' Moreover, they also had to deal as best they could with the personal ambitions of their members and, although the statutes of 1873 had been carefully drafted so as to give these paintings without a salon and without an audience a real chance, the experience of each exhi-bition showed that none of them was really ready for this adventure. In fact, no one was happy with the name 'Impressionism,' which even Monet greeted with more resignation than enthusiasm.

Indeed, from one Impressionist exhibition to the next (for 'Impressionism' was now a fact), we can trace the relations between the different chapels within the group, but also its capacity to generate new sources of dynamism. In 1876, Caillebotte emerged. In 1879, Gauguin was introduced by Pissarro and confirmed by Degas. Still shy, he was nev-ertheless eager to square up to the greatest artists of the historical nucleus. In 1886 the neo-Impressionists barged in, eating up exhibition space and edging out Impressionism itself with their sectarian theory and their critic, Fénéon, whose every trenchant word sounded like a meticulous putting to death of the older movement. There was also Redon, a Symbolist with a penchant for black who followed and admired the evolution of Impressionism in his notebooks. Every new arrival, except for Caillebotte and Mary Cassatt (1879), was greeted by wailing and the gnashing of

Édouard Manet
Émile Zola
1868. Oil on canvas
146x114
Paris, Musée d'Orsay

teeth. But it has to be admitted that these newcomers were born from and because of Impressionism. And that the works of the Impressionists, and the association they formed in order to exhibit and make their mark, inspired many new vocations and much emulation.

But then what do these recruits really matter? As of the late 1870s, the movement was no longer the property of its artists. Already, they were moving away. Cézanne, Renoir, Monet and even Degas, who continued to promote his little realist school, had already chosen their solitary paths. They wanted the recognition of the Salon but also, and above all, they wanted one-person exhibitions where their work could be appreciated in and for itself, where visitors would not get lost in comparisons, where critics would not confuse the true Impressionist and true painter with the last-minute guest. The history of Impression would be written by several hands, but above all by individuals.

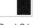

Paul Cézanne
Portrait of Gustave Geffroy
1895. Oil on canvas
116x89
Paris, Musée d'Orsay

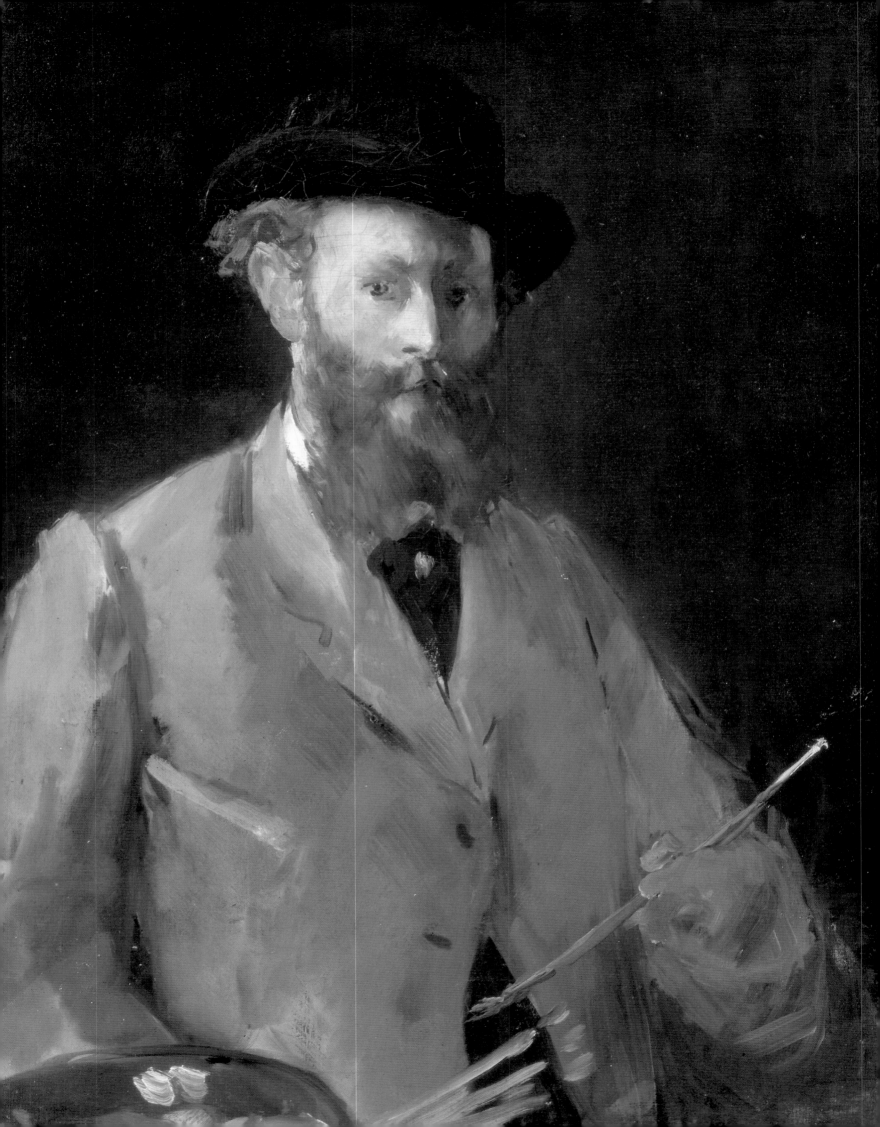

1 Manet

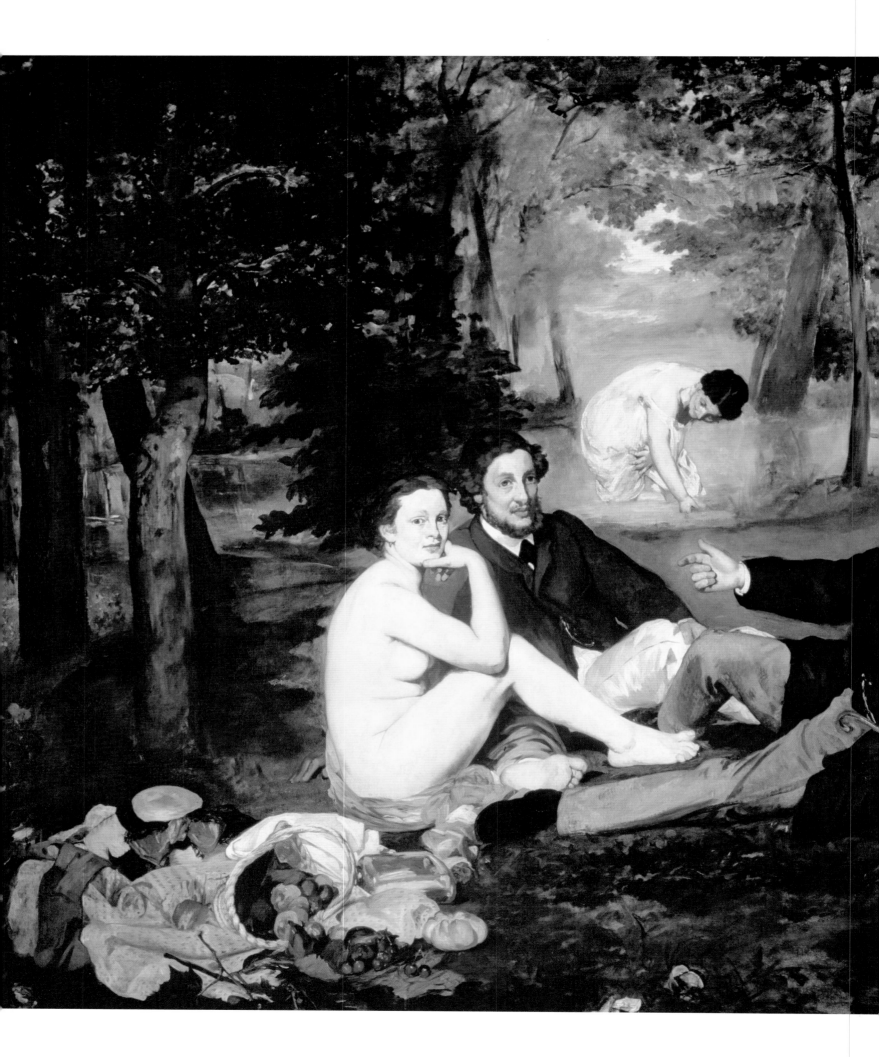

Previous page :
Édouard Manet
Self-portrait with a Palette
1879-1880. Oil on canvas
90x115
Private collection

Édouard Manet
Le Déjeuner sur l'herbe
1863. Oil on canvas
208x264.5
Paris, Musée d'Orsay

Although Manet was not a real Impressionist or, contrary to what some critics maintain, the leader of the movement, he was one of the first precursors.

No, Manet was no Impressionist. He always stayed away from the events, exhibitions and auctions that they organized. To the very end, he kept his taste for posed subjects, for studio work, for Old Masters, for the Salon, for official recognition and for black, which was the almost exclusive basis for his compositions. And yet what would Impressionism have been without the liberties taken by Manet? Without his *Déjeuner sur l'herbe*, the masterpiece of the 1863 Salon des Refusés where it took no little courage to exhibit a work that had already been condemned by the obtuse and sectarian taste of the jury. Without the one-person exhibition that he organized on the edge of the World's Fair in 1867. And without his ability to breathe new life into the old clichés of painting and to break all the Academy's rules.

Manet's personal background certainly helped prepare him for such challenges. He was born into the Parisian *grande bourgeoisie* and his family, though not enthusiastic about his calling as a painter, was sufficiently liberal to accept it. And so in 1850 the young Manet, a cultivated music-loving Parisian and adventurer (he had been in the merchant navy in 1848-1849), entered the studio of the painter Thomas Couture to serve his apprenticeship. The choice was bold one, if not original. For after his success at the 1847 Salon with the monumental *The Romans of the Decadence*, Couture had been trapped in an unhappy marriage between realism and tradition that was headed for failure. An assiduous visitor to the Louvre, Manet learned from his master a solid grounding in professional skills, a touch both fluid and vigorous and a remarkable visual culture. In his rebellious moments, he nevertheless decried the old-fashioned methods of this Couture who, he claimed, once told him that he would 'never be anything more than the Daumier of your day.'

When he left Couture's studio, Manet plumped for realism. This was realism à la Courbet, one not limited to landscapes, still lifes and rural scenes but embracing all the subjects that life offered, including women, children, nudes, peasants, landscapes, contemporaries and political or philosophical allegories. It could be a fairly acceptable realism when Manet painted his *Spanish Singer*, which, presented at the Salon of 1861,

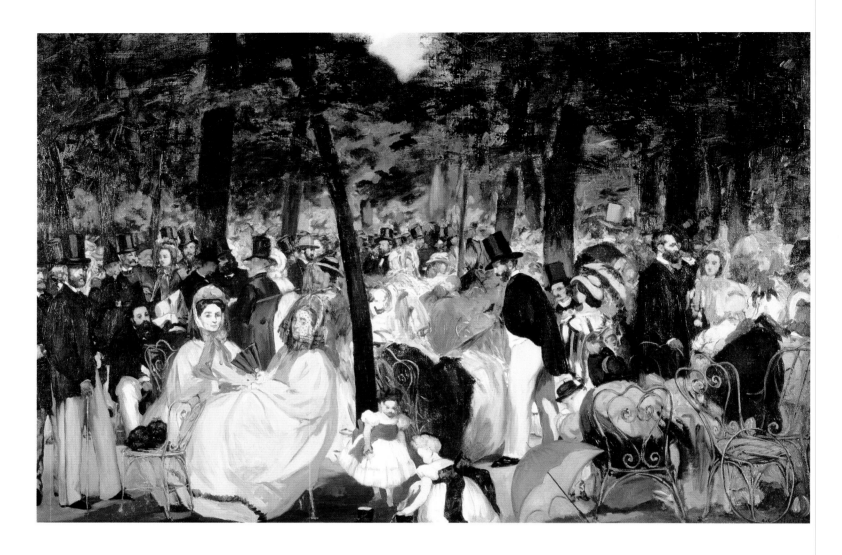

was greeted as proof that painting was acquiring a new vitality. But it was condemned when he used it for his portraits of the anonymous heroes of the street. The street singer and beggar are visual responses to the verse of Baudelaire, a poet of modernity who offered a penetrating, admiring and passionate vision of his times.

For a while, Baudelaire had been the champion of the realist Courbet. He now became Manet's, guiding and supporting him in his exploration of modern life. He makes an appearance as a *flâneur* and detector of new fashions in Manet's 1862 painting *Music in the Tuileries Gardens*. The subject, which had already been used in *vignette* form for the press, felicitously combines the theme of the crowd, which wants to see and be seen, and that of a group of friends gathering as they did every Sunday in the Tuileries. As his friend Tabarant recalled, 'Manet went to the Tuileries almost every day from two to four o'clock, making open air studies under the trees. [...] Baudelaire was his usual companion.' Manet the painter of modern life. Manet who does a few open-air studies in order to produce his picture. This was the first step towards Impressionism.

The second step was taken when Manet decided to present *Le Bain*, which has since come to be known as *Le Déjeuner sur l'herbe*, at the Salon des Refusés, and to expose himself to all the sarcasm of the critics. He had to exhibit, to show himself, even in this 'sub-Salon' designed to justify the official jury in its decision to spare visitors works that were ' an affront to modesty.' But there was nothing Impressionist about the painting itself.

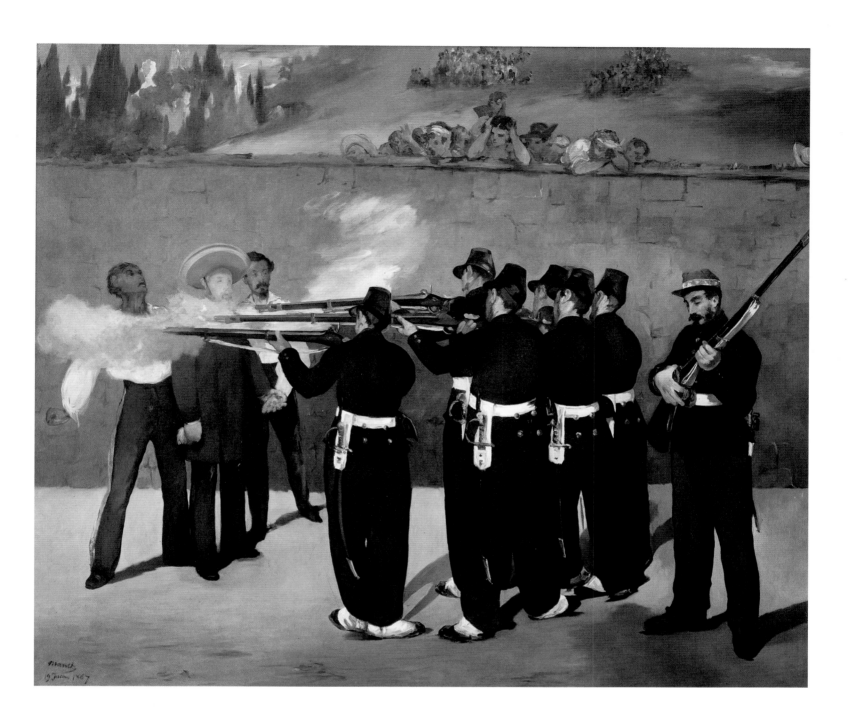

Édouard Manet
Music in the Tuileries Gardens
1862. Oil on canvas
76x118
London, National Gallery

Édouard Manet
**The Execution of the Emperor Maximilian
of Mexico**
1867. Oil on canvas
252x305
Mannheim, Städtische Kunsthalle

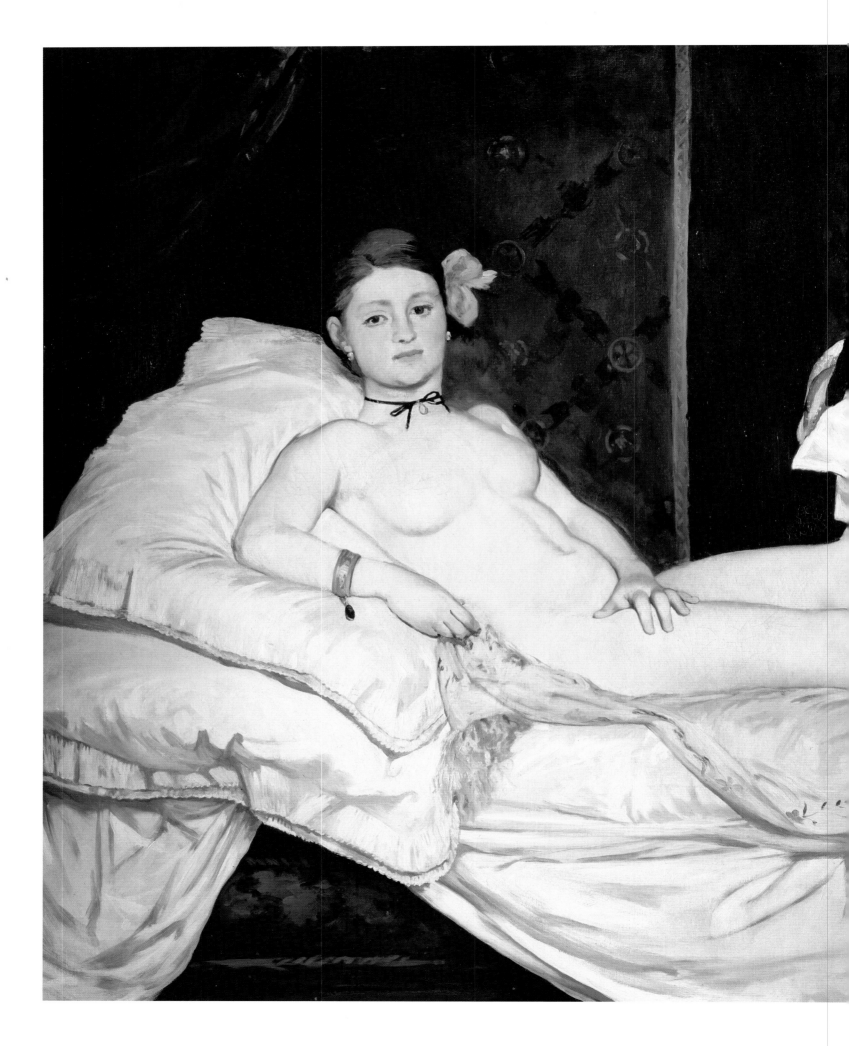

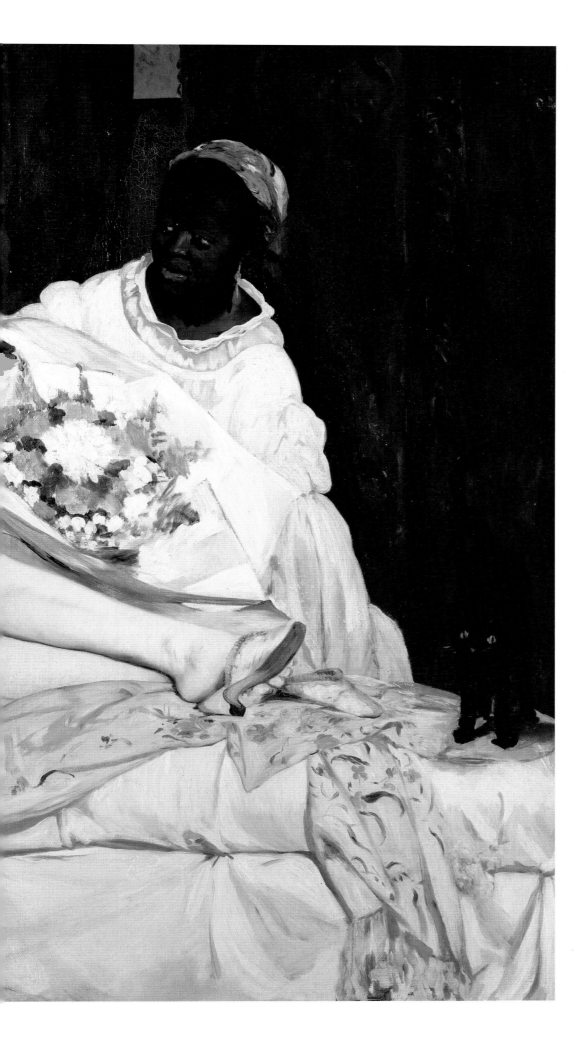

Édouard Manet
Olympia
1863. Oil on canvas
130x190
Paris, Musée d'Orsay

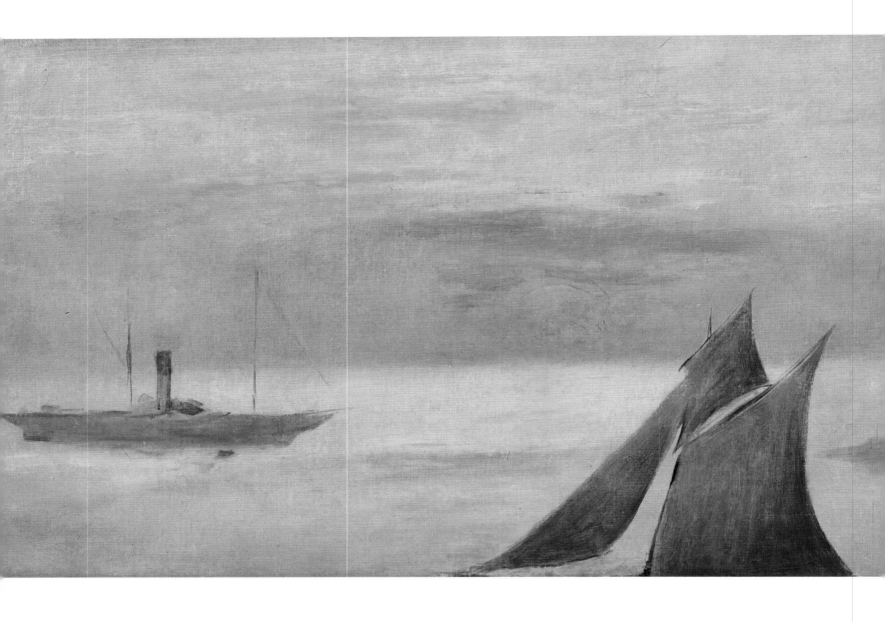

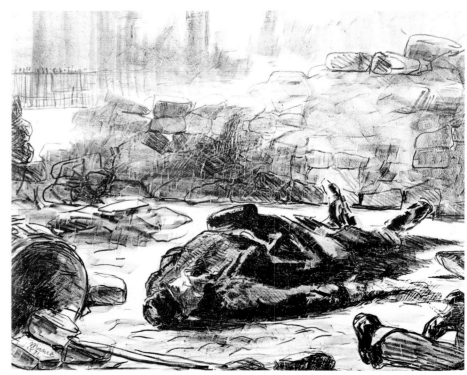

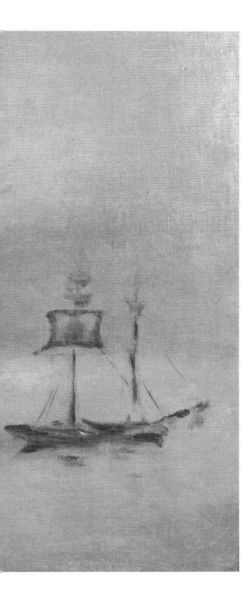

Édouard Manet
Boat out to Sea, Setting Sun
1872-1873. Oil on canvas
42x94
Le Havre, Musée des Beaux-Arts

Édouard Manet
The Barricade (Civil War)
1871-1873. Lithograph

Posed in the studio, fraught with historical references and, above all, utterly penetrable to modern mores, it nevertheless represented Manet's decisive attempt to renew traditional iconography—an attempt which, now and again, some of the future Impressionists would also make.

In 1865 Manet made the sirens of scandal shriek even louder. *Olympia* was at the Salon. Naked as Eve. Protected from visitors' gazes only by the feeble verses of Manet's friend Zacharie Astruc that construed this woman, whom everyone identified as a prostitute, as an 'august young woman in whom the vestal flame burns bright.' Even the ailing and weary Baudelaire could do nothing for his painter, to whom he wrote: 'You are merely the first in the decrepitude of your art.' The poet died two years later. In Manet's painting of his funeral, a tragic and desolate Paris is like El Greco's Toledo.

Fortunately for Manet, he soon found a new champion. A young writer and childhood friend of Cézanne's who was similarly impatient to shake up the established order that was stifling literature as well as painting. This was Emile Zola, who stated his intentions quite clearly: 'Taking Édouard Manet's case as typical of the way really original personalities are received by the public, I protest against this reception, and from the individual I proceed to a question which touches all real artists.' It was Zola who wrote the text for Manet's solo exhibition in 1867 and, in his portrait, began to develop his own definition of painting as 'Nature seen through a temperament.' Though only 35, Manet now treated himself to the luxury of a retrospective, an assessment of his career. There were portraits, street scenes, still lifes and sea scenes, and some of these works were also history paintings whose bold colors were set off by his thick, luminous black. As described by Zola in 1867, Manet was an artist who 'speaks in a language composed of simplicity and truth,' and who offered 'a harmonious and complete whole.' His 'place in the Louvre,' Zola asserted, 'is marked out already.' And indeed, the Louvre remained Manet's primary reference. He spent much time working there and it was with the Louvre in mind that he painted certain of his works—the compositions structured around the human figure, which subjects were modern heirs to traditional themes (women bathing) or contemporary history paintings (*The Execution of the Emperor Maximilian*, which he left unfinished).

In 1868, Manet painted a portrait of Zola which was also a self-portrait, containing as it did a print of *Olympia*, another of a work by Velasquez, who was such an inspiration, and a Japanese print evoking the flat colors, simplified forms and lack of perspective and shadow that he, like the Impressionists, had spent so much time musing upon.

Manet's Japonisme comes out in some of his marine paintings with their elongated format and airy grace, and in the bold interplay of masts and sails (*Boats at Sunset, Le Havre*). These works also bring to mind the paintings of Whistler, his fellow object of scandal in the Salon des Refusés (*Trouville*, 1865, Chicago) and also, no doubt, those of the young Monet. Other marine paintings show swelling, roaring waves, ready to swallow up both boats and sky.

As of 1866, there was a constant back and forth movement between Manet, a much decried but, even so, established figure on the contemporary scene, and the young Impressionists: Monet, whom Manet admired, and Cézanne, who frightened him and regularly reprised his own works,

Édouard Manet
The Railway
1872-1873. Oil on canvas
93.3x114

Washington, National Gallery of Art

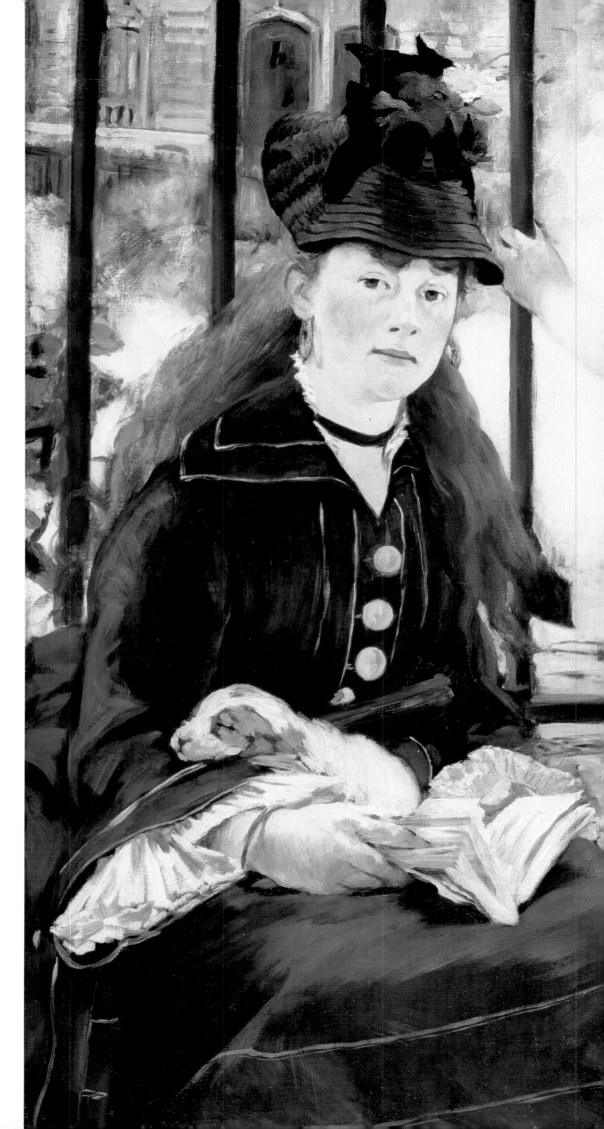

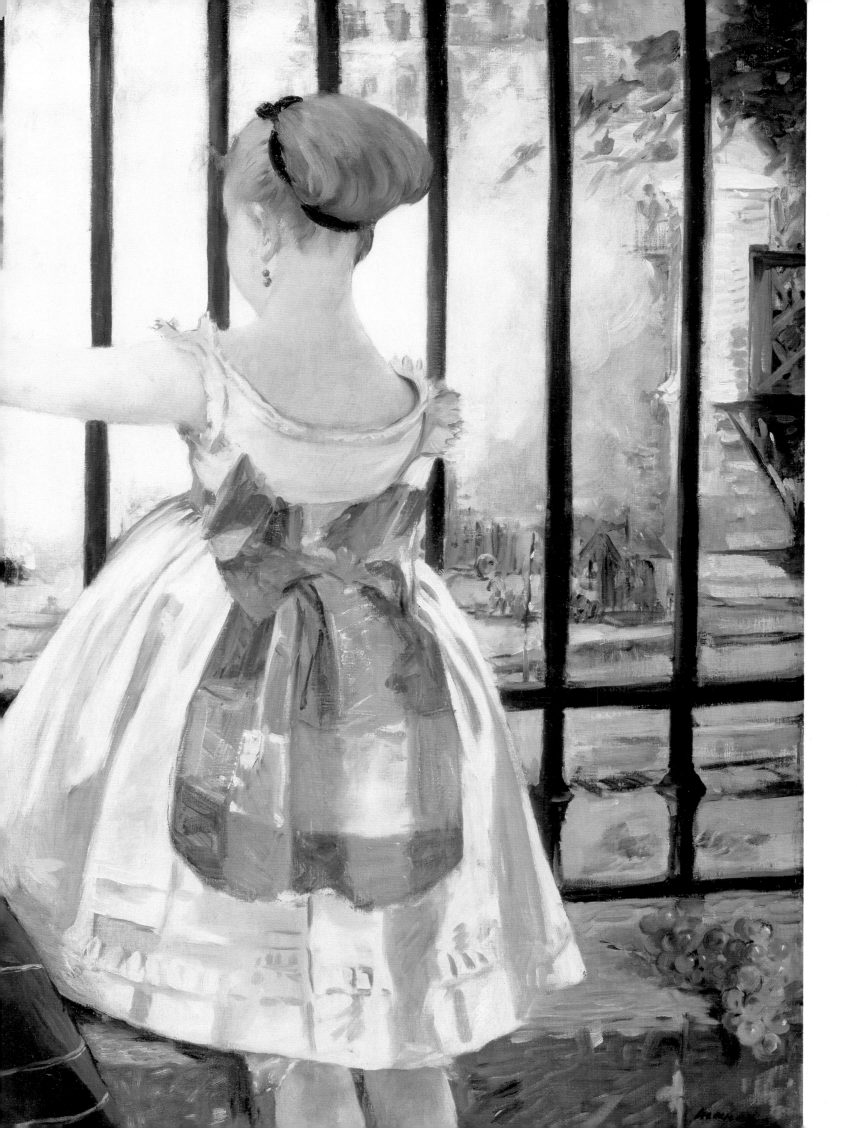

such as *Olympia* and *Le Déjeuner sur l'herbe*, or his solidly structured, light-drenched still lifes. These exchanges are attested by Bazille's *The Artist's Studio* (1869-1870, Musée d'Orsay). Bazille's portrait of his working environment is also a manifesto for the new painting of the day in its depiction of the painter's world and friends. Renoir and Sisley stand talking in one corner, while Manet, Monet and Bazille are engaged in an equal exchange of impressions concerning the latter's *View of the Village*. Manet was at the heart of this movement which seemed to take shape and bestir the world of painting on the eve of the Franco-Prussian war in 1870. He had been recognized and adopted by the coming generation, whom he frequented at the Café Guerbois. As Théodore Duret recalled in his *Histoire des peintres impressionnistes*, 'Amidst the general discussions at the Café Guerbois, Manet and his painter friends spoke more particularly about their art. In the process they developed the theory and practice of *plein-air* painting in light tones [...] Manet, who had always painted his outdoor scenes, such as *Le Déjeuner sur l'herbe*, in his studio, working from studies made outside, now began painting large-scale pictures in the open air.'

Still, Manet did not join this group of young artists when they exhibited together in 1874. This was not for lack of friendship: in 1877 he asked the critic Albert Wolff to take a look at the works of 'my friends Messrs. Monet, Sisley and Renoir and Mme Berthe Morisot,' as exhibited at the third Impressionist exhibition, because 'though you may still dislike that kind of painting now, you *will* like it. In the meantime, please be so kind as to give it a little mention in *Le Figaro*.' That said, Manet always considered the 'official Salon to be the main battlefield' (Tabarand). Moreover, we may also suppose that he was sorely tried by the horrors of 1871 (the siege, famine, the Commune, civil war) that had torn France apart, and that he had recorded in his drawings (*Bazaine before the Council of War*) and lithographs (*The Line at the Butcher's Shop, The Barricade, Civil War*), he had no stomach for any more acts of division, even aesthetic ones. And finally, while he liked and respected some of the painters in the Impressionist group, such as Renoir, Degas and Morisot, there were others, such as Cézanne, who made him uncomfortable, or with whom he had absolutely no affinities.

Even so, Manet's name appeared regularly in the reviews and articles on the Impressionist exhibition, and he was held up as the leader of the movement, and even as responsible for its secession. When his painting *The Railway* (Washington, National Gallery) was exhibited at the Salon of 1874, the public, already excited by the exhibition on the Boulevard des Capucines, reacted with great violence. The kind that Manet had already experienced at the time of *Déjeuner sur l'herbe* and *Olympia*.

However, *The Railway* clearly shows the difference between Manet and, say, Monet. Yes, the theme is modern: outside Saint-Lazare station, a new development in a smart quarter of the city. But the main subject is nevertheless a woman and the little girl who is with her.

And yes, we are very much in the moment, a moment that could have been taken from some sunny day: indeed, is not the woman wearing an outfit in the blue woven drill that was fashionable in 1872? Critics strove to find a hidden meaning in this painting (which they would never have done in a Monet) and came up against the railings that cut it in two: 'Seeing how they were being painted, these poor creatures tried to escape, but the prescient artist put in rails that cut off their retreat.'

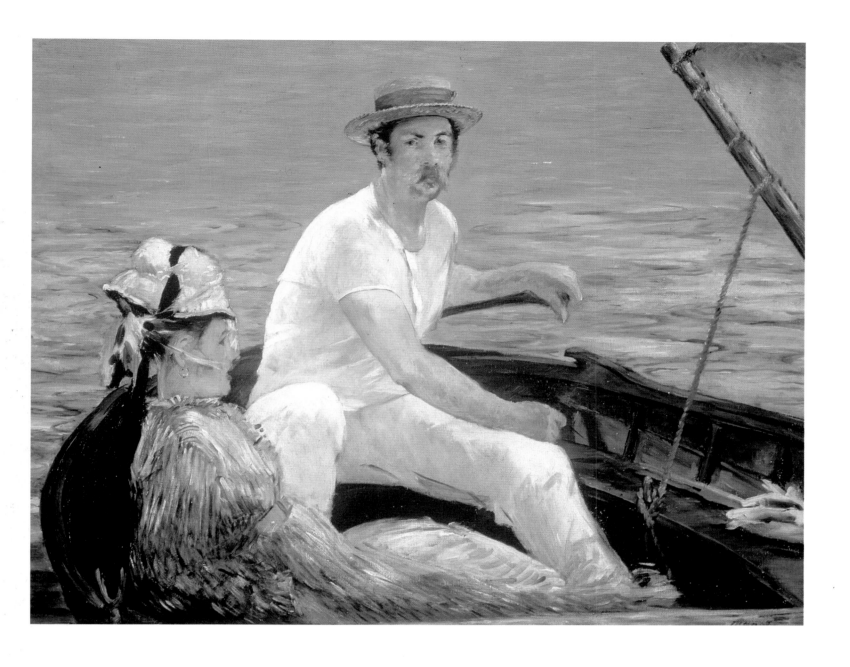

Édouard Manet
Boating
1874. Oil on canvas
97.2x130.2
New York, Metropolitan Museum of Art

It is, too, a *plein-air* painting, but only partially. Although Manet had his models pose in a friend's garden overlooking the railway, his painting is essentially a studio piece. It was painted in new, smart and respectable studio that Manet had just started renting in the area: its door and windows can be seen just behind the young woman. The painter had moved to a new quarter, he was representing modern life, with modern light and colors, but also with the distance of the old master and man of knowledge that he had always sought to remain, a man more interested in human destiny than in fleeting visions of passing time. This is confirmed by Castagnary, a critic who espoused the realist cause: 'What Manet paints is contemporary life. And about that, I imagine, we can have no complaints: the boating folk of Argenteuil are certainly equal to *Thamar chez Absalon*; at any rate, they interest us more.' A similar state of mind can be seen in the paintings from the 1870s: *Argenteuil* (Tournai) and *Boating* (New York, Metropolitan Museum), both painted in 1874 near the home of Monet, whom he saw regularly, and to which Castagnary is referring here. The men and women in *At le Père Lathuile*, *Plum Brandy* (1878,

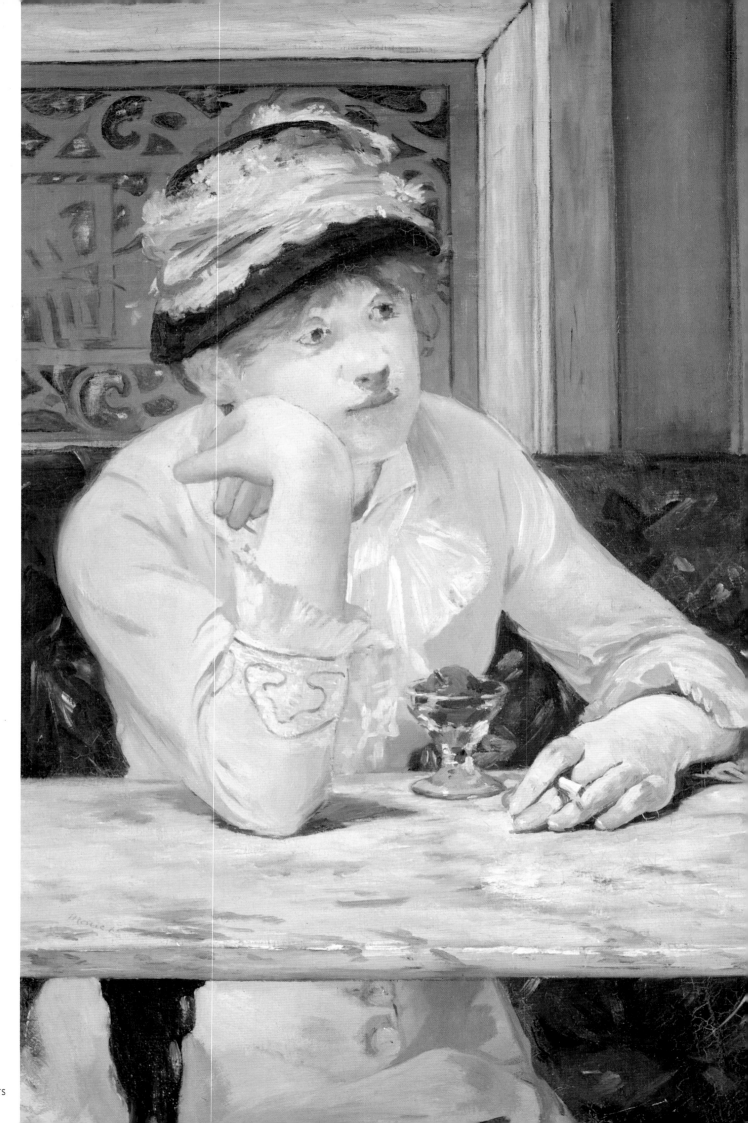

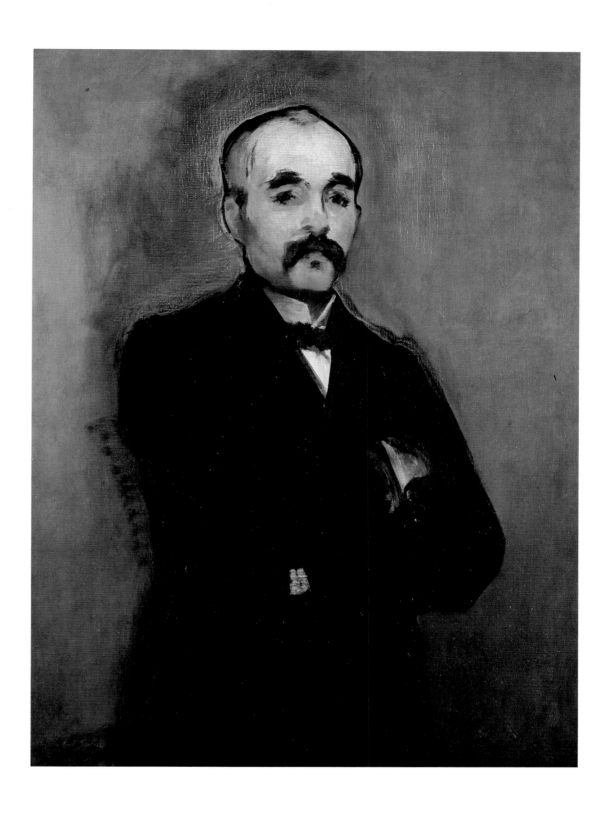

Washington, National Gallery) and *In the Greenhouse* (Berlin) are all bathed in vibrant light, but not permeated by it, as if insulated by their private destinies. Like *Pertuiset, the Lion Hunter*, that proud, vainglorious figure preparing to do battle with a ferocious beast, painted by Manet in his studio with irony but also affection.

Touched by the grace of Monet— 'The master has become a student in the 20th grade,' ironized one critic—Manet never forsook his own technical brilliance, his monumental facture, the sublime and absolute black that he used to brush in his portrait of the brilliant lawyer and radical deputy *Clemenceau* (1879, Musée d'Orsay), or his *Portrait of Rochefort*

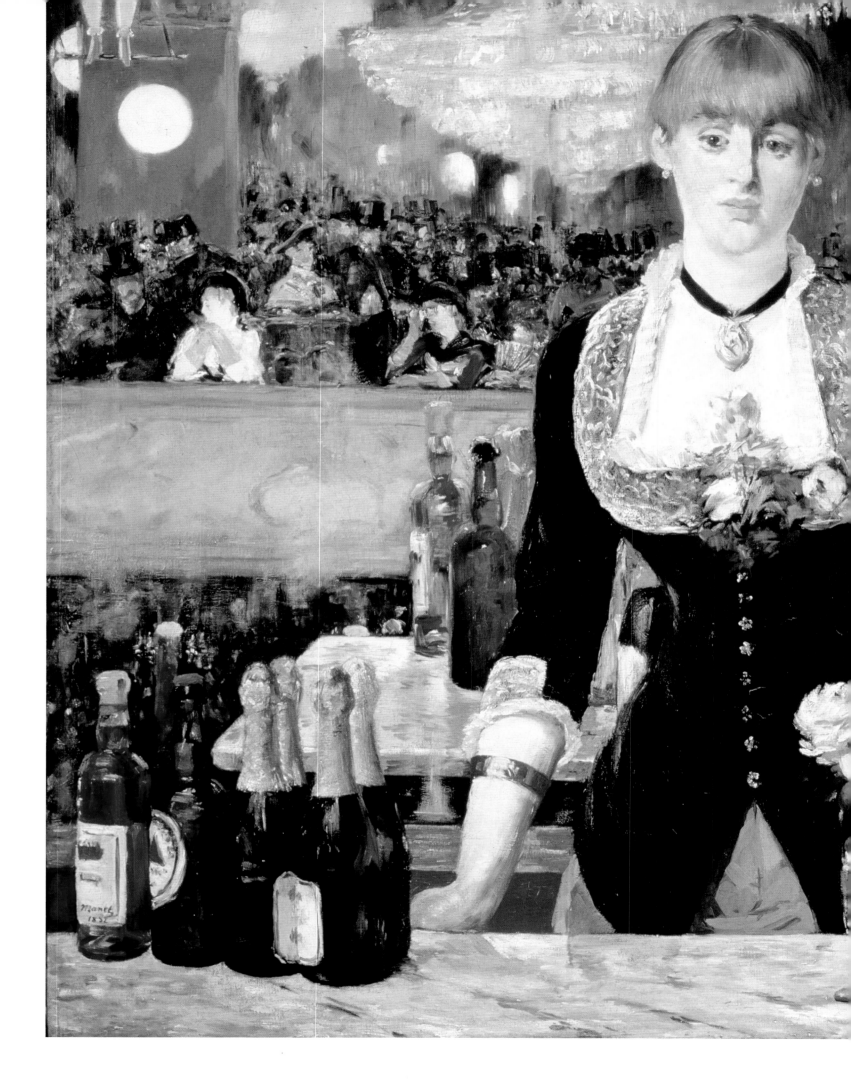

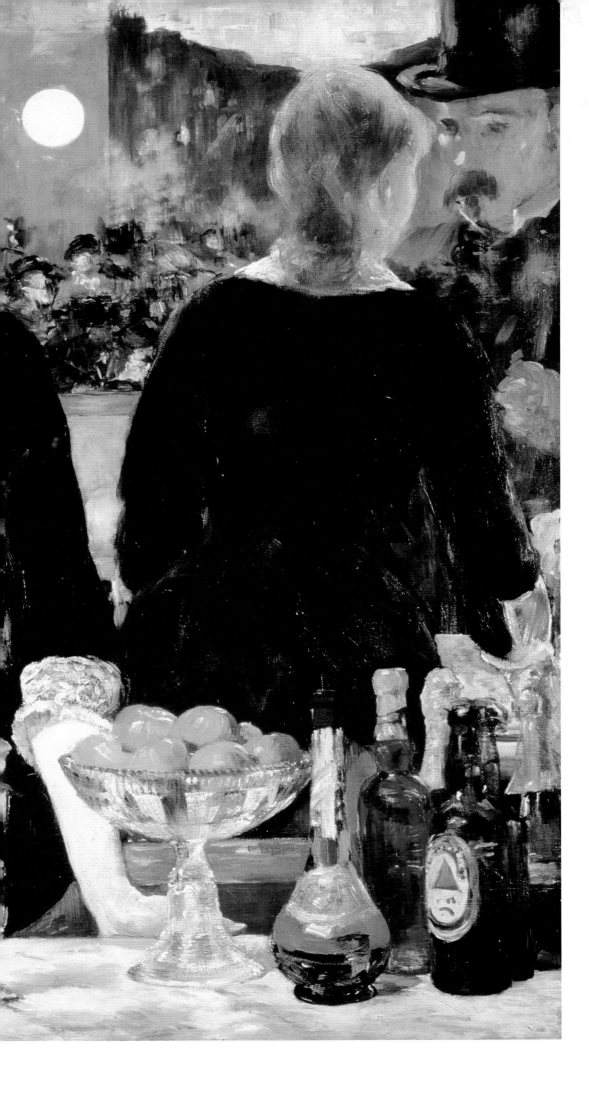

Édouard Manet
A Bar at the Folies-Bergère
1881-1882. Oil on canvas
96x130
London, Courtauld Institute

(1881, Hamburg) or his *Rochefort's Escape* (1880, Zurich). Here he was only too glad to be dealing with history in the making.

For if Manet was no Impressionist, he was, more than any other, the painter of contemporary history. *Masked Ball at the Opera*, the nocturnal pendant of *Music in the Tuileries Gardens, Nana* (1877, Hamburg) and *A Bar at the Folies-Bergère* all attest this fact. *Nana*, which was refused by the Salon, was exhibited in the window of a shop on the Boulevard des Capucines. The young critic and naturalist writer Huysmans wrote: 'Manet was absolutely right to present us in his Nana with one of those perfect samples of the kind of woman that his friend and our dear master Emile Zola will portray for us in his coming novels.' And indeed, having appeared in the final chapters of *L'Assommoir*, published in serial form at the end of 1876 ('She had the sweet smell of youth, the nude of the child and woman…'), she returned as a grown woman and full-fledged eponymous heroine of the novel *Nana* at the end of 1878. In spite of their mutual praise, relations between Manet and Zola had slackened off somewhat. Zola had given up criticism to devote himself to his Rougon-Macquart saga, and Manet had won the unconditional support of the poet Mallarmé, who savored his lightness of touch and his sometimes allusive way of approaching reality. Whereas for Zola Manet's way of representing the modern world was too incomplete and lacking in explicitness. 'Manet contents himself with the approximate,' he wrote in 1879. Failing as he did to appreciate Manet's skill at reconstructing reality, the writer was unjust.

For reconstruction is very much what we have in *A Bar at the Folies Bergère*, Manet's last great masterpiece, a single composition that manages to embrace not only the serving woman behind the bar but also a customer and, above all, the theater itself over which she is casting her weary gaze. Manet here reconstructs every single facet of a shifting whole. This effect had been achieved to notable effect in Velasquez's *Las Meninas*, a painting that he had admired when in Madrid. There the Spanish artist showed himself palette in hand. Here, Manet disappears, leaving us the noisy crowd. He was the first artist to capture this modern phenomenon in all its diversity and with all its particularities. Manet was more than an Impressionist. He was the painter of modern life. The painter with an eye for the permanent in a world of movement.

Édouard Manet
Nana
1877. Oil on canvas
150x116
Hamburg, Kunsthalle

Manet

Monet

The rich, deep relationship between Manet and Monet began with a misunderstanding which bears witness to the kind of internal rivalry that often arose in the avant-gardes of the mid-1860s. Both artists showed at the 1865 Salon. Manet, who was used to scandal and controversy, had his *Jesus Mocked by Soldiers* and *Olympia*. Monet, who was being admitted for the first time, was showing *The Mouth of the Seine at Honfleur* and *The Pointe de la Hève at Low Tide*. The public mixed up the names and Manet ended up being congratulated for his very popular marine paintings. This made him angry: 'Who is this blackguard who is basely pastiching my painting?' Monet's canvases were indeed close to the ones Manet had painted the year before on *The Battle of the Keasarge and the Alabama*, but had a quality of light and

spontaneity that Manet was soon to admire. The two artists saw a lot of each other in the late 1870s, but their friendship proper began in 1874, when Manet spent the summer near Monet's home in Argenteuil. There he made several paintings of his young friend, always outside, doing his outdoor painting: in his garden, gardening with his wife and son; or on his studio boat. It was as if Manet wanted to capture both the man, the artist and his method. In fact, his own palette grew much lighter as a result of his frequenting Monet. He painted *Argenteuil* and *En bateau*, two compositions that combine his taste for social record with Monet's passion for water, color and light. In 1876 he bought Monet's *Women in the Garden*, a figure painting full of life and light, from relatives of Bazille's. And throughout the 1870s, which was such a difficult time for Monet, Manet helped him, sought out collectors and wrote to critics on his behalf.

When Manet died in 1883, Monet was deeply distressed. In 1889 he started a subscription to buy *Olympia* from Manet's window and donate it to the Louvre. This, the supreme challenge to the art of the time and to the museums, had been Manet's exhibit at their first Salon together. After a year of dogged efforts, during which he himself stopped painting, Monet managed to collect the 20,000 francs from artists, journalists and art lovers who had admired Manet's work. In February 1890 he donated *Olympia* to the reluctant French State and paid a public homage to his friend, 'the representative of a great and fecund evolution.' The critic Duret had told Monet that 'You will make the hole through which Manet finds his way in.'

Photograph of Édouard Manet
Paris, Bibliothèque Nationale de France

Photograph of Claude Monet
Paris, Musée d'Orsay

Édouard Manet
Claude Monet Painting on His Studio Boat
1874. Oil on canvas
82.5x100.4
Munich, Bayerische Staatsgemälde-Sammlungen

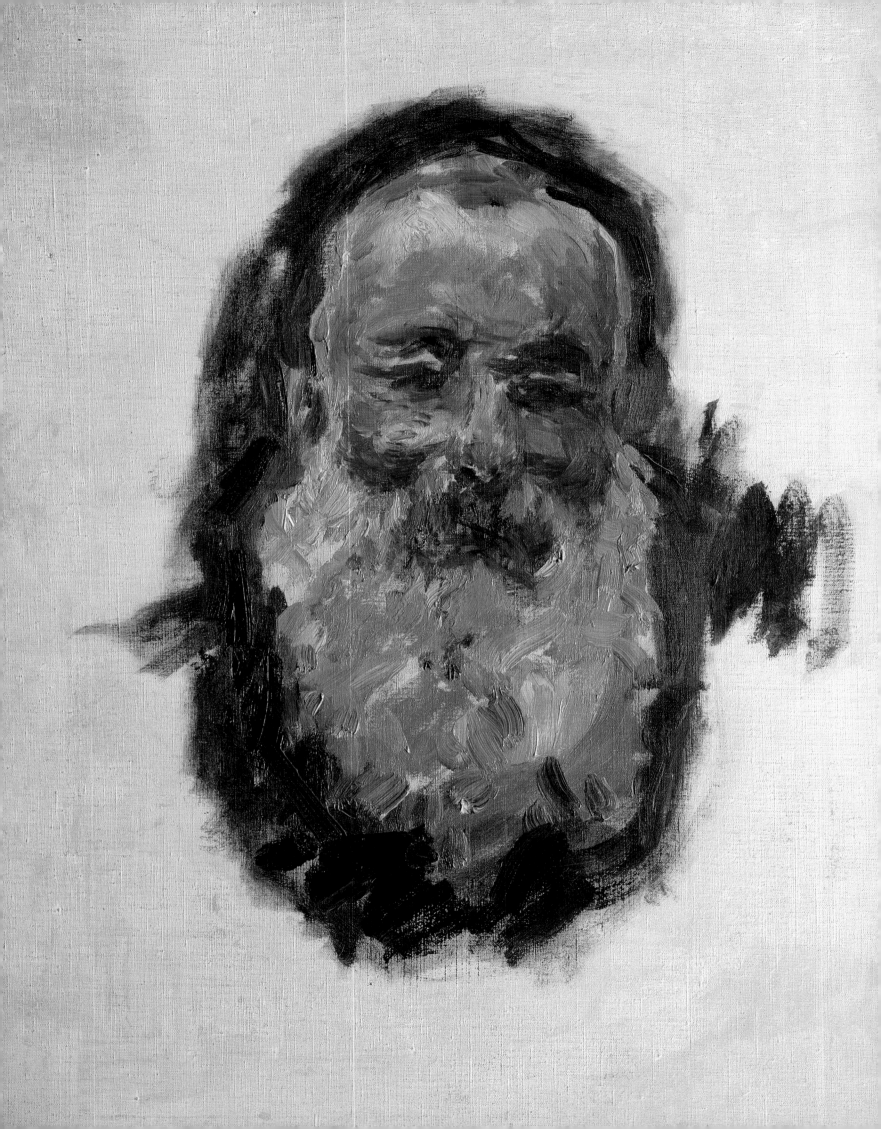

2 Monet

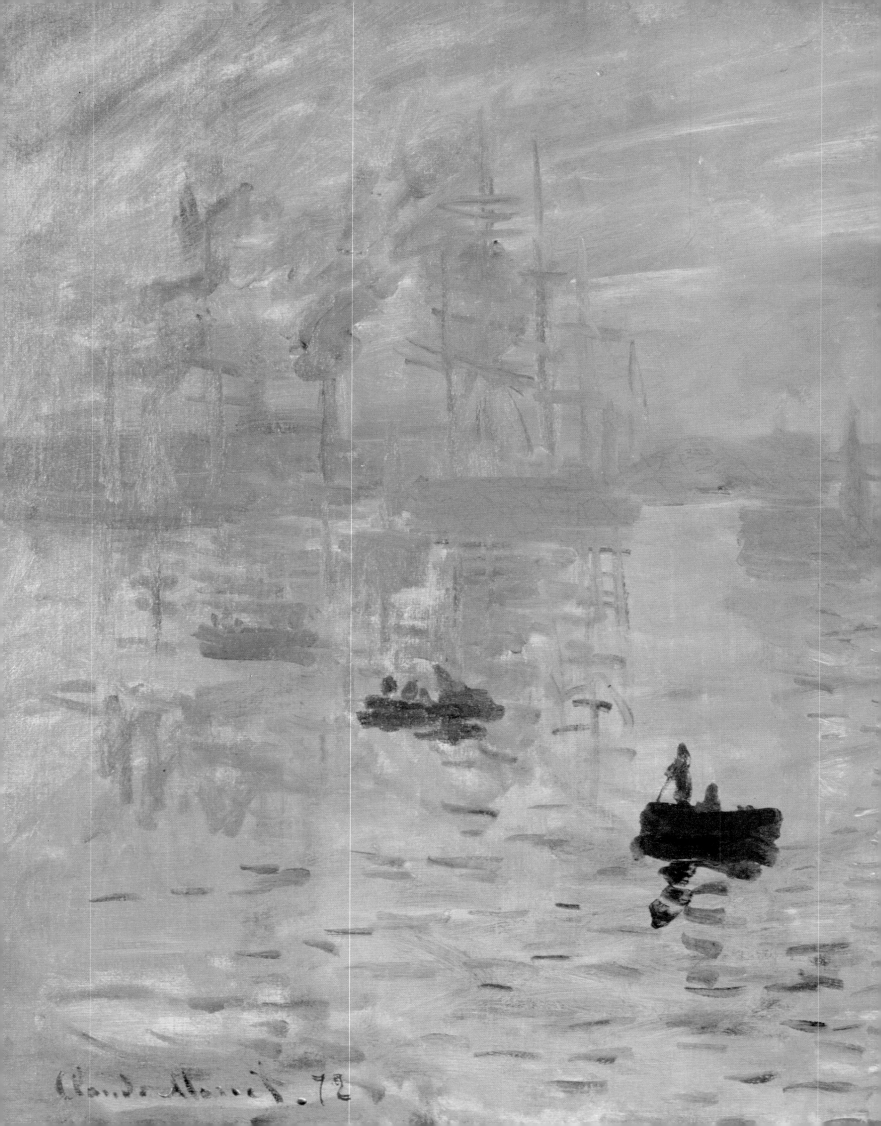

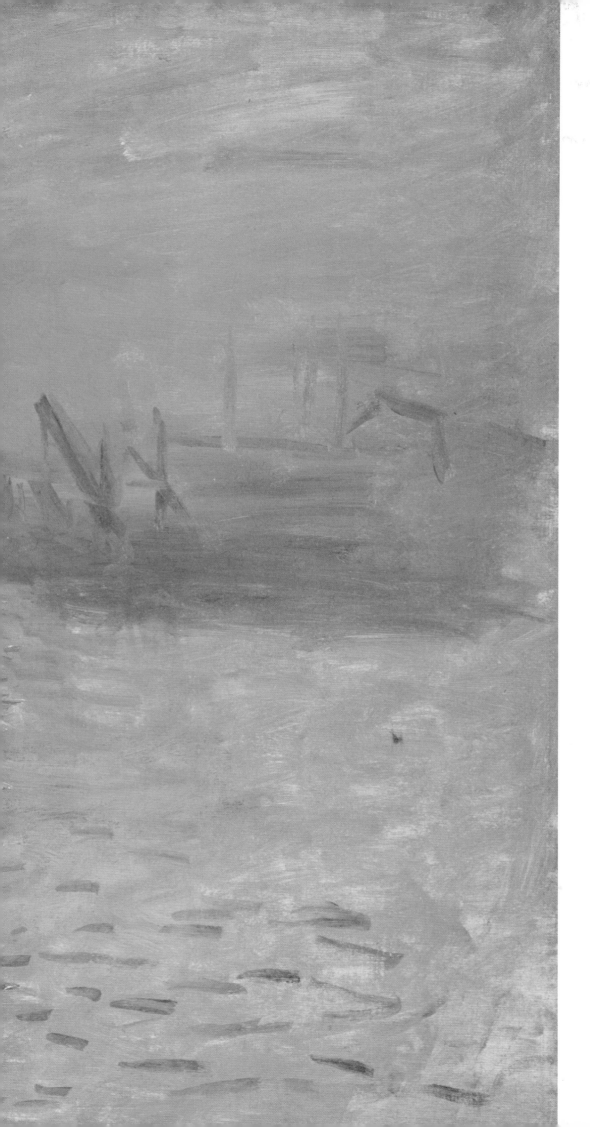

The word 'Impressionism' was invented by and for Monet. Witness this sarcastic review by the journalist Louis Leroy, seeing Monet's *Impression, Sunrise* at the exhibition of 1874: 'Impression, I was sure. And I thought, since I am impressed, there must be some impressions in it.' All over the surface of this large canvas painted in 1872 the artist had spread lively, bold touches, wide brushmarks that at first sight seemed to break up the subject (the harbor at Le Havre), but which, seen from the right distance, rendered the reality of its specific light, at sunrise. The word had been invented and was in use, and it was Monet who would develop its implications with the greatest thoroughness, along with the sensations of sketchiness, of fragmentation, speed and spontaneity even, which it conveyed.

Several years before that—in 1865 to be precise—Monet had begun working away quite independently on the foundations of this aesthetic revolution. While it is possible to say that Manet has his masters, the same cannot be said of Monet. While he spent some time at Gleyre's studio, where he met Bazille, Renoir and Sisley, his trips to the forest at Fontainebleau, or to the beaches of Normandy, palette and brushes in hand, were much more formative. Those and Boudin's words of advice: "Study, learn to see and paint, draw, do landscapes. They are so beautiful, the sea and the sky, the animals, the people and the trees, as nature made them, with their own character, their way of being, in the light, in the air, just as they are." And De Jongkind, with whom he quite literally tried to capture the clouds. From these two humble artists, both outsiders, Monet learnt about the sincerity of the gaze, the struggle against time, wind and rain. From Courbet, who admired the landscapes he exhibited at the Salon in 1865, and who paid him a visit in his garden at Ville d'Avray, and from Manet, who was even closer, he learnt ambition, the desire to make a name for himself, to establish his painting.

And Monet was ambitious. The favorable reception of his landscapes at the Salon was not enough. He now threw himself into a huge *Déjeuner sur l'herbe*. A real luncheon, with white sheets spread out in the green glass of a glade, a real glade flooded with real light, with real guests dressed in the appropriate manner for a country outing. Monet was positioning himself as a rival of Manet, but also of Courbet, who had painted hunting lunches in his studio. Bazille and Camille, his young partner, posed for him, and Courbet, more youthful and sprightly now, was also invited. The painting—which Monet never completed, but which is well known from the sketch and two large fragments—was not painted outdoors: 'I proceeded in the same way as everyone else in those days,' recalled Monet, 'making small studies from nature and recomposing the whole in my studio.' Still, its colors were bold and intensified by a joyous, vivid light. Zola acclaimed this new vision of the world: 'This is a man who has been nursed on the milk of our age, who has grown and will continue to grow in the adoration of what is around him. He loves the horizons of our towns, the grey and white blots made by the houses against the light sky, the bustling, busy people [...] he loves our women and their rice powder, everything that makes the daughters of our civilization.'

It is this direct, keen gaze, this lively curiosity about the modern world that make Monet's pre-1870 works so original. His portrait of *Camille*, walking in her green dress, can stand as a picture of all modern women,

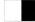

Claude Monet
Camille in a Green Dress
1866. Oil on canvas
231x151
Bremen, Kunsthalle

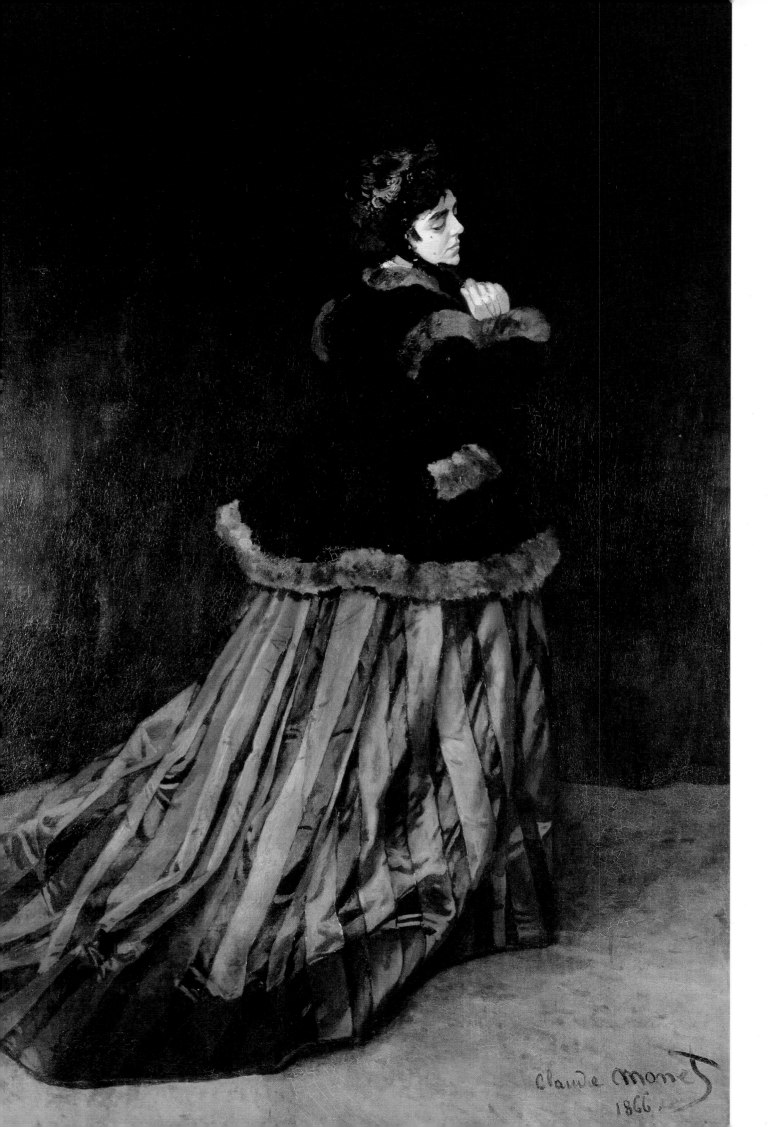

Claude Monet
1866.

'bedecked with their vices and their elegance.' The views of Paris, *Saint-Germain-l'Auxerrois* and *Le Pont Neuf*, reveal the new face of this capital, its streets full of visitors and walkers come to stare and wonder, its mixture of ancient monuments and modern details. The beaches of Normandy welcome tourists brought in by steam trains (*Train in the Country*), accommodated in brand new hotels (*The Regatta at Sainte-Adresse, Hôtel des Roches Noires, Trouville*). The gardens are in bloom and filled with elegant women (*Women in the Garden, The Garden of Aunt Lecadre*). Nature is calm and familiar (*The Magpie*). Nothing is declamatory or demonstrative. All this joy, this youthfulness and freshness of vision, which reach a pitch in *Bathing at La Grenouillère*, nevertheless failed to win over the jury of the Salon, which clung to its vision of old worlds. Monet, along with his friends, had to fight inch by inch. He dreamed of being able to exhibit freely, and to sell without care.

The Franco-Prussian war in 1870 and the events that followed marked a deep break in his work. He left France and took refuge in London, where he found Pissarro and met the dealer Paul Durand-Ruel, who bought his

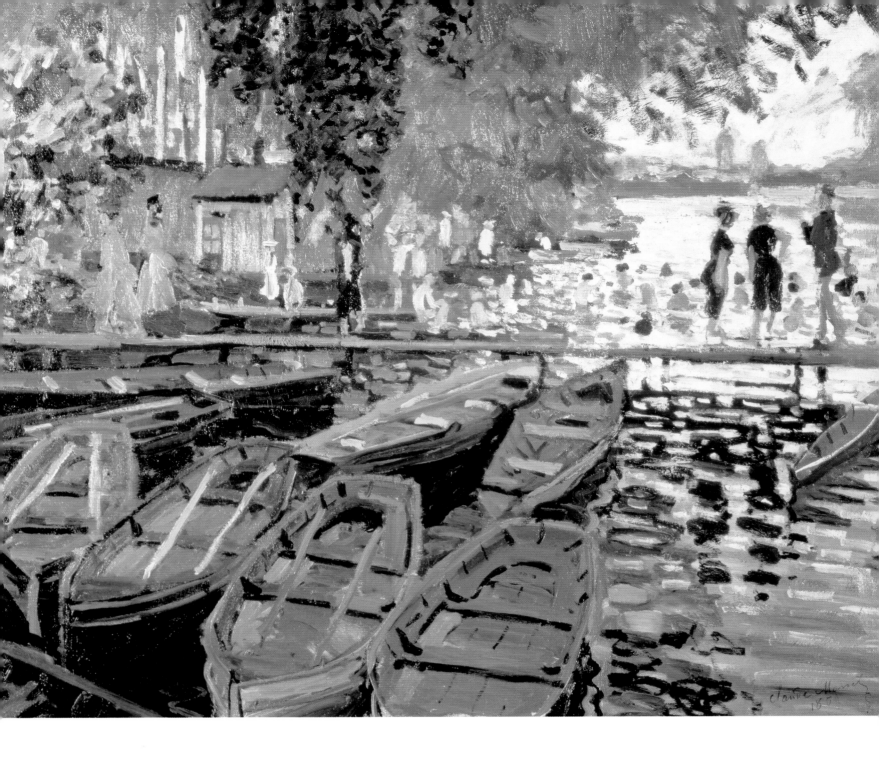

paintings, then moved on to Zaandam in the Netherlands. Bazille died. His friends were far away. Monet abandoned his ambitious compositions, concentrating now on landscapes and intimate scenes. He removed the large, foreground figures, let the diffuse feeling of disquiet enter into his paintings. At the end of 1871, he settled in Argenteuil, a small town a few minutes by train from Saint-Lazare station. There he could afford a house, a garden with flowers. The surrounding environment offered a mixture of rustic and modern whose contradictions he now explored. Nearby was the Seine and its boats. This was the setting for Monet's Impressionist period, close to his friends, of the struggle to gain recognition for his paintings as he deepened his visual sensations.

The first years in Argenteuil were serene. Benefiting from the support of his new dealer, Monet lived comfortably with his wife and young son.

However, in 1873 Durand-Ruel was forced to stop buying and Monet began playing an active role in the organization of the first Impressionist

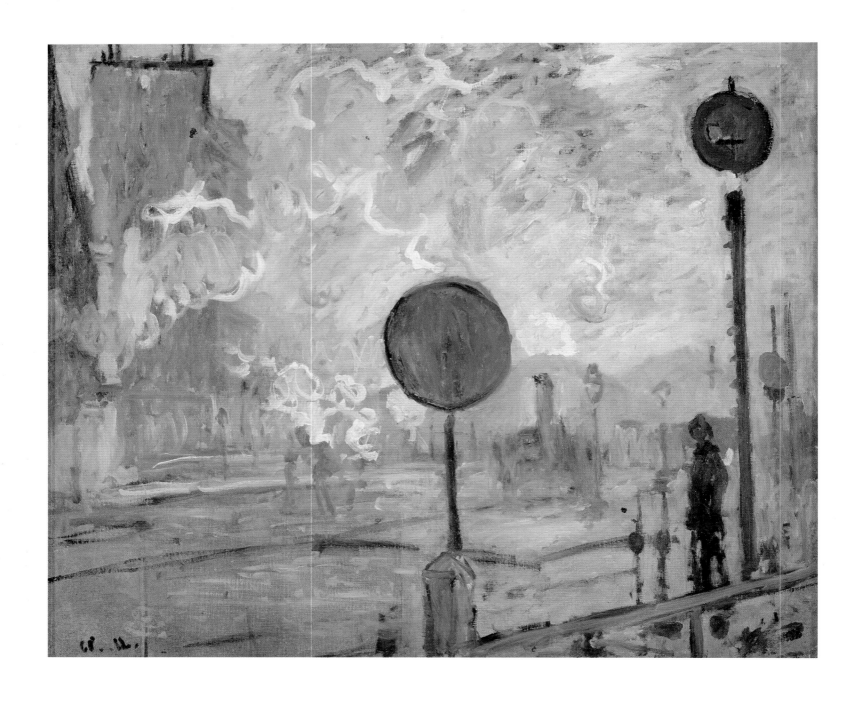

exhibition in 1874. There he presented *Impression, Sunrise* and *Poppies, Boulevard des Capucines, Lunch, Fishing Boats Leaving the Harbor, Le Havre.*

The four different themes showed the diversity of his interests. They would recur throughout his life.

Luncheon: a peaceful family scene, a bourgeois interior, painted in 1868, with a gleaming still life, the whole scene expressing Monet's passion for his family, his house and his creature comforts. *The Poppies*: simple countryside, covered with flowers. Other paintings from the Argenteuil period combine these two centers of interest. *Lunch*, this time laid out on a table in the garden with a child playing and the nonchalant mother. *Apartment Interior* with a child hidden by the light and shade of the familiar room. Or *Camille Reading beneath the Lilac*, her clothes speckled with violet blotches from the light filtered through the flowers.

Le Boulevard des Capucines: the movement and noise of the city, whose agitation amazed Louis Leroy—"So, that is how I look when I am out

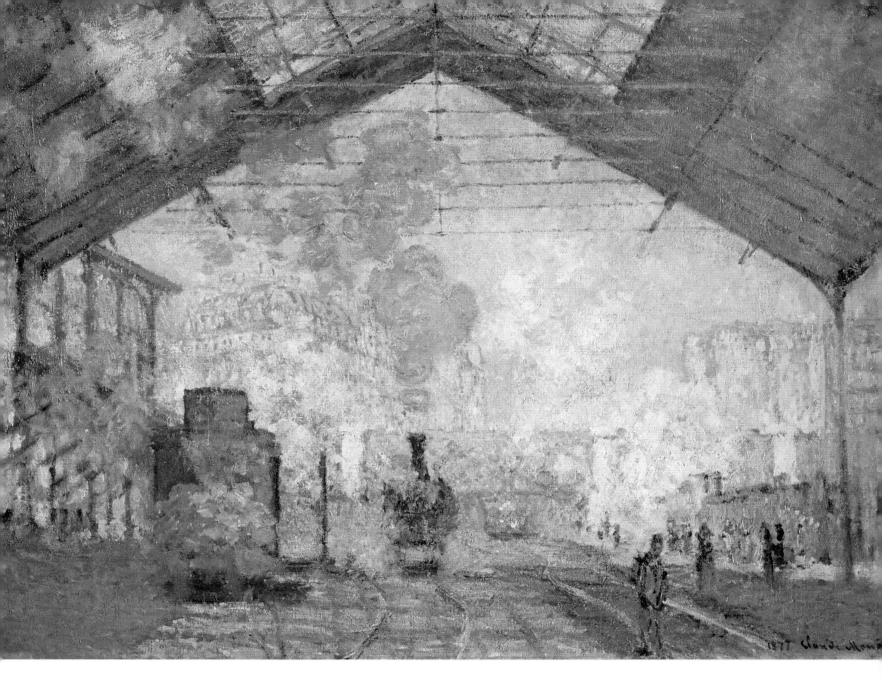

Claude Monet
Exterior of Gare Saint-Lazare (the Signal)
1877. Oil on canvas
65x81.5
Hannover, Niedersächsisches Landesmuseum

Claude Monet
Gare Saint-Lazare, Paris
1877. Oil on canvas
75.5x104
Paris, Musée d'Orsay

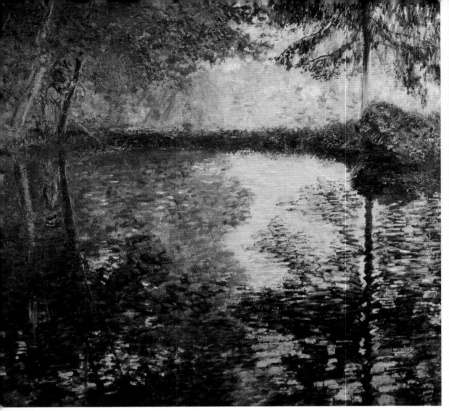

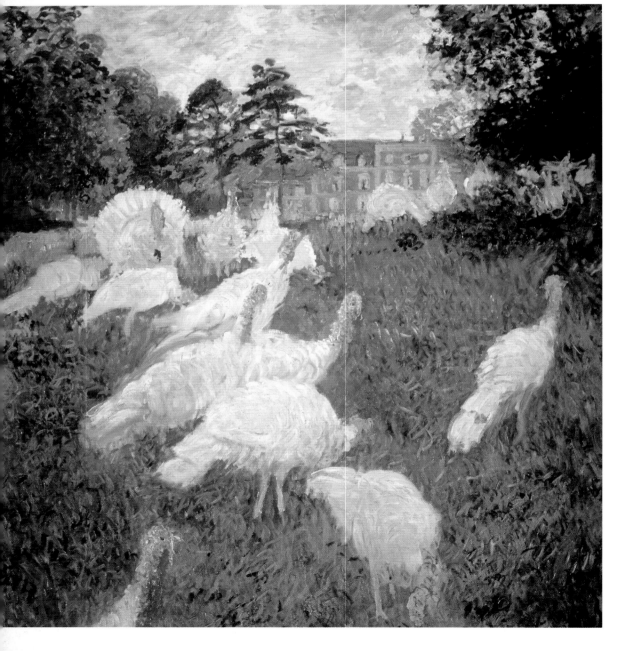

Claude Monet
The Pond at Montgeron
1876. Oil on canvas
174x194
Saint Petersburg, Hermitage Museum

Claude Monet
The Corner of the Garden at Montgeron
1876. Oil on canvas
172x193
Saint Petersburg, Hermitage Museum

Claude Monet
Turkeys
1877. Oil on canvas
194.5x172.5
Paris, Musée d'Orsay

Claude Monet
The Hunt
1876. Oil on canvas
170x137
Private collection

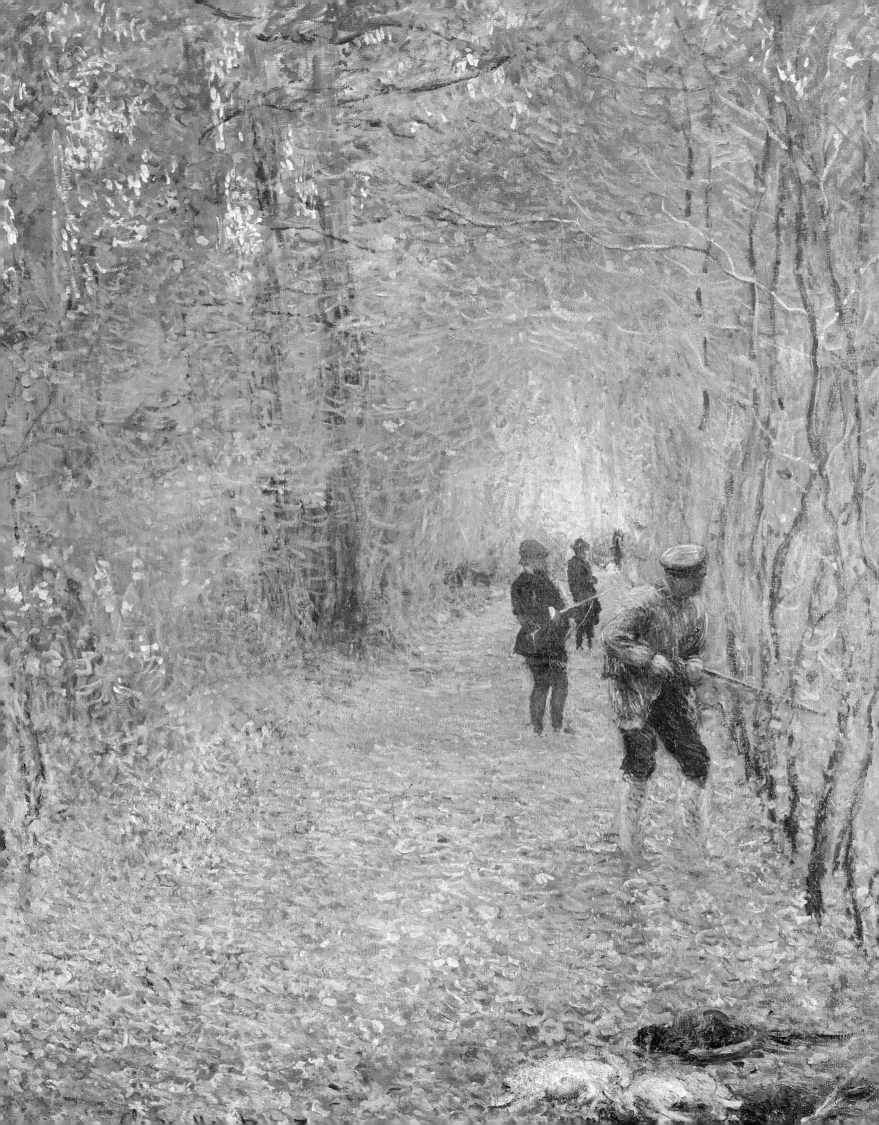

Claude Monet
Pyramids of Port-Coton
1886. Oil on canvas
65x81
Moscow, Pushkin Museum

walking on the Boulevard des Capucines?" These soon became key themes for Monet as he plunged into the urban inferno, amidst the railways lines of the Saint-Lazare station. In 1877 he painted, not a series, but a set of seven different views of that temple of modern times. Seeing them at the third Impressionist exhibition, Zola wrote: "This year Monet exposed some superb railway station interiors. You can hear the rumbling of the trains as they are swallowed up, you can see the spreading steam billowing beneath the huge sheds. This is the place of painting today. Our artists must find the poetry of stations just as their fathers found that of the forests and rivers." Monet was the true inventor of the modern landscape.

Impression and *Le Havre*: scenes centering on water, an element in which Monet loved to let his gaze become absorbed. In Argenteuil, he had them build him a studio-boat, thus taking up Daubigny's practice of sailing down the Seine in his *Bottin* and drawing as he went. He was thus as close as could be to the fleeting, shifting reflections. But he never let these take his mind off the environment and activities around the river itself.

During this intensely active period, in 1876, Monet was commissioned to decorate the château of Ernest Hoschédé, a rich collector. The result was four paintings: *Turkeys, The Hunt, The Corner of the Garden at Montgeron (the Dahlias)* and *The Pond at Montgeron*. The last two compositions, with their luxurious vegetation and interplay of water and reflected plants, prefigure the paintings of the Giverny period.

At the beginning of 1878 Monet left Argenteuil for Paris, and shortly afterwards moved to Vétheuil. This village was further from the capital, and his residence there coincided with a period of moral and financial difficulty, a time of doubt. Camille died, leaving him with two sons. In addition, Monet now offered his roof to Alice, the wife of Hoschédé, who had gone bankrupt, and her five children. He now had two families to provide for. Artistically, he began to move away from his favored themes. He ceased to be interested in water and plants. His touch became febrile and agitated, his compositions larger and more conventional. *Lavacourt*, the painting that he presented at the official Salon in 1880, hoping to enjoy the same success as Renoir the year before, is emblematic of this tormented period. 'I am working flat out on three large canvases, of which only two are for the Salon,' he wrote. 'For one of the three is too much to my own personal taste to send, and it would be refused anyway, and instead I have had to do something safer, more sedate.'

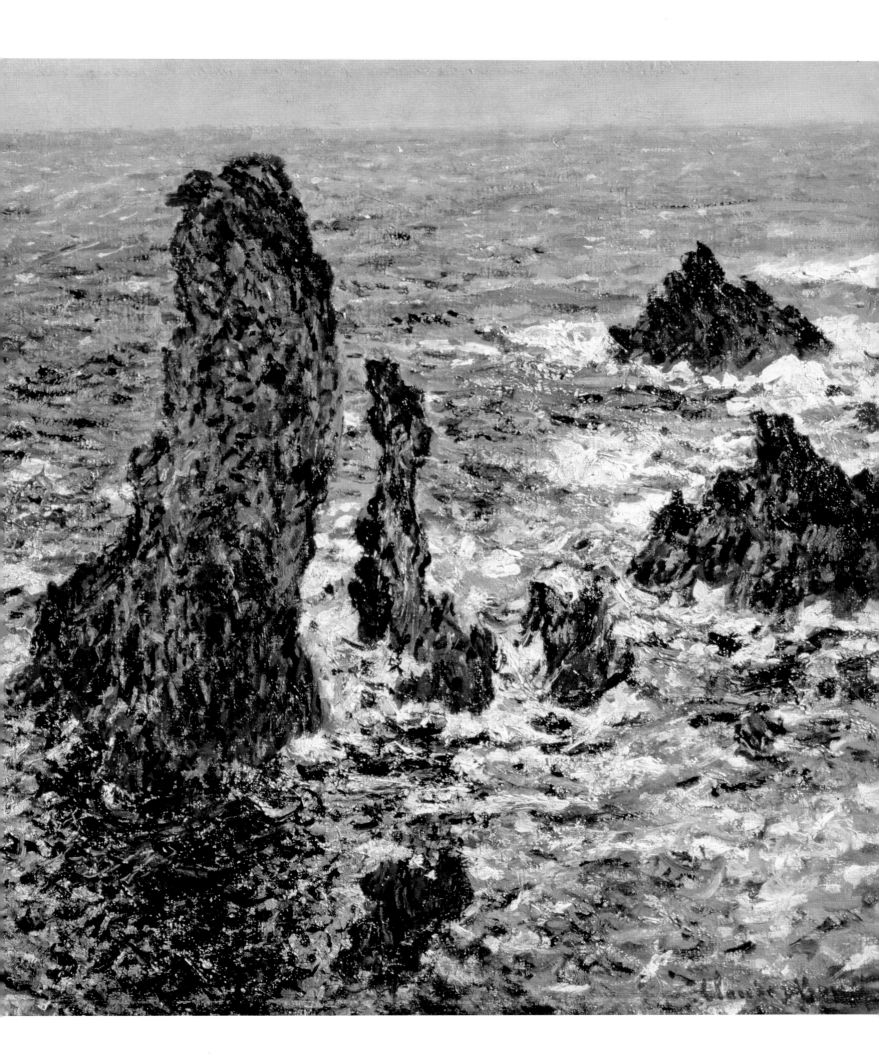

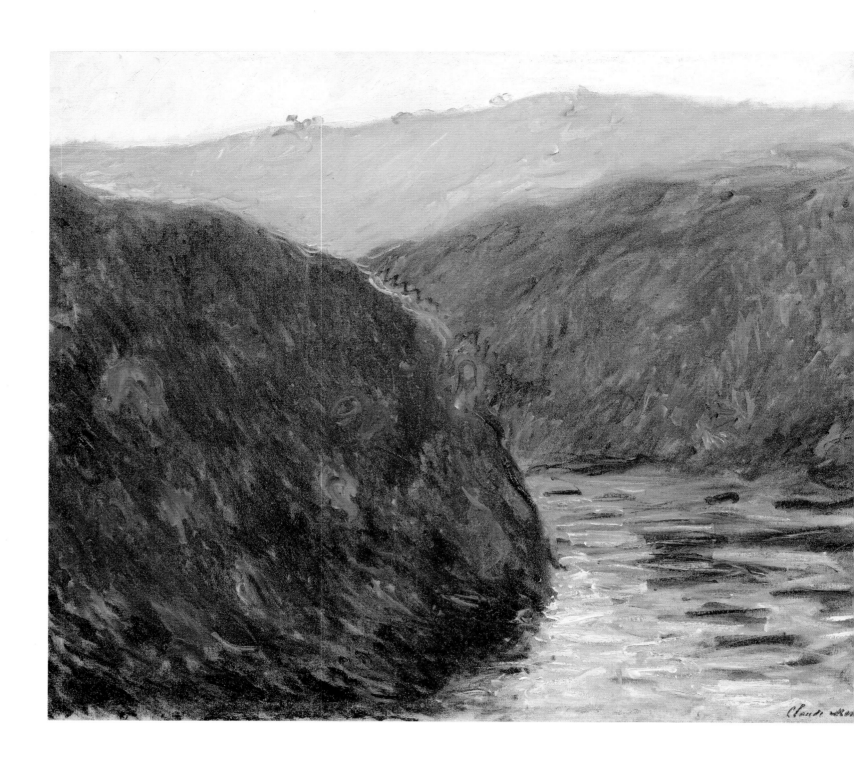

Claude Monet
La Creuse, Sunset
1889. Oil on canvas
65x81
Paris, Musée Marmottan

In 1881 Monet's situation began to brighten up a bit: Durand-Ruel had started buying again. In 1883 the dealer organized a solo exhibition for him, and he began to exist independently of the Impressionist group. That year he also discovered Giverny and the house where he would live for the rest of his life. He was getting his energy back, getting a new lease on life and reinventing his art. He went on regular painting expeditions as he sought to renew his themes and refresh the curiosity of his admirers. 1884: Bordighera;1886: Belle-Ile; 1888: Antibes and Juan-les-Pins; 1889: the Creuse valley;1892-1893: Rouen; 1895: Norway; 1899: London; 1908: Venice. It was always the same process: Monet hunted for a theme and despaired of finding one: 'It is too dense, there are always these bits with lots of details, tangles that are terribly difficult to render when I am a man for solitary trees and wide open spaces' (1884). Then it came to him. 'Now I have it, this magical country.' And he got to work. Fretted about not having enough time. Missed Giverny, his family and Alice. 'Our dear nettle island… give me news of our big boat… I feel more eager than ever to live your life with you, to be with you, to garden' (1885). He worried about not being able to finish the paintings he had begun: 'I am struggling, struggling but making no headway. I believe I am trying for the impossible' (1888). So he would extend his stay and go back to his paintings in the studio before exhibiting them, triumphing a little more every time.

It was during one of these trips that he chanced upon the principle of the series. This was in 1889, in the Creuse Valley. As usual, Monet was struggling with his theme: 'I follow nature without being able to grasp it, and then, this river that sinks then rises, is green one day and yellow the next, is dry today and will be a torrent tomorrow after the terrible downpour we are now having! I am, anyway, deeply worried.' He nevertheless produced nine paintings, all from virtually identical vantage points, striving to render a particular moment in each one. Octave Mirbeau, who had been asked to write the preface for the exhibition where these paintings of Monet's were shown alongside works by Rodin, explained it thus: 'Monsieur Claude Monet understood that, in order to achieve a more or less exact and emotional rendering of nature, it is necessary to paint not only the general lines of a scene, but also the hour at which you have chosen to characterize that scene: the instant. He observed that, on a normal day, an effect lasts barely thirty minutes. Having chosen the figure and the moment of that motif, he threw down his first impression on the canvas. He set himself the strict rule of covering that canvas in this short space of half an hour.'

The series is, without a doubt, the ultimate vehicle of Impressionism. It became Monet's favored mode of expression. He followed up the experiment of the Creuse with the grainstacks in the next-door field at Giverny (for he also made a lot of paintings in the countryside around his home): *Grainstacks* (1890), *Mornings on the Seine* (1896), *Poplars* (1892)… Increasingly now, he would paint in his garden, just outside his house. The series allowed him to paint a certain kind of instantaneousness and freeze the moment, which is by definition fleeting, on the canvas. But it also allowed him to become absorbed in a motif, to forget all material circumstances except the passing of time. The motif here is extracted from the modern world. Monet, the artist who had been 'nursed on the milk of our age,' was turning his back on civilization.

Claude Monet

Grainstack – Pink and Blue Impressions

1890-1891. Oil on canvas

73x92

Private collection

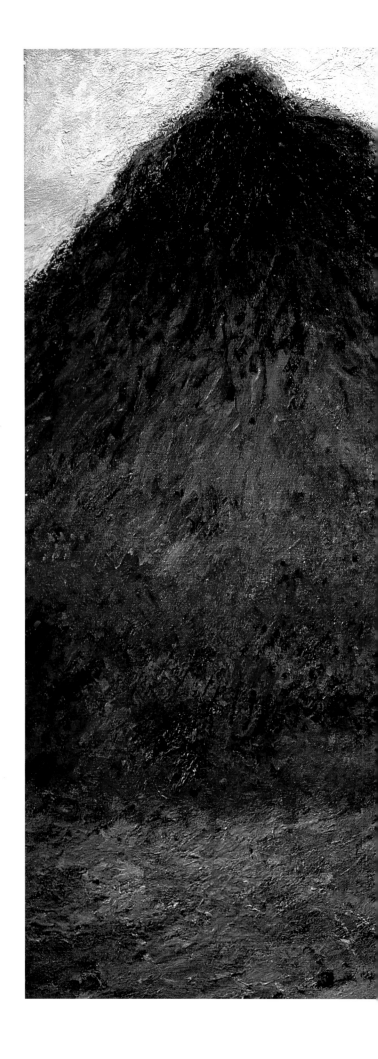

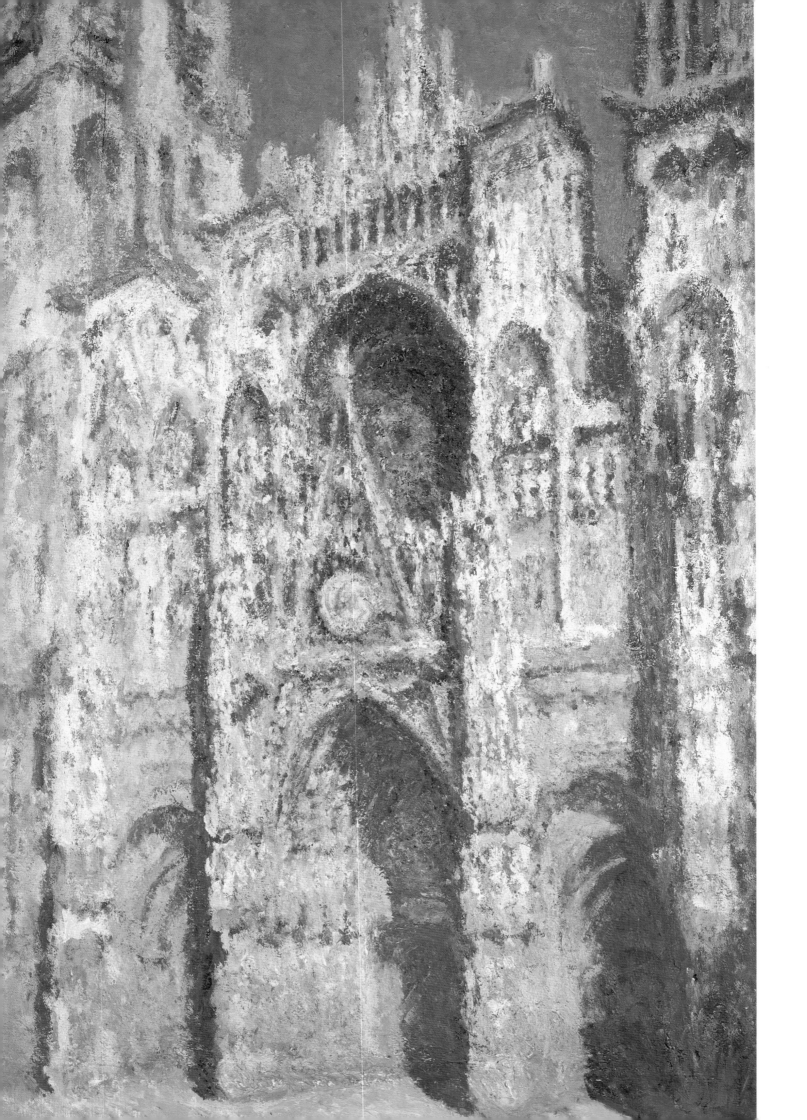

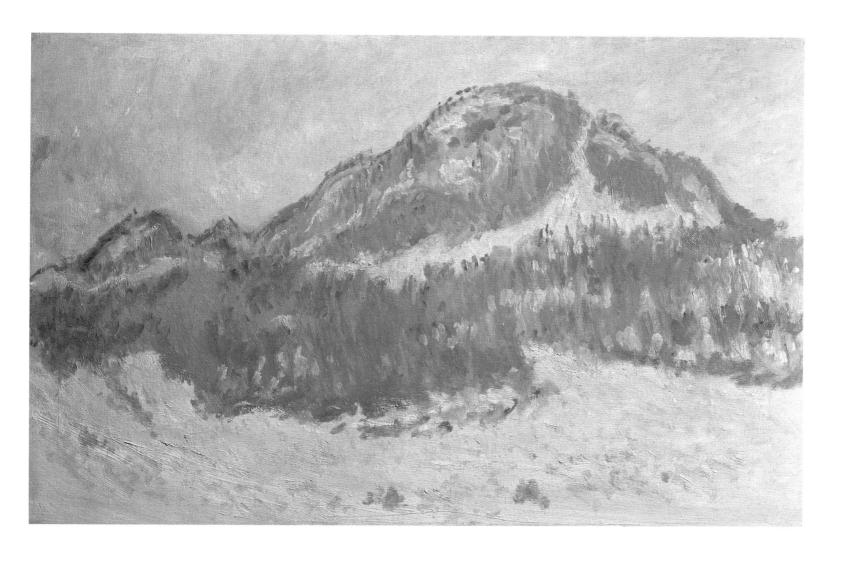

Claude Monet
**Rouen Cathedral, the Portal
and Tour d'Albane, Full Sunlight**
1894. Oil on canvas
107x103
Paris, Musée d'Orsay

Claude Monet
Mount Kolsaas in Norway
1895. Oil on canvas
65.5x100
Paris, Musée d'Orsay

What he was looking for in his *Rouen Cathedral* series (1893), his trees and grainstacks, his mountains (*Mount Kolsaas*, 1895), his views of water and even of London (1903-1904) and Venice (1908-1912), was what was timeless, or rather, what changed only in the light. Monet the 'painter of the moment' and the 'naturalist' of 1865-1880 had become a symbolist, turning his back on the developments of civilization. Except, that is, when civilization meant parading at full speed down the streets of Giverny at the wheel of his yellow Torpedo.

But civilization confirmed Monet's disillusionment when war broke out in 1914. From his garden in Giverny, Monet, who had lost Alice in 1911, had a sense of the destruction and suffering; the slaughter. He himself lived among the flowers that he had planted, like so many perpetually renewed motifs. In 1893 he had laid out a 'water garden' at the end of his garden, a pond hidden among the plants and covered with water lilies, spanned by a Japanese bridge. This would constitute the great work of the end of his life. In 1897 he had the idea of a decorative scheme whereby beholders could lose themselves in the water and flowers around the pond. The series followed, *The Water Lily Pond* (1899-1900), *Water Lilies* (1903-1908), *The Japanese Bridge* (circa 1919-1924), including the great decorative panels he donated to the French State after the armistice in 1918, now installed in the Orangerie (Tuileries, Paris). In these round, square, oval, rectangular, large or monumental canvases, Monet did away with all sense

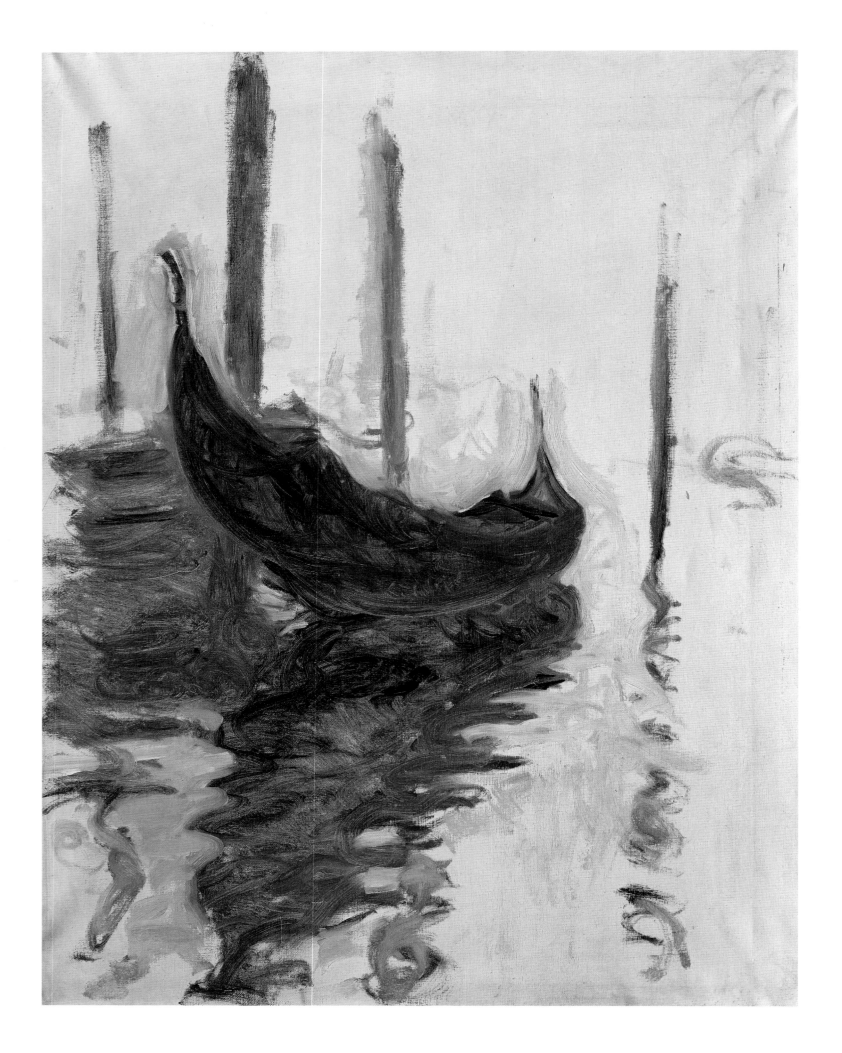

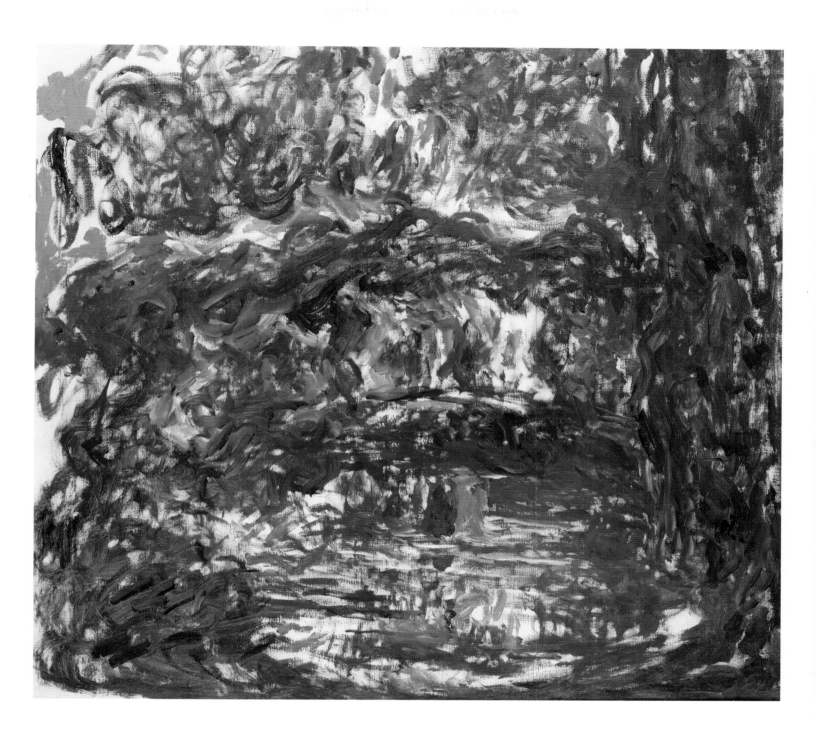

Claude Monet
Gondolas in Venice
1908-1909. Oil on canvas
81x56

Nantes, Musée des Beaux-Arts

Claude Monet
The Japanese Bridge
1918-1924. Oil on canvas
89x100

Paris, Musée Marmottan

of perspective or depth. The motif remained but was simply broken up and multiplied by reflection. The color flows or, sometimes, spurts out abruptly. In his flowers and in his daily practice of painting Monet found consolation for all his sorrows as an old man. Here was the justification of a life spent working with landscape: 'My only wish is to be more intimately at one with nature, and the only destiny I yearn for is, in keeping with Goethe's precept, to have worked and lived in harmony with its laws.'

Monet

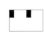

Photograph of Claude Monet

Paris, musée d'Orsay

Photograph of Frédéric Bazille

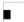

Claude Monet

The Picnic

1865-1866 (central panel). Oil on canvas
248x217

Paris, Musée d'Orsay

Claude Monet

Women in the Garden

1866-1867. Oil on canvas
256x208

Paris, Musée d'Orsay

Bazille

Monet and Bazille met in Gleyre's studio in 1862. The teaching of this artist who triumphed at the Salon with *Lost Illusions* in 1843, and who had stopped painting since, was rather liberal. Gleyre even went so far as to advise his students 'to work outside his studio if they wanted to make serious progress.' And so when Monet and Bazille made their numerous escapes to go and paint from nature, they did so with total impunity. In April 1863, Bazille wrote his parents thus: 'As I told you, I went to spend eight days in the little village of Chailly near Fontainebleau forest. I was with my friend Monet, from Le Havre, who is rather good at landscape and gave me some advice that was very useful to me.' In 1864 the two men went to Honfleur, in the region where Monet had learnt about outdoor painting: 'We had a charming journey [...] We were able to see the Gothic marvels of [Rouen], and the museum, which has an admirable Delacroix collection.' The young artists painted side by side, making numerous sketches, including the ones that, the following year, Bazille used to paint *Seascape (Beach at Sainte-Adresse)*, a work similar in feel to Monet's paintings. Gleyre's studio closed for good in the winter of 1864, so Bazille spent every day with Monet in his studio. 'I am working very hard at the moment. Monet takes the trouble to come and wake me up every morning and I spend my days in his studio painting live models.'

There was a deep friendship between the two men, but also a muted jealousy: Bazille being favored by his parents' wealth, Monet was inclined to see him as a fortunate dilettante. He was constantly exhorting him to work harder. In 1864 he wrote: 'I hope that you are working hard, you really must get down to it seriously because your parents are letting you off medicine.' And: 'Are you making progress? Yes, I am sure you are, but I am also sure that you are not working hard enough or in the right way.' Monet became even more insistent in the summer of 1865 when he was painting his *Picnic* in the woods of Chailly-en-Bière. Bazille, his main model, was not giving him as much time as he would have wished for and Monet grew exasperated and irate: 'Time is passing, and still you do not come. I beg you, my dear friend, do not leave me in the lurch. All my studies are going wonderfully well. All I need now are my men.' The hard-up and talented Monet wanted to have the charming and well-heeled Bazille all to himself. And when Bazille bought his *Women in the Garden*, Monet wanted more. He wanted the interest of the rich patron Bruyas, who had supported Courbet and who, like Bazille, was from Montpellier. He wrote his friend: 'Try to show it to Mr. Bruyas, see if it pleases him. Do not forget me.' Then came the insistent and pathetic calls for the money that Bazille had promised when he bought *Women in the Garden*. 'As for yourself, do not forget me, for we are counting on your 50 francs!'

And yet the bond between Monet and Bazille involved much more than self-interest. Theirs was a solid friendship. 'It is clear that we would still have been friends even if we had never made any deals together—perhaps more so,' recalled Monet. And this went with an unfailing admiration. 'Monet,' Bazille always insisted, 'is the best of the lot.'

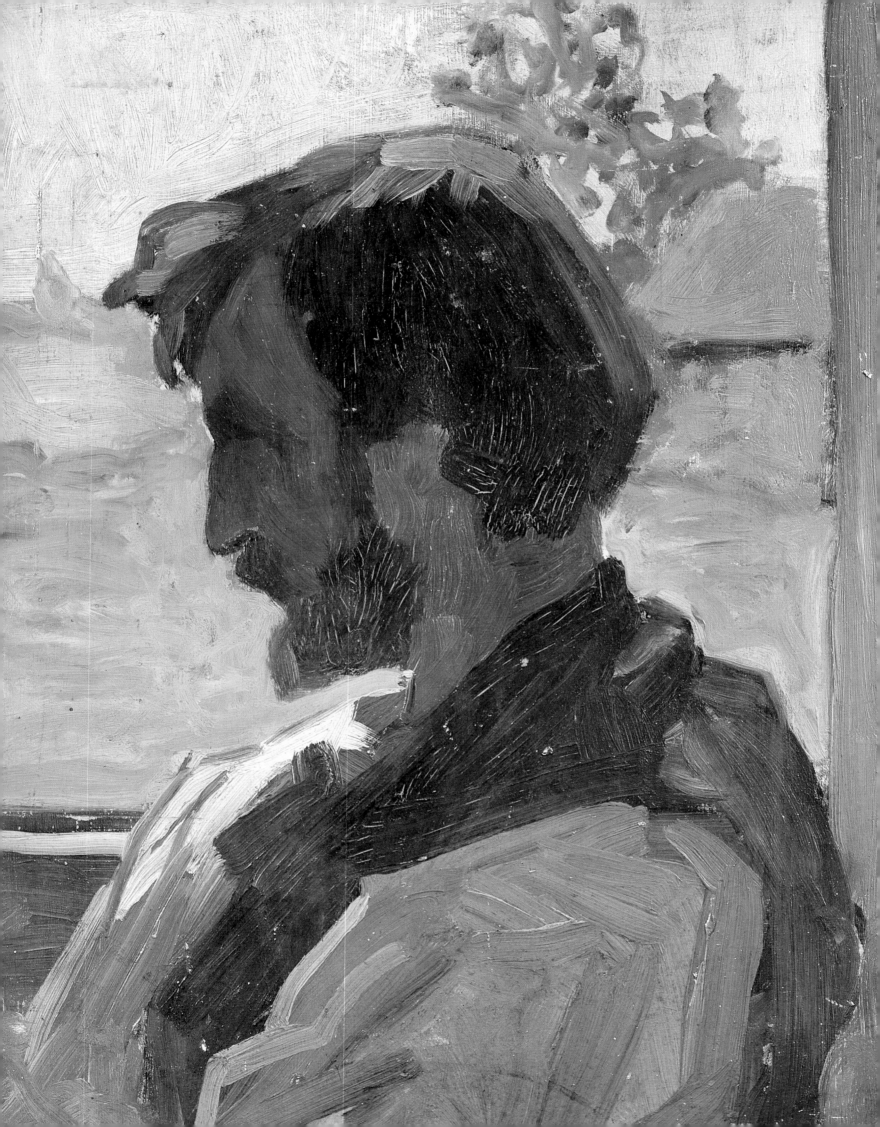

3 Bazille

Previous pages:
Frédéric Bazille
Self-portrait in Saint-Sauveur
1868. Oil on wood
40x31
Montpellier, Musée Fabre

Frédéric Bazille
Toilet
1870. Oil on canvas
132x127
Montpellier, Musée Fabre

The abruptly and tragically curtailed œuvre of Bazille leaves us with an insoluble question: had he lived, would he have been an Impressionist, like his friends Monet, Renoir and Sisley? For among his last works, such as *Ruth and Booz* or *The Toilet*, we find themes and styles that suggest he was moving away from the nascent Impressionism and a certain deference towards Delacroix that was not surprising, given that the latter was considered the greatest colorist of the century, but was nevertheless excessive. We may therefore wonder if this young man, who divided his time between the medical studies that he continued with varying degrees of assiduity until 1864 in order to satisfy his parents, his passion for music, boating, theater, a glittering Parisian social life and painting, and who, on the eve of his death, said: 'Personally, I am sure not to kill myself, there are too many things I want to do in life,' would have chosen painting and the hard struggle that such a course implied. Indeed, Bazille's father himself expressed concern at his son's dilettantism: 'I regret your break with Monet. I hear that he was a hard worker who must often have made you blush at your laziness. And when you are on your own, I fear that many mornings and even days will be spent in a sweet idleness that will do nothing to carry forward the paintings for your exhibition' (1865).

And yet Bazille was one of the most important protagonists of Impressionism in the years before 1870, a key figure both by his capacity to stimulate the little group, to lead and support it, and by his paintings, which often get to the heart of their concerns at the time.

The son of a rich bourgeois family in Montpellier, Bazille entered Gleyre's studio in 1862. There he met Renoir and Monet. He and Monet were soon working together. In 1865, Bazille painted several of the figures in Monet's *The Picnic*. The following year, after sharing Monet's studio with those guests, he was lodged in Renoir's. Bazille's role gained in importance again in 1867, when he tried to mediate between Monet and his father, who was furious to discover that Camille Doncieux, his son's mistress, was expecting a child. And, in order to help his friend but also to start out his own career as patron of the arts—an activity whose charms he had been able to appreciate from his many visits to the gallery of Alfred Bruyas, a fellow native of Montpellier who had supported Courbet in the 1850s and who, in recent months, had been enjoying spectacular success—he bought Monet's *Women in the Garden*, which had just been

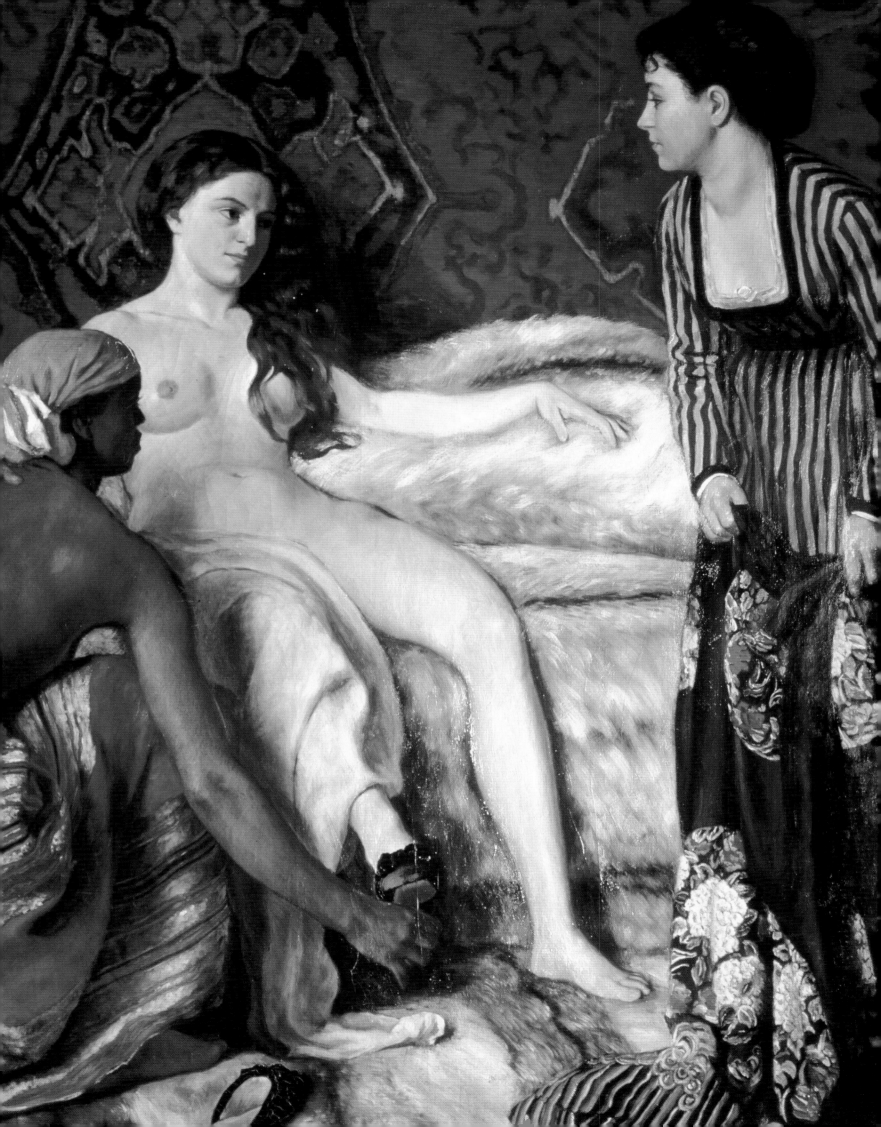

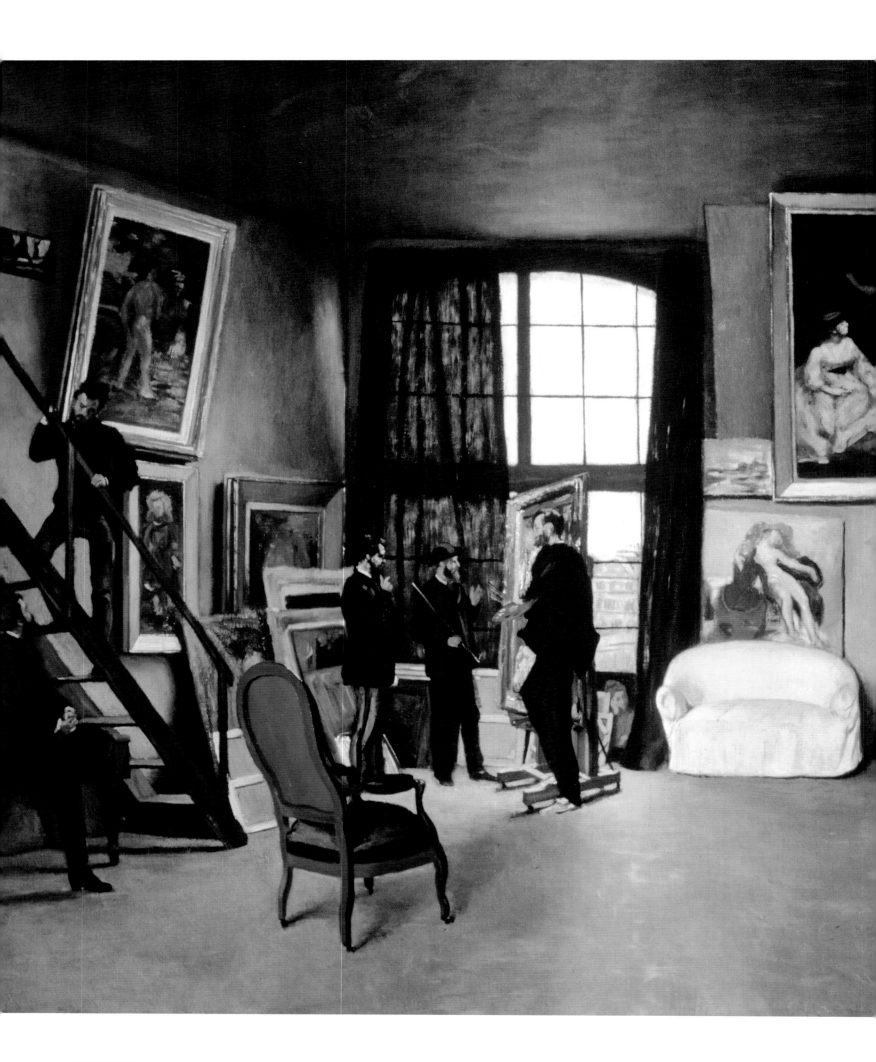

rejected by the Salon. The sum, 2,500 francs, was a large one. He had agreed to pay it in monthly installments of 50 francs, taken from the allowance given to him by his father. And finally, in April, after the Salon had rejected two of his own submissions, Bazille invested in a scheme for an independent exhibition. As he explained to his parents, 'We have decided that every year we will rent a large studio where we will exhibit as many of our works as we wish.' The project came to nothing. 'By bleeding ourselves as much as we could, we managed to amass the sum of 2,500 francs, but that is not enough. We therefore have no choice but to renounce what we wanted to do. We must return to the bosom of the administration.' But the idea remained, and it was this palette of activities—friend, patron, go-between, artist and music lover—that he represented in his painting *The Artist's Studio, Rue de La Condamine.* As he wrote his parents: 'Up to now, I have been amusing myself painting the interior of my studio with my friends. And Manet is painting me in.' This portrait of the studio is the last in a series of paintings that Bazille made of his successive workplaces and comes after the *Studio on the Rue Furstenberg* and the *Studio on the Rue Visconti.* Bazille was constantly moving, with each new location apparently materializing his ambitions and intentions as an artist.

This light, convivial space offers an image of what the hoped-for exhibition of 1867 might have been. A place for meeting and exchanging as much as a place of representation. And indeed, even if this desire for independence seemed to have come to nothing when Bazille painted this picture in1869-1870, this image of the studio is very much a manifesto of the new movement that would become Impressionism. Indeed, its atmosphere of open camaraderie and love of painting is a direct response to Fantin-Latour's painting, *A Studio at Batignolles,* itself the stiff manifesto of a new school. Fantin-Latour's work is dominated by literature and venerable aesthetic references, its atmosphere one of silent devotion. It shows a cramped, dreary space filled by Manet and his faithful friends, including Bazille, Zola, Monet and Renoir. Bazille revisits the story from a personal angle. In his painting, Manet, Monet and he are equals. As are the writer Zola and the painter Renoir. The paintings hanging on the walls are all attempts to find an original new approach. The work resting on the easel, which the artists are discussing, is a *plein-air* work and, above all, even if the friends are gathered in a Parisian studio, the wide window opens onto a Haussmannian landscape that is there waiting to be painted again, and onto to a sky as blue as it is infinite, which will always be there to be painted.

Frédéric Bazille
The Artist's Studio,
Rue de la Condamine
1870. Oil on canvas
98x128.5
Paris, Musée d'Orsay

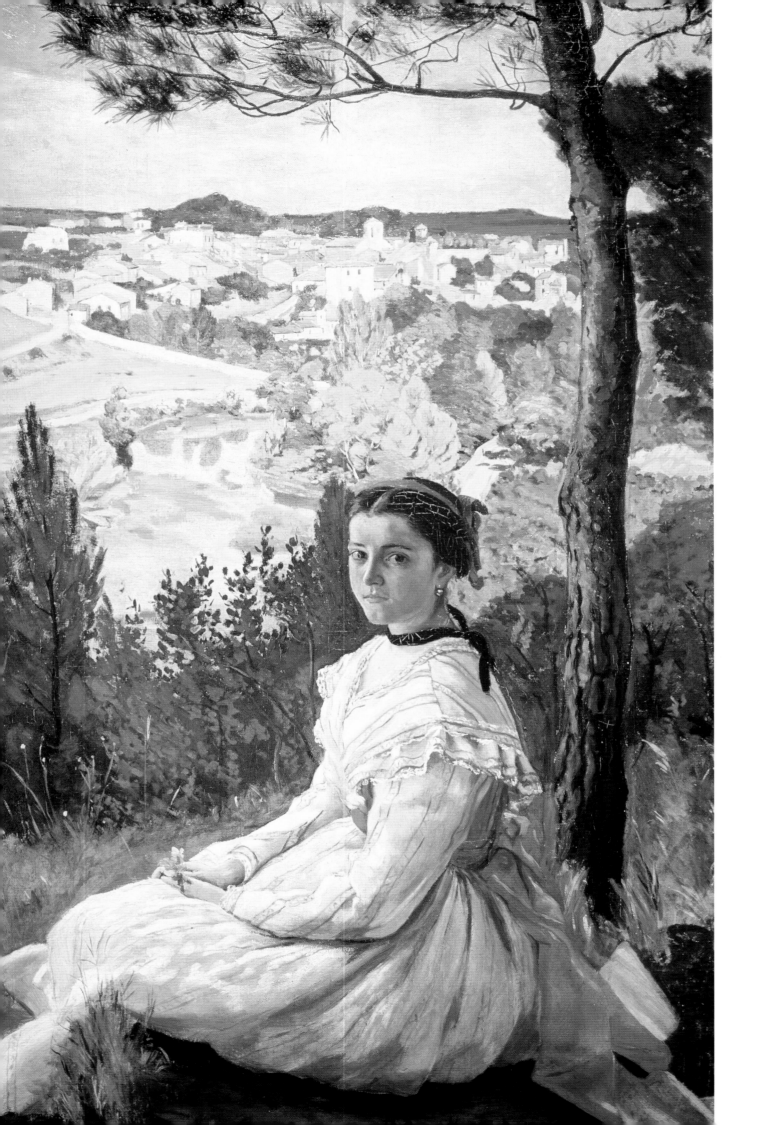

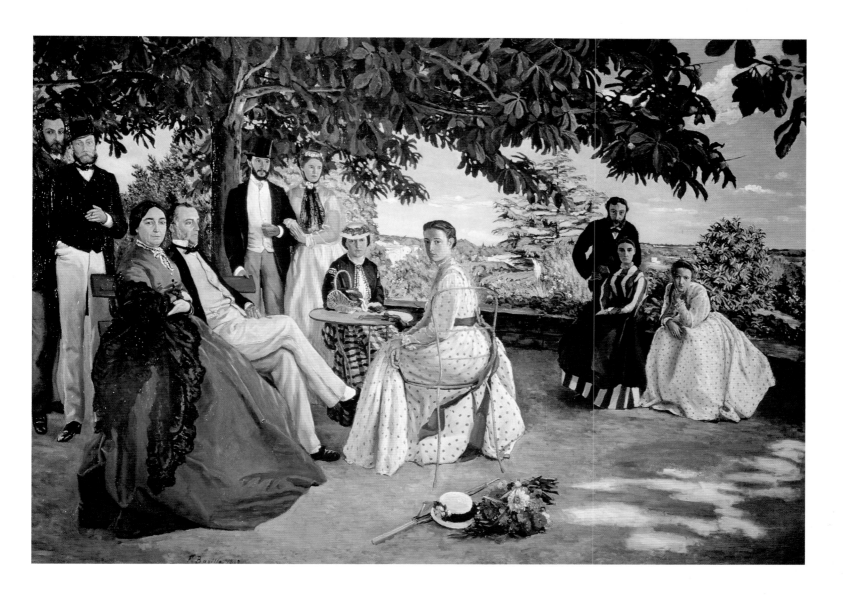

Bazille was more than the charming dilettante that Monet, who had no choice but to succeed quickly, harassed and exhorted to work harder. He was a convinced participant in some of the great pictorial efforts of the 1860s. Thus his *View of the Village*, which, by some miracle, was admitted to the 1869 Salon, and which Bazille is discussing with Manet and Monet in his *The Studio on the Rue de la Condamine*, met with an enthusiastic response from Berthe Morisot: 'The great Bazille has done something that is, I think, extremely fine. It is a young girl in a very light-colored dress, in the shadow of a tree behind which we can make out a village. There is a lot of light, of sun. He is looking to do something that we have all tried to do so often, to place a figure in the open air. This time, I think he has succeeded.' This outdoor figure was the obligatory exercise for all the Impressionists after Manet's *Le Déjeuner sur l'herbe*. Bazille made several attempts at it, taking advantage of the intense light of southern France. *The Pink Dress* inaugurated these experiments in 1864: a young girl is absorbed in the contemplation of the village of Castelnau, and Bazille manages to enwrap both the young girl and the manifestly distant scene in the same soft, end of afternoon atmosphere. Then, with *Family Reunion* in 1867 he managed a group portrait—an idea possibly inspired by Manet's *Music in the Tuileries Gardens* (1862)—that maintains

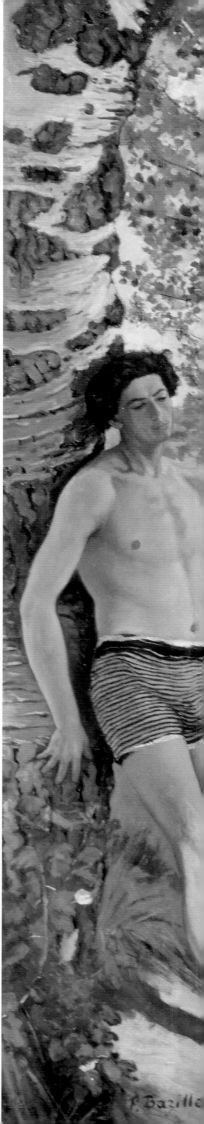

Frédéric Bazille
Bathers (Summer Scene)
1869. Oil on canvas
158x158.9
Cambridge, Fogg Art Museum, Harvard University Arts Museum

the fixity of the photographic portrait, the stiffness of a certain kind of social convention, yet is suffused with the warm, enveloping light that falls on the terrace of the family home. Zola, who could not fail to be won over, wrote in his review of the Salon that '*Family Portrait* […] attests a keen love of truth. Each physiognomy is studied with extreme care, each figure has its own particular style. One can see that the painter loves his times, as Claude Monet does, and that he thinks that one can be an artist and still paint a frock coat. There is a charming group in the canvas, the group formed by the two young girls sitting on the edge of the terrace.'

The culmination of this approach is no doubt to be found in the large canvas from 1869, *Summer Scene*. As he had always done, Bazille began by making his studies, particularly the nudes, in the studio, then started on the outdoor landscape. As he wrote in a letter to his father: 'In the meanwhile I shall not be wasting my time. I shall draw the figures for my painting of men in advance.' This painting seemed all the more daring because he was putting male nudes in these natural surroundings. Bazille made a first attempt at this with *Fisherman Casting a Net*, which was turned down for the Salon in 1869. Here, he was pushing back his own limits. Before there were two nude men; now there were eight. The contextual justification was no longer a fishing trip, but a simple bathing scene of the kind that the childhood friends Zola and Cézanne had known on the banks of the Arc near Aix-en-Provence. Bazille presents us with a medley of references—a Saint Sebastian for the man leaning against the tree on the left, a Courbet painting for the wrestlers in the background. The landscape is intensely green, the scene profoundly calm. More than in his other works, Bazille here shows how far he is from Monet. His characters, though shown in the bright light, remain impervious to its effects, as if concentrating intensely on their own, increasingly monumental selves. They evoke the paintings of bathers that Cézanne started doing in the early 1870s.

Bazille died at the battle of Beaune-la-Rolande, on November 28,1870. As a good modern painter and worthy Impressionist, he wrote: 'I have chosen the modern age because it is the one I understand best and that I find the most alive for people who are alive.'

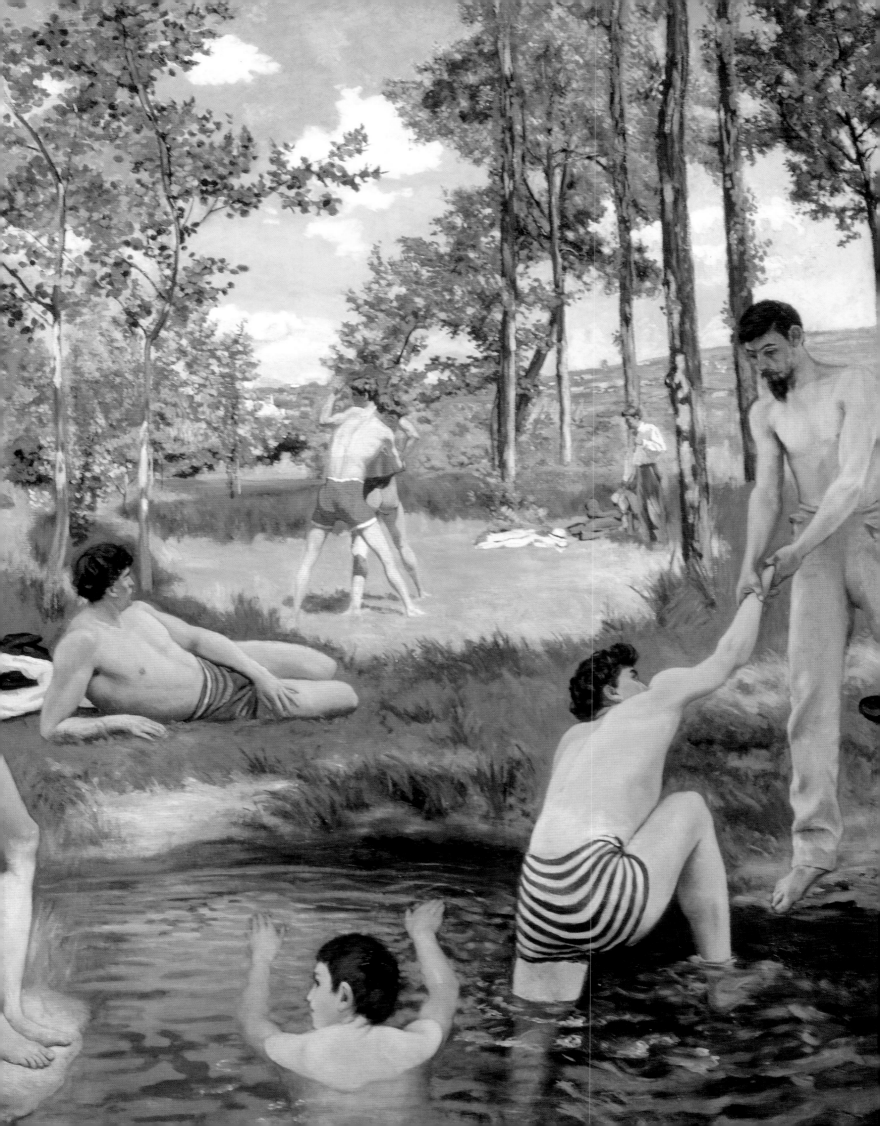

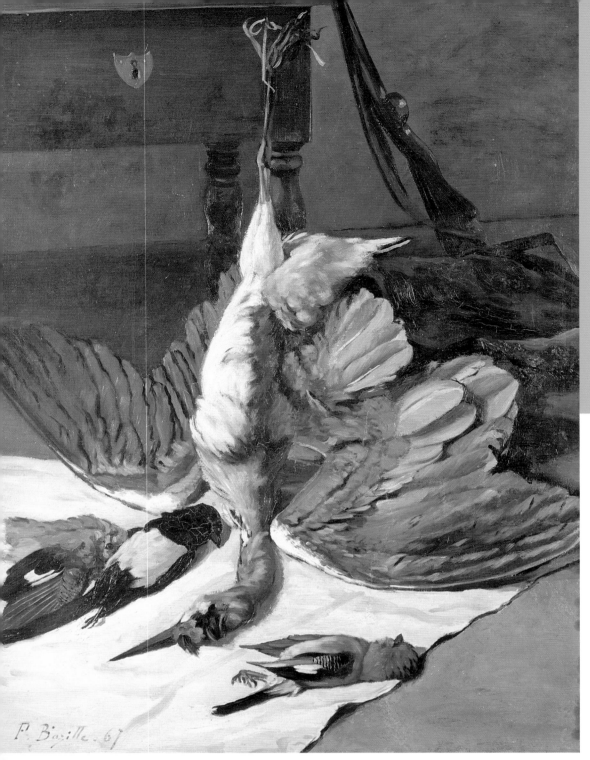

P. Bazille. 67

Bazille

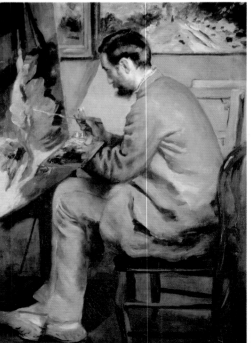

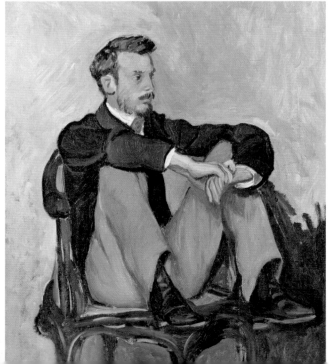

Frédéric Bazille
The Heron
1867. Oil on canvas
100x79
Montpellier, Musée Fabre

Auguste Renoir
Frédéric Bazille at his Easel
1867. Oil on canvas
105x73.5
Paris, Musée d'Orsay

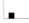

Frédéric Bazille
Auguste Renoir
1891. Oil on canvas
62x51
Paris, Musée d'Orsay

Photograph of Alfred Sisley

Sisley Renoir

Although the two men had a privileged relationship, Monet was not the only artist to share Bazille's horizons. There were also Sisley and Renoir. The former Bazille is said to have introduced to Gleyre's studio. Renoir he met there. These friendships are illustrated by the fact that in 1867 Bazille and Sisley both painted a big heron with its wings spread out, concentrating on its sumptuous grey, white and black plumage and voluptuous textures, and that Renoir was there to watch his two friends and painted a *Bazille at His Easel* working on that same picture of the heron. This portrait was most certainly the counterpart to the *Portrait of Renoir* that Bazille painted that same year, no doubt when the two men were sharing a studio in Paris. And the final piece in this interpersonal jigsaw is the snow-covered landscape by Monet, the great absentee in this little three-way exchange, hanging behind Bazille in Renoir's portrait.

These young artists were in the habit of taking each other as models. Professional models were expensive and, besides, they also wanted to record in their painting this friendship that was forged and exalted in their irresistible urge to paint against the established aesthetic order. Their paintings were thus tokens of friendship or genuine artistic manifestoes. Renoir's *The Hostel of the Mère Anthony* (1866) can fulfill both roles. Many years later, he explained how this work came to be painted in Marlotte, a village near Barbizon: 'I took as the subject of my study the shared room, which also served as the dining room. […] I got some of my friends, including Sisley and Le Cœur, to pose around the table. As for the motifs constituting the ground of my painting, I took

them from the pictures painted onto the walls. These were the unassuming but often highly successful work of the place's regulars. I myself had drawn the silhouette of Mürger, which I reproduced in the top left part of my canvas.' The setting of this friendly get-together also alluded to the previous generation, that of the painters of Barbizon, who sought a direct relation with nature and the elements in the rocks and forest of Fontainebleau. The sketch of Mürger also brings to mind his novel *Scènes de la Vie de Bohème* and its Bohemian world, with which these young and for the most part impecunious young men, these bearded, pipe-smoking dreamers, identified to some extent at least. To conclude, the newspaper unfolded on the table recalls present realities, the immediate situation of painting, and its great revolution in which Renoir and Sisley, isolated at Marlotte, intended to play a role. The organ in question is *L'Événement*, the daily in which Zola wrote his first *Salon* and took up the cause of the new painting.

And so Bazille, Renoir and Sisley (but also Monet, who was never far away), all aware of their common heritage, turned boldly towards the future that they intended to build together.

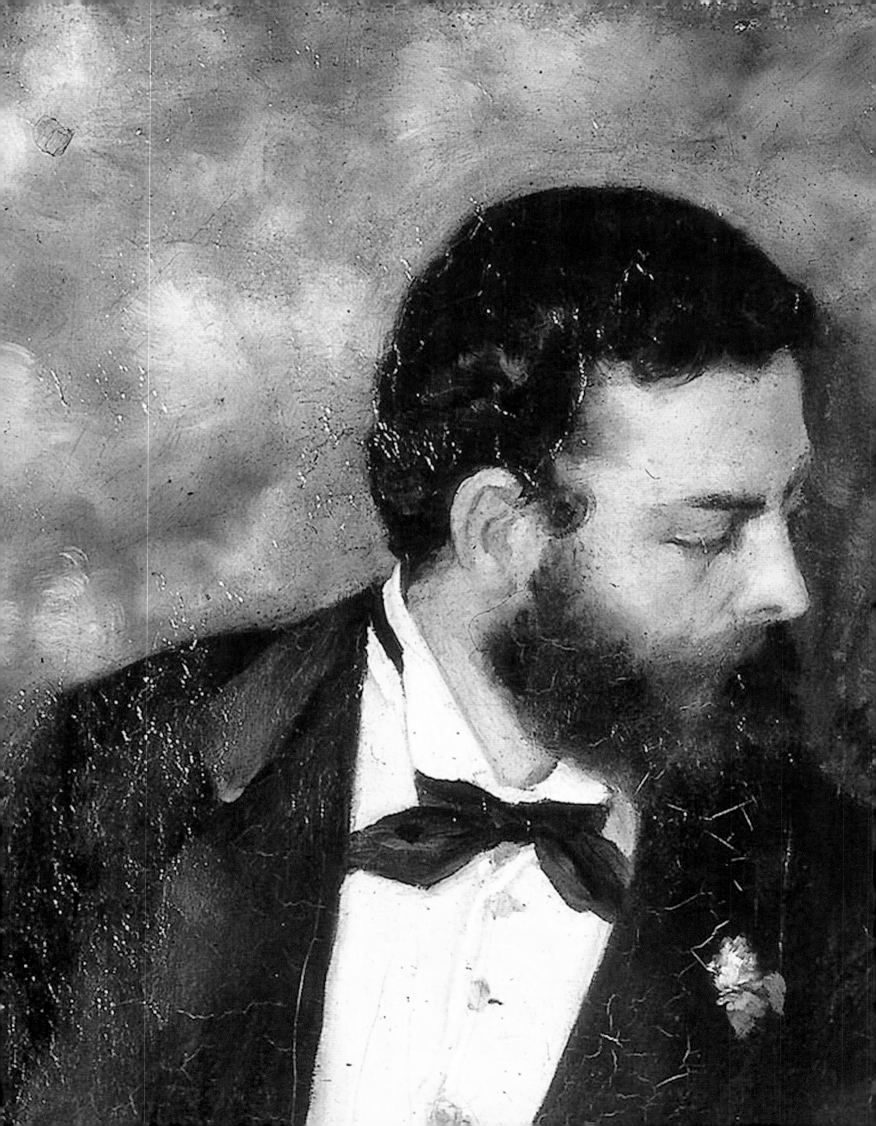

4 Sisley

In 1895 Pissarro wrote that 'I remain, with Sisley, like a tail end of Impressionism.' A 'tail end' because Impressionism, at this century's end, has been transformed, reconstructed and even renounced, and no longer existed. A 'tail end' also because these two painters had yet to experience the renown that was the lot of most of their comrades in painting and in arms. A 'tail end,' too, because they were the only ones who had kept faith with the pictorial principles of their early days. Indeed, when Matisse asked Pissarro 'Who is really an Impressionist?' he replied 'Sisley.' Sisley, who died four years after Pissarro's sad reflection, was to know the difficulties of being an Impressionist right up to the end of his life.

Yet Sisley was a long way from such bitterness and disillusion when, introduced by Bazille, he entered Gleyre's studio in 1862. As Arsène Alexandre would recall in 1899, 'In the small, hard-working and carefree and light-loving group formed in Fontainebleau by Monet, Renoir, Sisley and Bazille, he represented gaiety, vim and imagination.' Renoir, too, remembered the young Sisley as 'free of money and melancholy.' And that was how he depicted him, gallant and playful, taking the arm of is companion, Lise, in *Alfred Sisley and His Wife*, a painting from 1868. Unlike Renoir, with whom he explored the forest at Fontainebleau, or Monet, whom he met at Gleyre's studio, or Bazille, Sisley disdained the human figure and devoted himself solely to landscape. This orientation may well have been determined between 1857 and 1859 when, sent to London by his father, an English merchant, in order to learn about business, he was an assiduous visitor to the city's galleries and discovered the work of Constable and Turner. In the 1870s, indeed, the latter was being cited by critics as a precursor of Impressionism. 'Turner's Impressionism cannot be denied [...] Throughout his life he was constantly and doggedly studying phenomena of light,' wrote Emile Verhaeren in 1885. The landscape of this artist adulated in England must surely have made a deep impression on Sisley.

Sure of his vocation as a landscape artist, Sisley left Gleyre's studio in 1863 to study from life. He was strongly affected by the works of Corot, which were a major influence on his first landscapes. As Julien Leclercq noted in 1899, 'It is Corot who impresses him, the light, silvery Corot who is both airy and solid, always broad, deep, infinite.' Indeed, Sisley declared himself to be 'the student of Corot' in the catalogue of the 1866 Salon. But instead of Corot's fleecy touch, Sisley applied the paint with greater firmness and strength, in a more lively manner that reveals the influence of his Impressionist friends, and especially Monet and Bazille. This new touch can be seen in the painting *Avenue of Chestnut Trees near La Celle-Saint-Cloud* (Paris, Musée du Petit-Palais), or in the two views of the village of Marlotte, *Village Street in Marlotte* and *Women Going to the*

Alfred Sisley
Haystack on the Banks of the Loing
1891. Oil on canvas
75x92
Douai, Musée de La Chartreuse

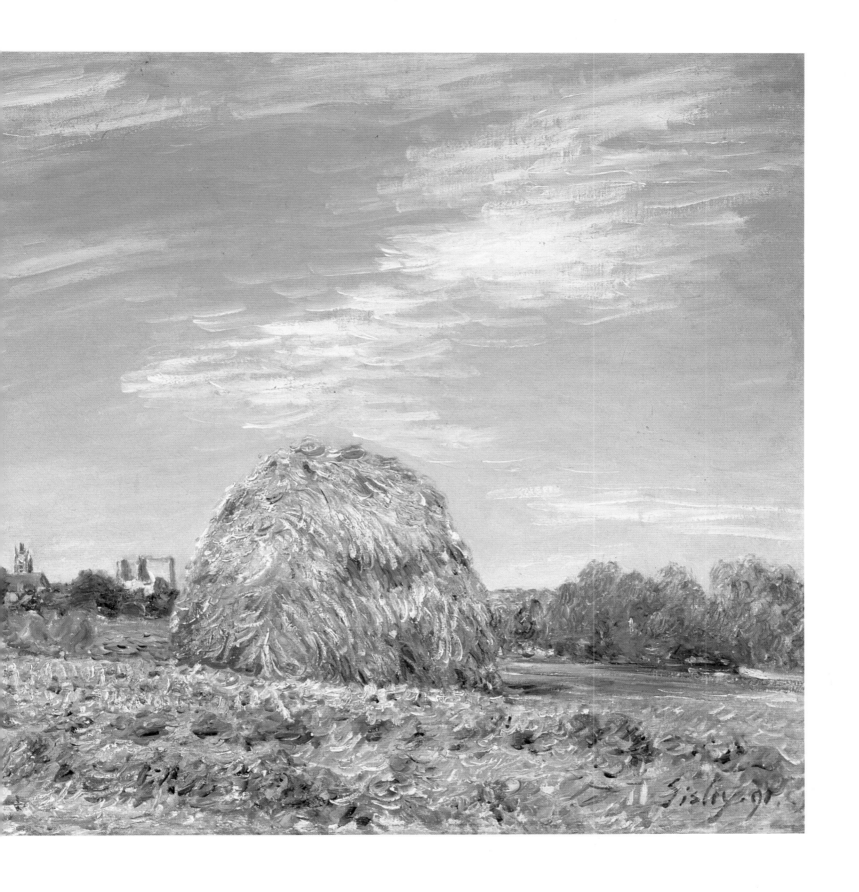

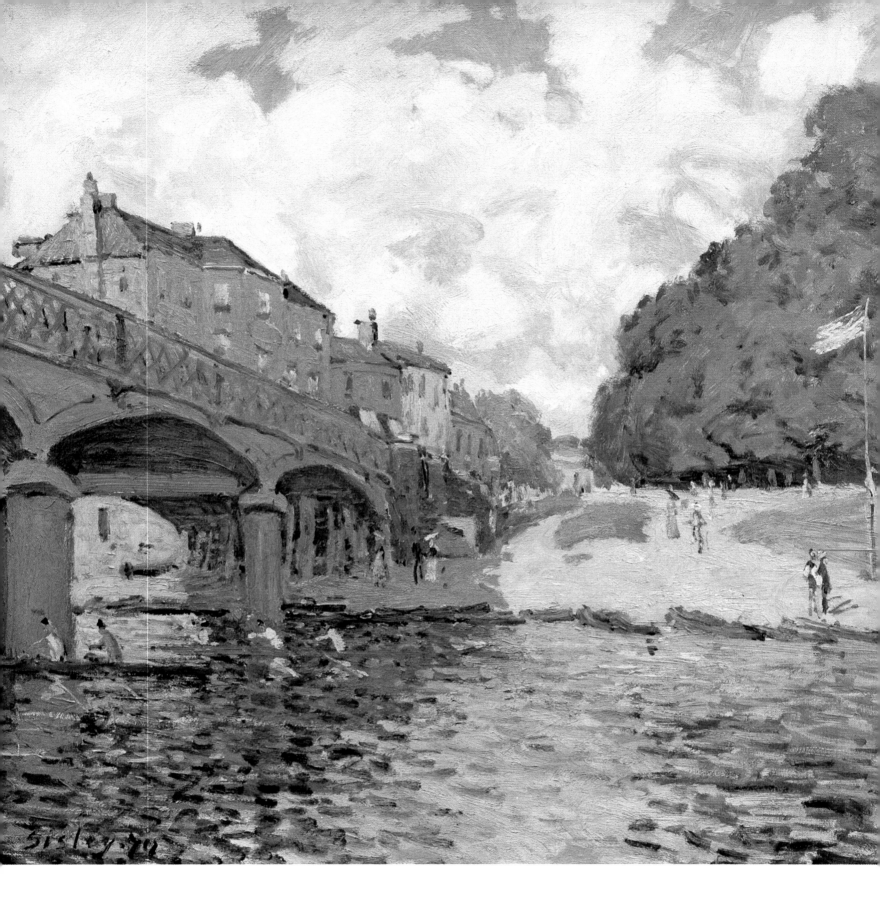

Alfred Sisley
Under the Bridge at Hampton Court
1874. Oil on canvas
45.5x61
Cologne, Wallraf-Richartz Museum

Woods, exhibited and largely ignored at the Salon of 1866. The construction of these two works is based essentially on the alignment of the buildings, but also on the perspective of the streets. Small vigorous figures animate the compositions, their clothes and poses providing hints as to the season, rather in the manner of Pissarro, and making these landscapes traditional-style rustic images of the country around Paris. However, we know little of Sisley's early work. His house at Bougival was pillaged and destroyed during the war in 1870 and most of his paintings were lost.

In 1872 Sisley, like his comrades, was given hope when a few works of his were bought by the dealer Paul Durand-Ruel. But Durand-Ruel stopped making his acquisitions at the end of the following year and Sisley came to the same conclusion as his colleagues: they had to exist outside the Salon (Sisley himself had only been admitted twice, and even then no critic had condescended to write about him) and find collectors elsewhere. He was thus among the secessionists who exhibited at Nadar's home in 1874. Among the six paintings he showed there was *The Orchard,* which gave the critic Leroy an opportunity to continue with his mockery of 'impressions': "'An Orchard by Mr. Sisley. I recommend the little tree on the right; it is very gay, but the impression"... "Leave me alone with your impressions, will you! It is perfectly half baked."' Still, Sisley's works did not whip up the same kind of storms that surrounded those of his comrades. This discreet landscape painter went down more easily with the critics in the gazettes: 'This time Mr. Sisley, among other mediocre canvases, is exhibiting a charming work' (Prouvaire); 'Mr. Sisley has distinction, and in one truly poetic landscape, that he has entitled *Road from Saint-Germain* he elevates this quality to grace' (Castagnary); 'Mr. Sisley is one of the artists who is making progress here' (de Montifaud); 'Not everything that Mr. Sisley submits is of equal quality, but there is one work, *Flood at Port-Marly,* which is the absolute realization of the school's ambitions in terms of landscape' (Chesneau). Sisley's work—and this would prove to be his handicap—was not original enough to annoy. Leaving the human figure, which was the big taboo for the critics of the day, who did not forgive these artists their deliberate approximations, he limited the risks of absolute rejection run by his colleagues. Moreover, in his calm and orderly compositions, everyone could find something of a classical heritage. Moreover, the subjects he chose never confronted beholders with the raw and upsetting spectacle of the industrial and urban revolution then in full flow: *The Saint-Martin Canal in Paris, The Machine at Marly, The Aqueduct at Marly, La Grande Rue, Argenteuil* and the streets of Louveciennes—here there was no aggressive architecture, no bustle, no violence.

The Orchard, with its blossoming tree at the center of the composition, was redolent of certain compositions by Courbet or Théodore Rousseau that had already gained acceptance. *The Road from Saint-Germain to Marly* is structured around the ample bend in the road that disappears into the painting. *Ferry to the Ile de la Loge* also has a classical, harmonious composition with its horizontal and vertical lines structuring a landscape where the sky and light meet and blend.

But Sisley was capable of more audacity in his compositions, of more dazzling colors. *Under the Bridge at Hampton Court,* painted during his trip to England with the important collector Jean-Baptiste Faure in 1874, offers a highly original point of view, showing the succession of piers sup-

porting that then modern structure, and the boats sailing past on the river. The same palpitating life is captured in *Regatta in Molesey* with touches that are more fluid and lighter than in the earlier compositions. These touches can also be seen in the works of the mid and late 1870s, in which water predominates: *Flood at Port-Marly* and *Boat in the Flood at Port-Marly*, that Sisley exhibited at the second Impressionist exhibition in 1876. In 1899, Pissarro wrote: 'He is a fine and great artist. I am of the opinion that he is a master to equal the greatest of them all. The works of his that I have seen again are of a rare magnitude and beauty, among them a *Flood* which is a true masterpiece.

Like Renoir, Sisley, for whom they were a failure, abandoned the Impressionist exhibitions and submitted his works to the jury of the official Salon in 1879. As he explained to his friend, the critic Théodore Duret: 'I am tired of vegetating as I have been for so long. The time has come for me to take a decision. […] I have made up my mind to submit to the Salon. […] I need to be able to work and, above all, to show what I do in adequate conditions.' His submission was rejected.

Still, Sisley found new dynamism when he obtained the regular support of Durand-Ruel and moved to the region of Moret-sur-Loing in 1880. 'Sisley has found his region,' declared the critic Geffroy, and the

Alfred Sisley
Regattas at Moseley
1874. Oil on canvas
66x91.5
Paris, Musée d'Orsay

Alfred Sisley
Flood at Port-Marly
1876. Oil on canvas
50.5x61
Paris, Musée d'Orsay

Alfred Sisley
The Church at Moret, Winter
1894. Oil on canvas
81x65.6
Bucharest, National Museum of Art

artist confirmed his judgment in his own description of the area: 'The countryside is not bad, a little bit chocolate-boxy. Moret is two hours from Paris […] the church is very pretty, with fairly picturesque views.' His activity in Moret seemed to echo the career of his increasingly renowned friend Monet. And indeed, the names of the two artists are often linked: 'At first glance, it is hard to see the difference between Mr. Monet's painting and that of Mr. Sisley. […] A little examination soon shows us that Mr. Monet is more adroit and more daring. Mr. Sisley is more harmonious.' So judged Arsène Alexandre in 1873. In 1883, Huysmans noted that, 'Endowed with a less abrupt artistic temperament, less nervous and with an eye that at first view is less wild than that of his two colleagues [Monet and Pissarro], Mr. Sisley is now clearly less determined, less personal than they are.' If we compare the work done by the two painters in the 1880s, we will see that this confirms Alexandre's view. And such a comparison is all the more justified in that Sisley followed Monet step by step in his choice of subjects. His views of Moret echo Monet's views of Vétheuil. Where Monet's haystacks are monumental and timeless, Sisley's are fragile, light and ephemeral. When Monet painted the rugged, wild coast of Belle-Ile (1886), Sisley dwelt on the round, untamed rocks of the Welsh shoreline (1897). And lastly, whereas Monet's *Rouen Cathedral* (a series begun in 1892) was isolated, vertiginous and dramatic, Sisley's twelve renderings of the *The Church at Moret*, painted a year later, were solid and rustic and very much a part of daily life in the little town. They showed the same obsession with instantaneousness, but without Monet's obsession with the solitary subject in its struggle against time.

When Sisley died, it was Monet who organized the funeral and, above all, organized a sale on behalf of his children. In the words of his friend Gustave Geffroy, this was when Sisley 'came to occupy his rightful position in the glorious lineage of landscape painters.'

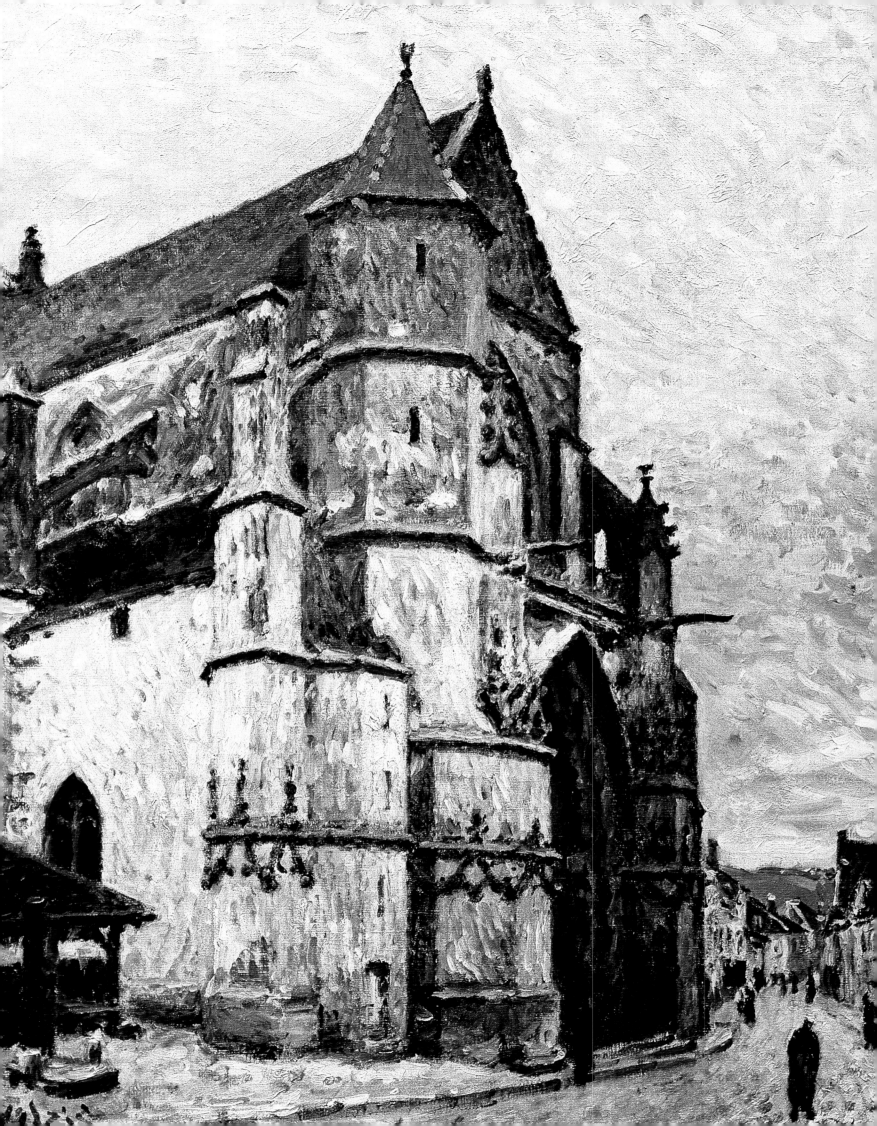

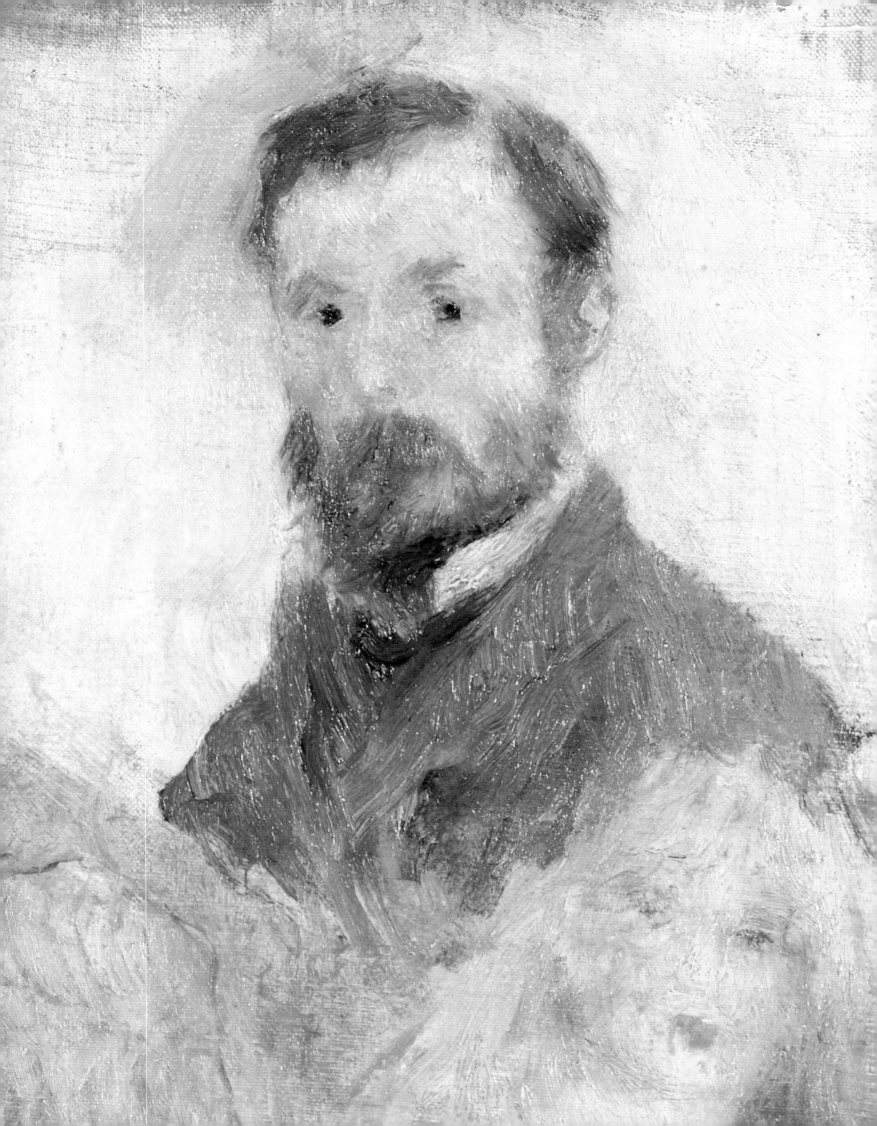

5 Renoir

Auguste Renoir
Portrait of the Artist
1879. Oil on canvas
19x14
Paris, Musée d'Orsay

'I suppose you paint for your own amusement?' To this observation by Gleyre, who made weekly visits to his studio, Renoir replied: 'But of course, and if it didn't amuse me, then believe me, I would not do it!' (Albert André). Throughout his career, Renoir retained this basic pleasure in painting, this particular way of never taking art in general or his own art too seriously, of adapting to events and getting the most out of his pleasures as a man and an artist."

His artistic career began rather nonchalantly when he was apprenticed to a painter of porcelain. There he learnt the importance of 'embellishing,' of making his art 'something likeable, joyous and pretty—yes, pretty!' For him there were 'too many tedious things in life already for us to make yet more of them.' He knew that, parallel to the glorious path of the fine arts, there ran another way, that of the decorative arts, where a talented artist could always find ways of making a living. Which is not to say that the young Renoir was lacking in ambition: in 1862 he was admitted to the École Impériale et Spéciale des Beaux-Arts, which was the official track to becoming a recognized painter. However, he found the teaching there uncongenial and preferred to attend Gleyre's studio with his new friends, Bazille, Monet and Sisley. The studio was of fundamental importance to Renoir, who was more a painter of figures than of landscapes. Indeed, his personal tastes tended towards Delacroix and especially Courbet, whose influence can be detected in his *Diana*, a submission rejected by the Salon in 1867. At the 1868 Salon Renoir, a close friend now of Monet's, presented a *Lise* that, in the words of Zola, 'looks like the sister of Claude Monet's *Camille*. She is one of our women, or rather, one of our mistresses, painted with great truthfulness and a felicitous striving for modernity.' Like Monet, Renoir now cast aside the still-tempting trappings of myth and threw himself into the modern world. Both men painted views of Paris in 1867 and, above all, they both set up their easels on the banks of the Grenouillère bathing ponds at Croissy. The summer of 1869 was a time of great closeness between them. Both as men and as artists. In human terms, Monet, who had settled in Bougival with his wife and son, relied on Renoir's support. As he wrote to Bazille in August: 'Renoir brought us bread from his house to keep us from starving.' As regards the artistic relation, another letter to Bazille reveals that 'I have this dream, a painting, the ponds at La Grenouillère. [...] Renoir, who has just spent two months here, also wants to do such a painting.' The two artists both painted three views of the site, and from

Auguste Renoir
Lise with a Parasol
1867. Oil on canvas
184x115
Essen, Folkwang-Museum

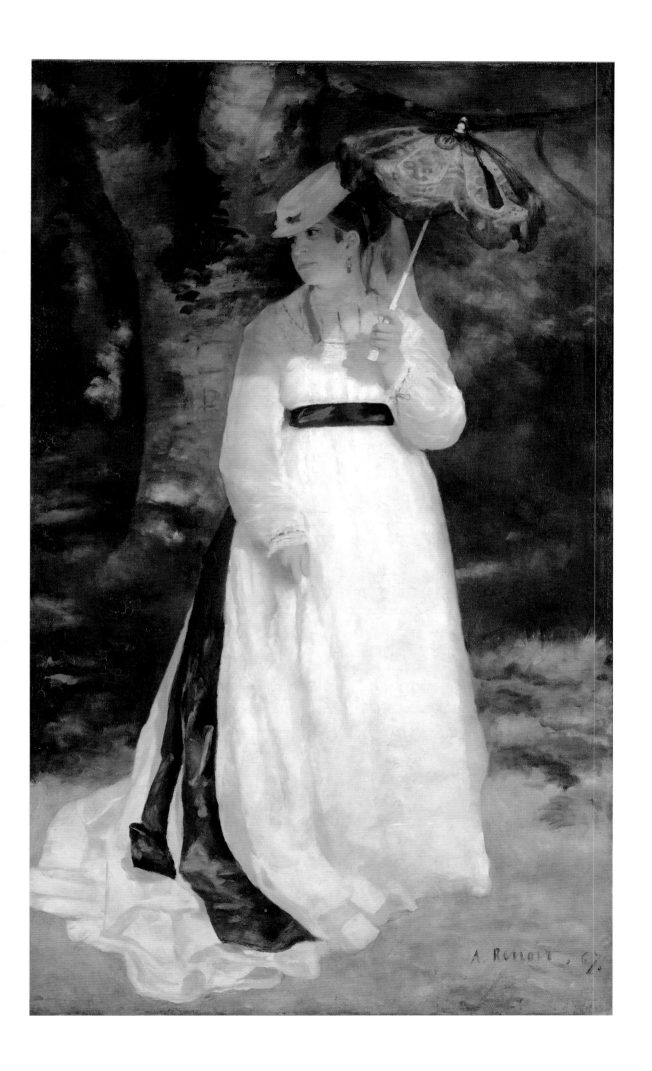

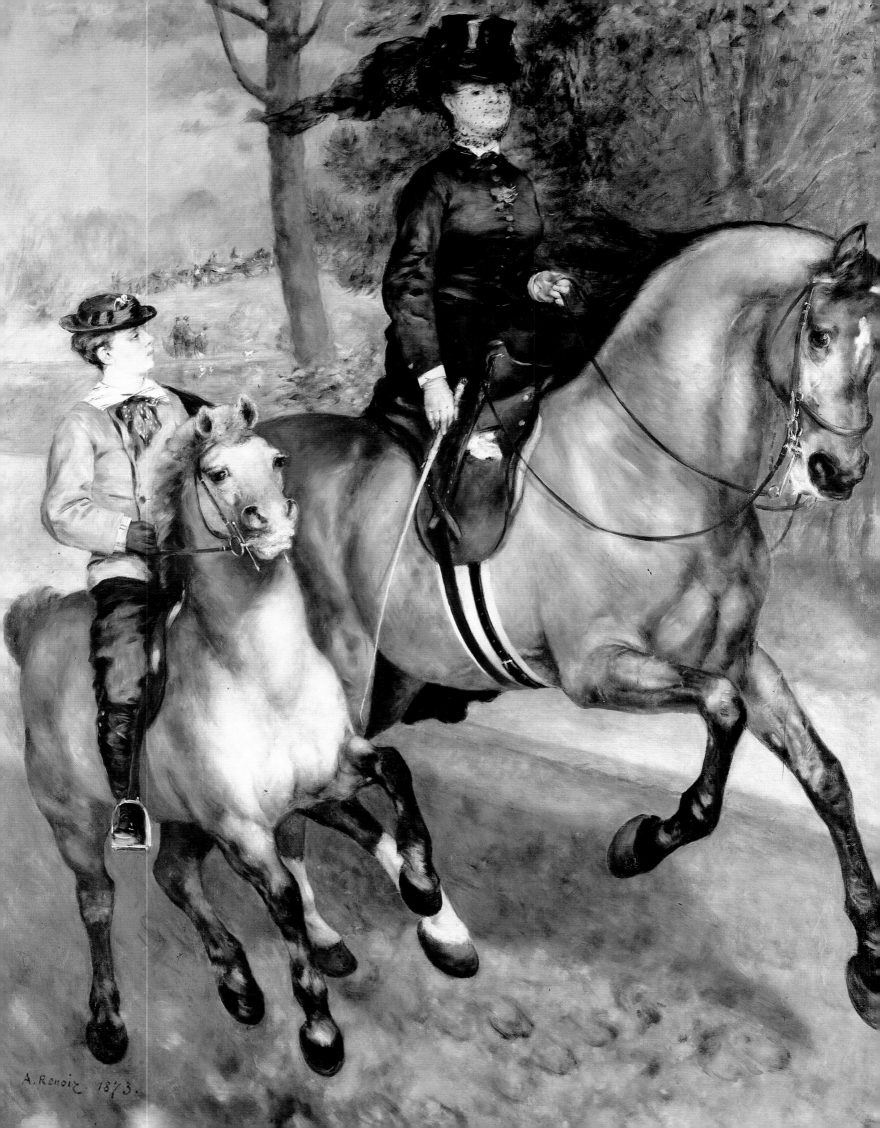

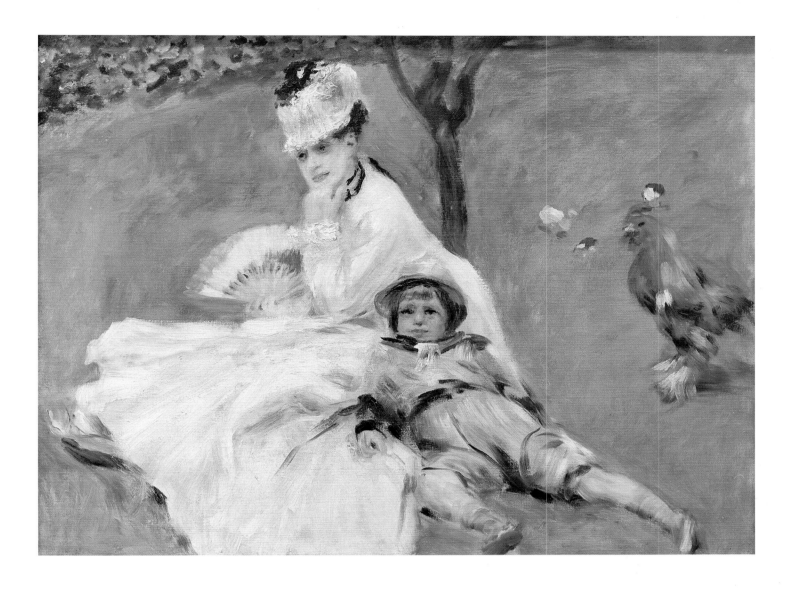

viewpoints that were virtually identical. Their techniques, though, were very different. Monet's used lively, dense, thick touches. Renoir had lighter, more melting touches, seeking to pick out more detail. Both, in their scenes of modern life and in their concentration on breaking down the image in terms of the play of light, were inventing Impressionism. However, Renoir still did not give up his ideal of big figure paintings and, at the same time, painted several monumental portraits (*Clown* and *A Morning Ride in the Bois de Boulogne*) in which his figures retain all their density and presence as individuals.

After the war, Renoir met up with Monet again in Argenteuil, where the two of them painted the banks of the Seine, and he did his portraits of his friend, *Monet Painting in his Garden at Argenteuil*, and of Monet's wife and son in *Camille Monet and Her Son Jean in the Garden*, a scene depicted by Manet in the same period. Manet, on seeing Renoir painting, is reported to have said to Monet: 'That young lad has no talent! You are his friend, tell him to give up painting.' In his portraits and in his landscapes, Renoir's touch was warm and vibrant, even more sensitive to light and, like Manet that same summer, he had never been more of an Impressionist. Indeed, he had just taken part in the first Impressionist exhibition, where he had exhibited, among other works, *La Loge*, a con-

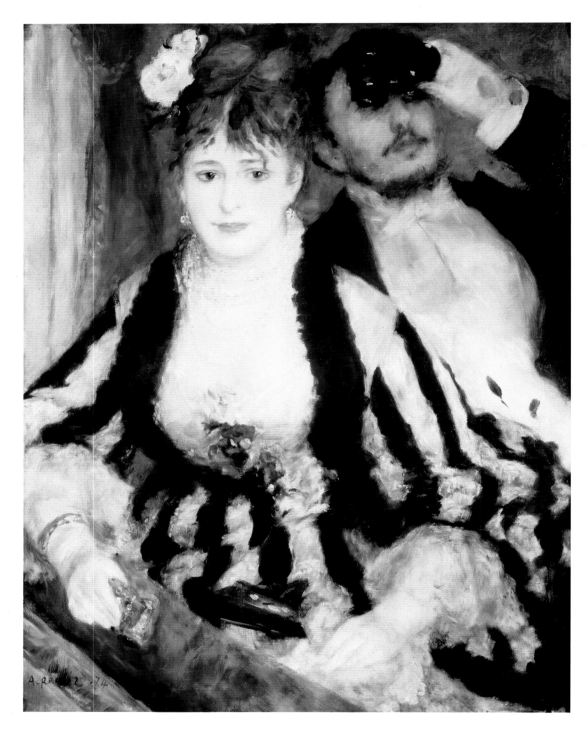

Auguste Renoir
La Loge
1874. Oil on canvas
80x64
London, Courtauld Institute

Auguste Renoir
Nude in the Sunlight
1876. Oil on canvas
81x64.8
Paris, Musée d'Orsay

temporary genre scene, and two fantasy figures, *The Dancer* and *The Parisian.* The critics responded with a certain benevolence and praised his drawing for its 'firmness' (Burty) and 'audacity' (Castagnary). Reactions to his works at the second Impressionist exhibition were more cruel. *Study: Torso, Sunlight Effect,* brought a violent response from Albert Wolff, the critic at *Le Figaro*: "Can someone explain to Mr. Renoir that a woman's torso is not a heap of decomposing flesh with those green and purple blotches that denote a state of total putrefaction in a corpse." This work, whose title was simply a statement of Renoir's experimental concerns, represents the furthest point of his investigation into the effects of light and the natural environment on the human figure.

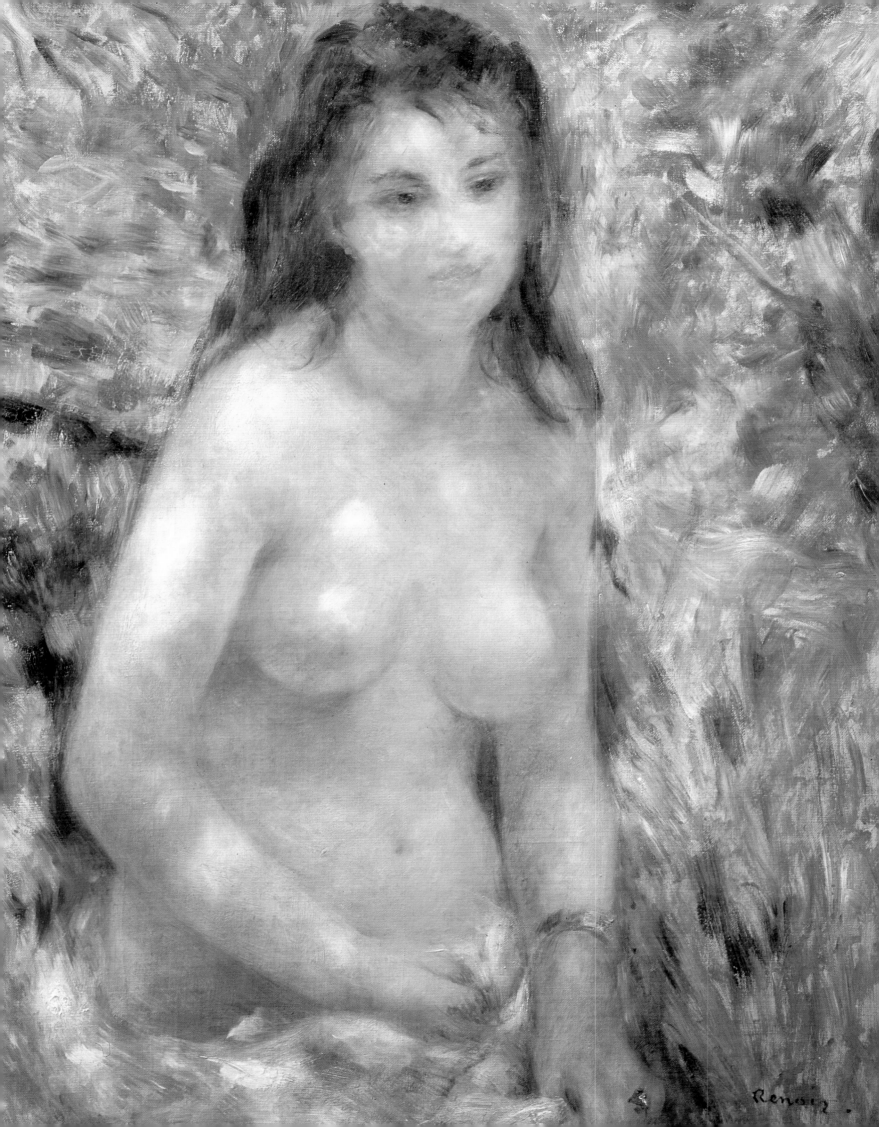

These experiments began with the bathing at *La Grenouillère*, which was the subject of two other paintings shown at the third Impressionist exhibition in 1877: *The Swing* and *The Ball at the Moulin de la Galette*. *The Ball at the Moulin de la Galette* was painted "entirely on-site" (Georges Rivière), in the courtyard of the famous *guinguette*. This painting represents a 'page of history, a precious monument to Parisian life, rigorous in its exactitude.' The two works are very much in keeping with the tendency of this exhibition, dedicated to the pictorial translation of modern life, whose other contributors included Monet with his *Gare Saint-Lazare* series, and Gustave Caillebotte, a newcomer to the group.

Although Renoir also took part in the fourth Impressionist exhibition in 1878, he was, along with Sisley, the first painter to abandon the group and return to the Salon. In this he was vigorously encouraged by the critic Théodore Duret and by Georges Charpentier, an influential client who was the publisher of Flaubert, Zola, Goncourt and Maupassant, the editor of the journal *La Vie moderne*, on whose premises Renoir was soon to be granted a one-man exhibition, and a strong believer in naturalism. His return to officialdom was a triumph: *Madame Charpentier with her Children* brilliantly updated the society portrait by showing its subject in the sketchily depicted intimacy of the salon. Madame Charpentier now introduced the painter into the circles of the Parisian *haute bourgeoisie*, where he received numerous portrait commissions (*Les Demoiselles Cahen d'Anvers*). 'Renoir has made it,' observed Pissarro, 'and good for him: poverty is so hard!' His success was all the more assured when, in 1881, Paul Durand-Ruel, who had started buying the occasional canvas from him in 1872, became his exclusive and regular dealer, as well as an attentive friend. It was for him that Renoir agreed to join his former comrades and show his *The Luncheon of the Boating Party* in the seventh Impressionist exhibition of 1882. This work, which was just as ambitious

Auguste Renoir
La Grenouillère
1869. Oil on canvas
59x80
Moscow, Pushkin Museum

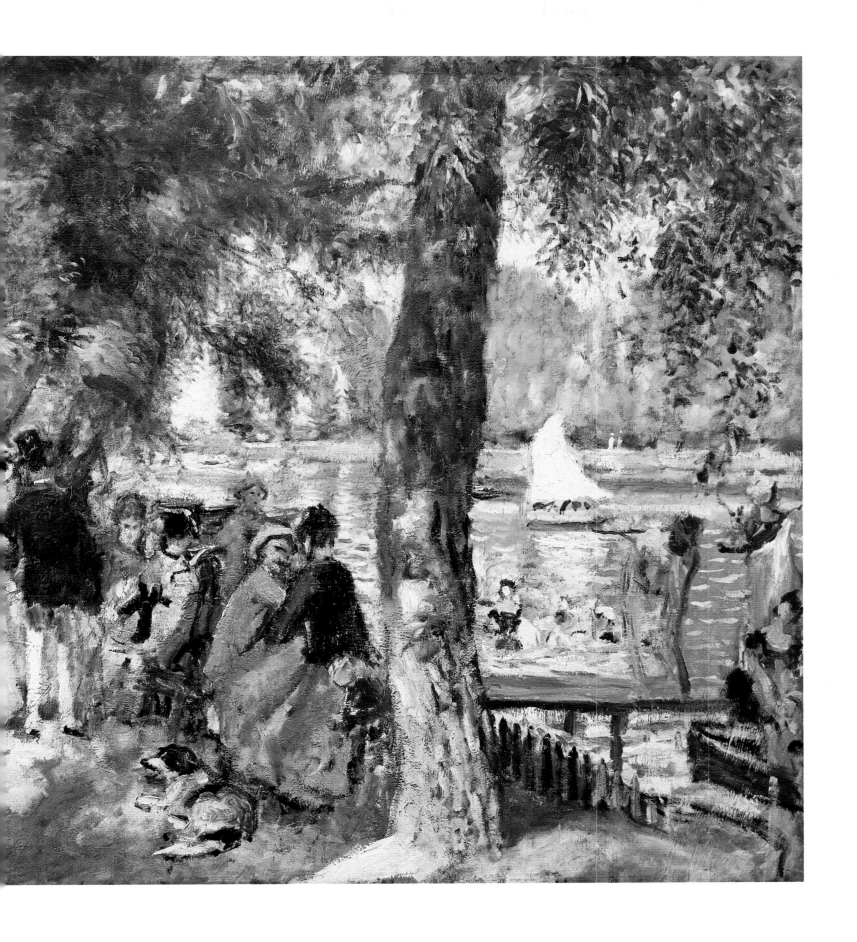

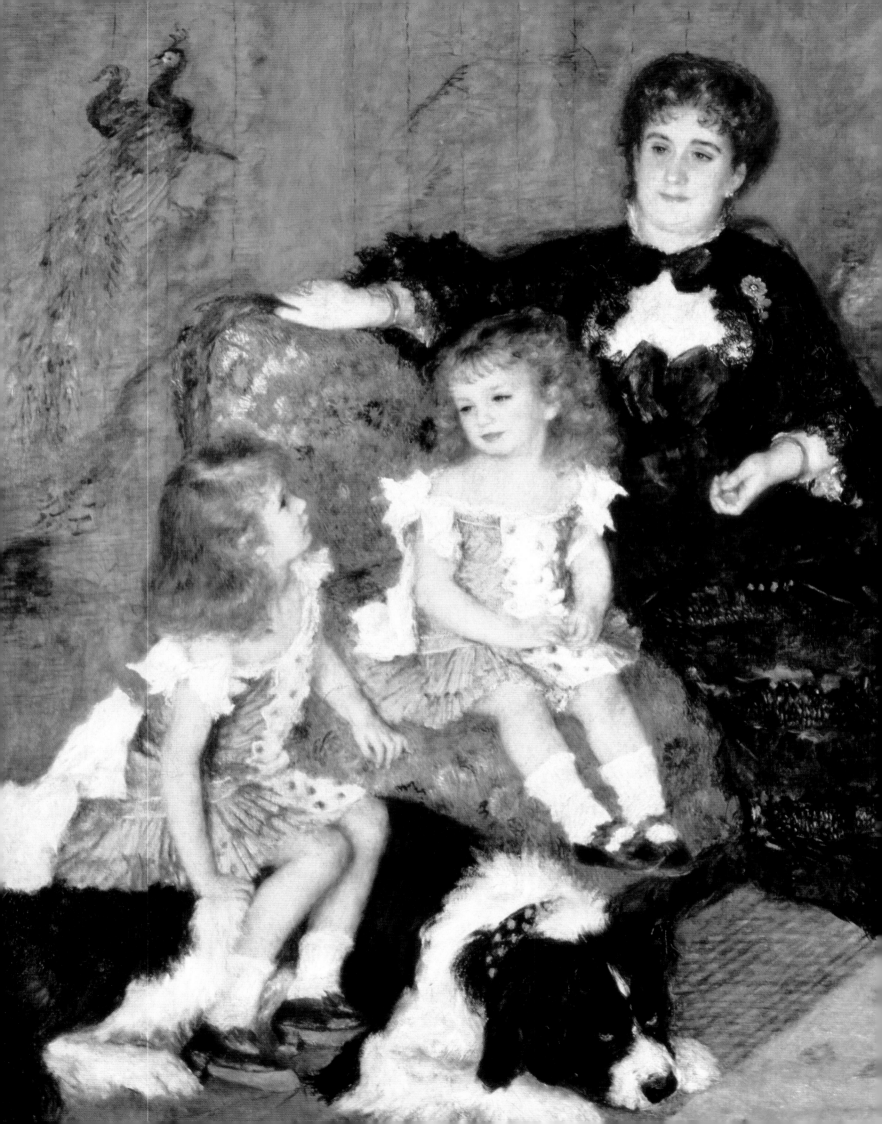

Auguste Renoir
Madame Charpentier with Her Children
1878. Oil on canvas
153.7x190.2
New York, Metropolitan Museum of Art

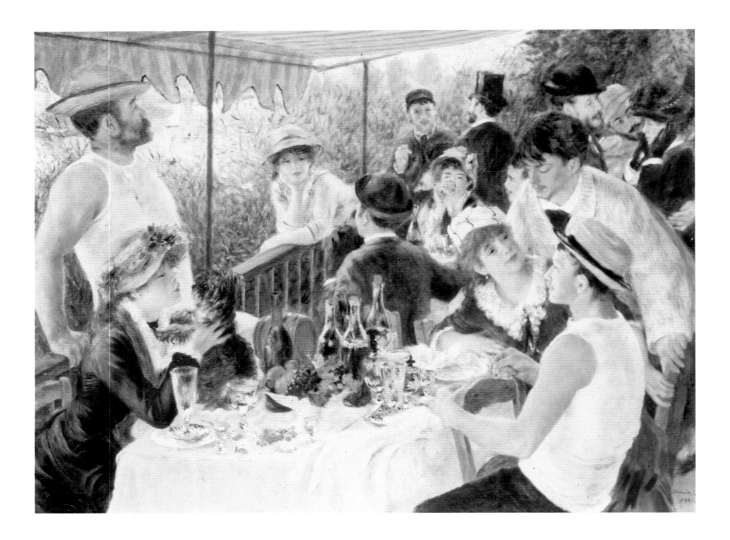

as the *The Ball at the Moulin de la Galette*, opened up a new path. It combined a modern subject and an atmosphere that was responsive to air and light with a construction and attention to the identity of the characters that seemed intended to bestow a historical dimension on the image. Renoir here seemed to be responding to Zola's reproach, that the Impressionists contented themselves with overly hasty paintings. His friend, Rivière, explained the importance of this picture: 'After painting this canvas, [Renoir] profoundly changed his facture, his palette became richer, he was more skilled at […] composing his characters.' Renoir was also harking back to the painting of the 18th century, that of Watteau, Boucher and Fragonard, which had so impressed him on his visits to the Louvre. His response was repeated in *The Umbrellas*, begun in 1881 but no doubt completed in around 1885. One group of figures (the young woman on the right, accompanying the two young girls) displays a fluttering, downy touch close to that of *The Luncheon of the Boating Party*. The other group (comprising passers-by under their umbrellas) is executed with a finer, smoother touch, with firm, fine lines. In between these two halves of the painting came…Italy.

No longer beset by material problems, Renoir was now free to travel. In 1881 he set off for Algeria, which revived his old passion for Delacroix. A few months later, he made another, even more decisive stay in Italy. There he discovered Antiquity, the classical school and Raphael. It was a revela-

Auguste Renoir
The Lunche of the Boating Party
1881. Oil on canvas
128x173
Washington, Philips Collection

Auguste Renoir
The Umbrellas
1881-1885. Oil on canvas
180x115
London, National Gallery

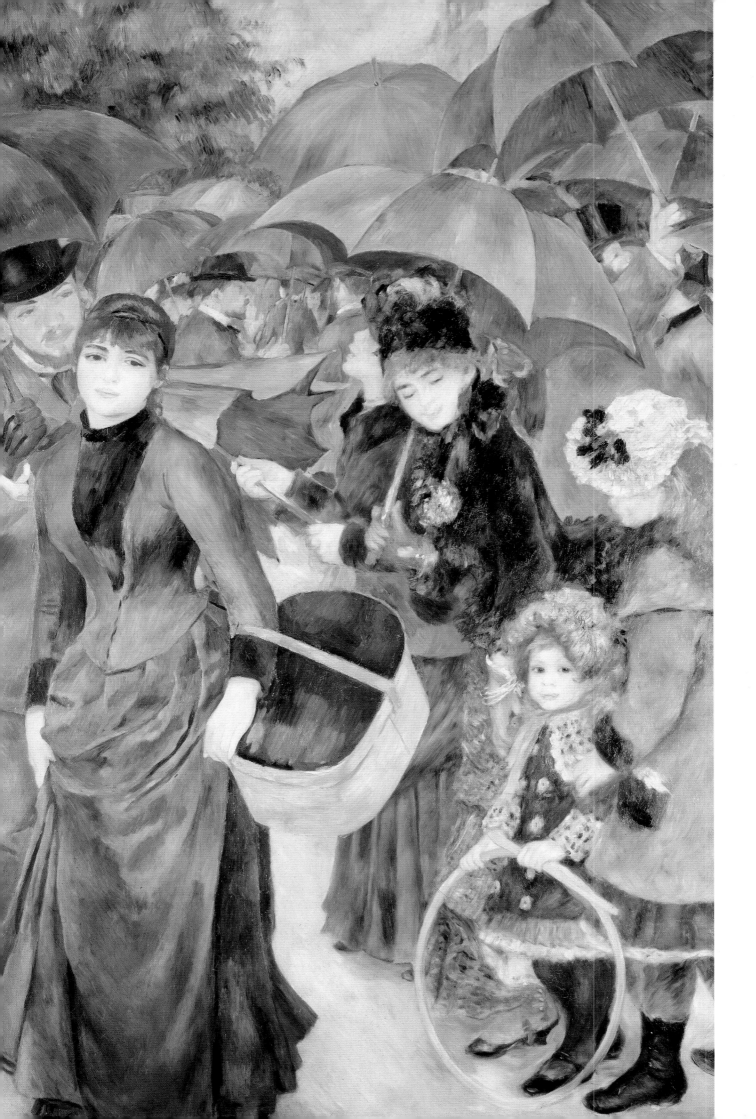

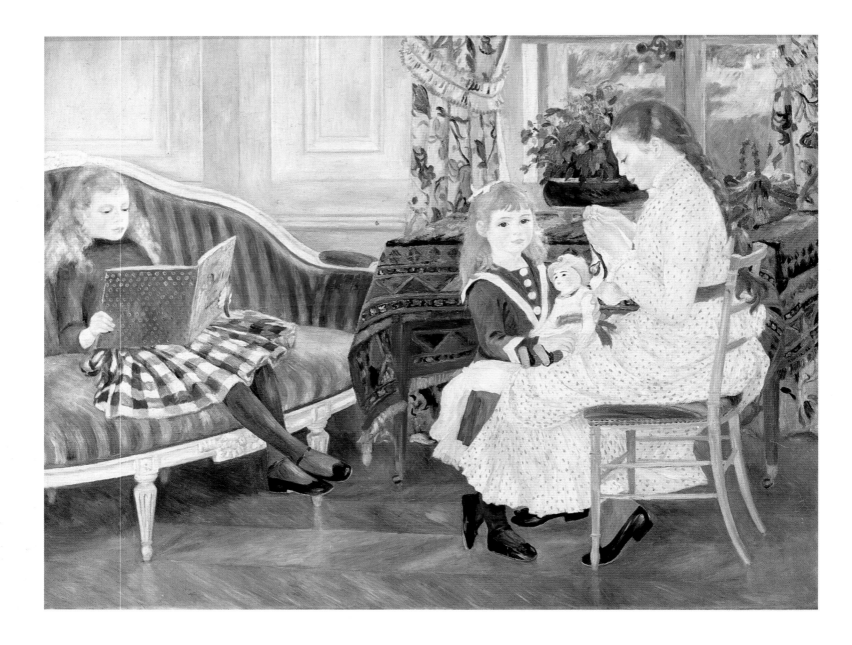

tion. 'Raphael broke with the schools of his day and devoted himself to Antiquity, grandeur and eternal beauty.'

Not long afterwards, he reached some conclusions that were crucial to his brand of Impressionism. As he explained to the dealer Ambroise Vollard, 'In about 1883, a kind of break occurred in my work. I had gone as far as I could with Impressionism and I had come to the conclusion that I could neither paint nor draw. In a word, I had reached a dead end.' Just as Monet, with whom Renoir made a short trip to the Côte d'Azur in 1882, was becoming increasingly obsessed with the law of the instant and the primacy of atmosphere over form and drawing— with landscape, Renoir was reasserting himself as a 'figure painter.' He found it impossible to imagine dissolving the figure in light, which is what Monet's experiments were tending towards. His various *Bathers* provide the clearest illustration of his reaction. His sunlit torso of 1876 was 'eaten' by green, white, orange and purple blots caused by the sunlight filtering through the foliage. Whereas the *Blond Bather* of 1882 is isolated from the setting in the porcelain-like splendor of her body. The sharp line and acid colors of

Auguste Renoir
Children's Afternoon at Wargemont
1884. Oil on canvas
127x173
Berlin, Nationalgalerie

Auguste Renoir
Garden in Brittany
1886. Oil on canvas
54x56.2
Merion, The Barnes Foundation

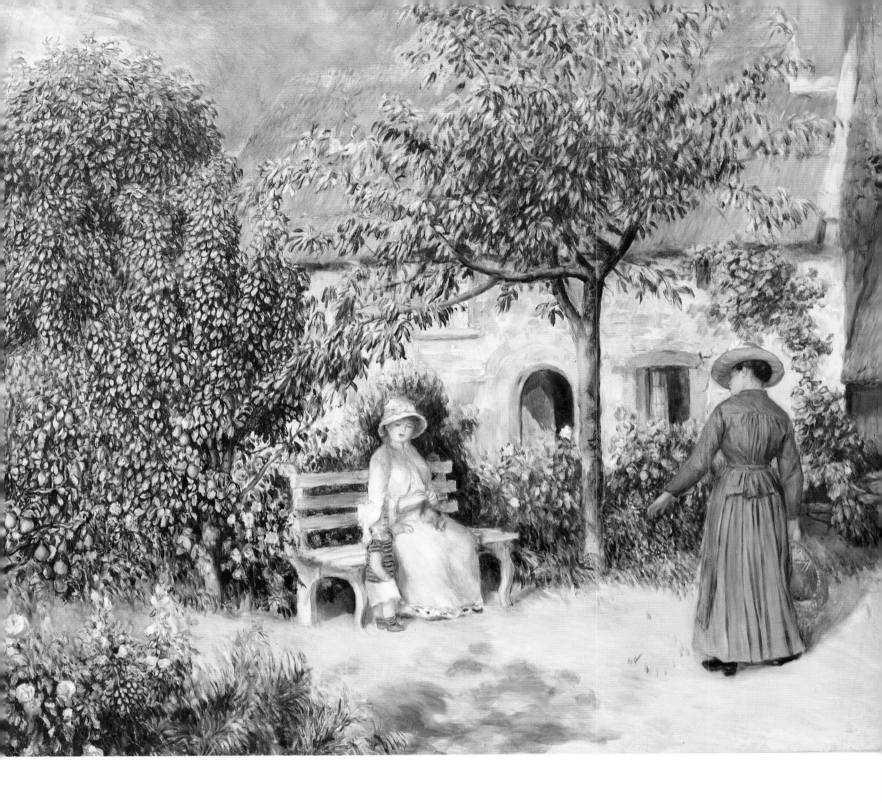

Renoir's work in the 1880s produced paintings that were strange and extremely seductive, such as *Children's Afternoon at Wargemont*, *Maternity* and *Garden Scene in Brittany*. The few landscapes that he made during these years (*La Roche-Guyon*) reflect a degree of influence from Cézanne, with whom Renoir spent a few weeks in 1882, and who, in his own way, and using different methods, was trying to reconstruct Impressionism.

This period of doubt and tension between color, light and drawing came to an end towards the end of the 1880s. In 1886 Durand-Ruel confessed, 'I do not like his new manner, not at all.' And Renoir now stated that he had 'gone back to the old, gentle and light way of painting, and will stay with it.' He was now developing a 'sequel to the paintings of the 18th century.' There were genre and fantasy scenes presenting robust

countrywomen (*The Washerwomen*), gracious young women (*Picking Flowers, Young Girls at the Piano*) and bathers who sometimes turned into goddesses (*The Judgment of Paris*). These were themes that Renoir returned to again and again, and even rendered in sculptural form. He took up this discipline in 1913 at the instigation of his dealer: 'When Vollard spoke to me of sculpture, at first I told him to go the devil, but I gave it some thought and then let myself be persuaded.'

In 1892 Maurice Denis, the young theoretician of the Nabis, summed up Renoir's art as follows: 'Idealist? Naturalist? As you like it. He has managed to stick with the expression of his emotions, of all nature and all dreams using his own methods. With the joys of his eyes he has composed marvelous bouquets of women and flowers.' Renoir confirmed this pleasure that he took in painting. 'Ah! That breast! Is it soft and heavy enough? The pretty fold that is below it, with that golden tone […] it is enough to make you get down on your knees […] And if there were no breasts, I believe that I would never have painted figures' (A. André).

Now wealthy and acclaimed, and soon covered with the honors that he refused at first and eventually accepted with a natural modesty, from the 1890s onwards Renoir was spending more and more time out of the capital. Among his increasingly frequent stays there was Brittany and Provence, where he saw Cézanne and admired his works: 'There is something here that is analogous to what is in Pompeii, so crude and so admirable.' The heat of the South soothed the pain of his rheumatism. In 1899 he discovered the village of Cagnes and in 1897 he had a house built there, Les Collettes. He made his models pose in the garden while he painted them from his behind the wide, open windows of his studio. He went back to his work on the human figure, work that he had doggedly resisted before permanently devoting himself to it: 'I fight with my figures until they are one with the landscape that serves as their ground and I want people to feel that neither they nor the trees are flat.' All Renoir's late paintings, in which the color red is dominant, express this concern, but also the radiant warmth of the sun in which he lived. This is certainly true of the *Bathers* (Paris, Musée d'Orsay), which, according to his son, the film director Jean Renoir, represented a 'culmination. He considered that he had summed up the work done throughout his life and prepared a good springboard for the work to come.' With its idealized models, its calm, its undulating rhythm ('There are no straight lines in nature,' he liked to say), Renoir had achieved a new classicism in what was his final work.

In 1919, a few months before his death, Paul Léon, the director of the Louvre, invited Renoir to come and see his portrait of *Madame Charpentier* exhibited among the museum's latest acquisitions. Now he could return to those halls where he had spent so much time as a young man and judge his own position among the old masters he so admired.

Auguste Renoir
The Girls at the Piano
1892. Oil on canvas
116x90
Paris, Musée d'Orsay

Next pages:
Auguste Renoir
The Bathers
1918-1919. Oil on canvas
110x160
Paris, Musée d'Orsay

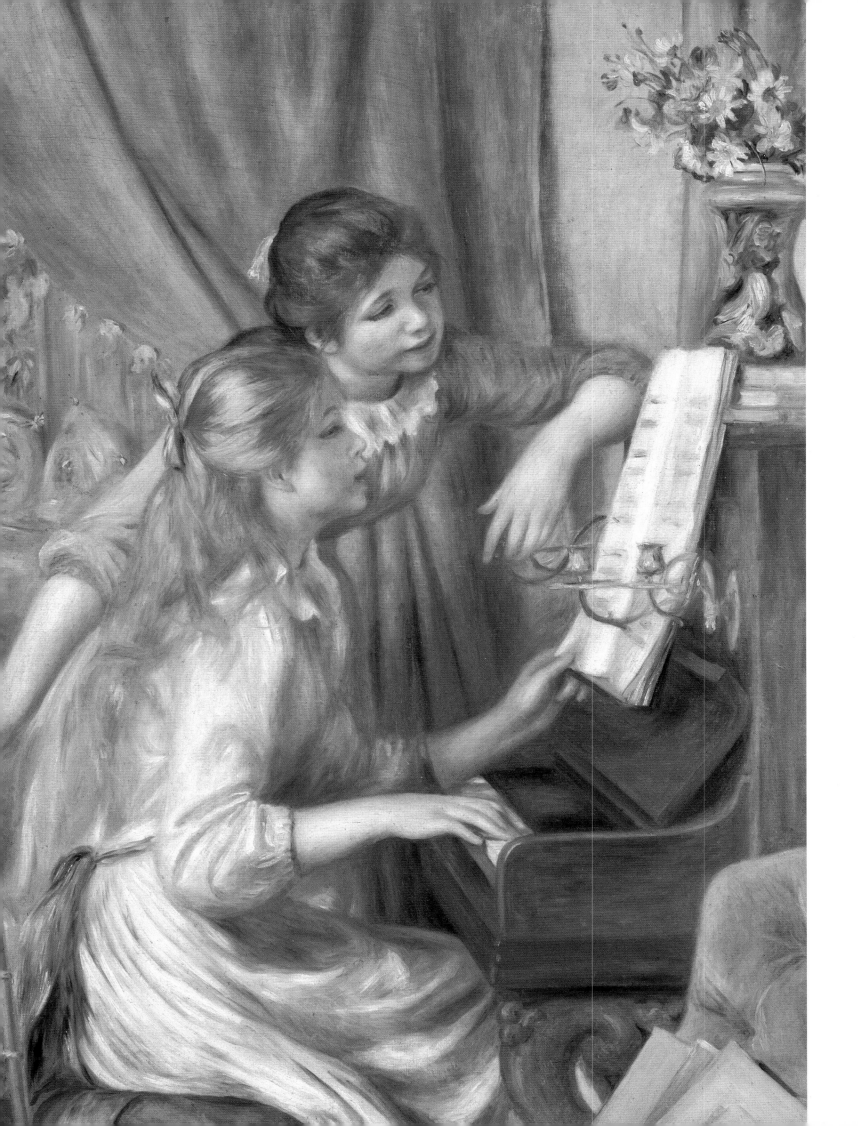

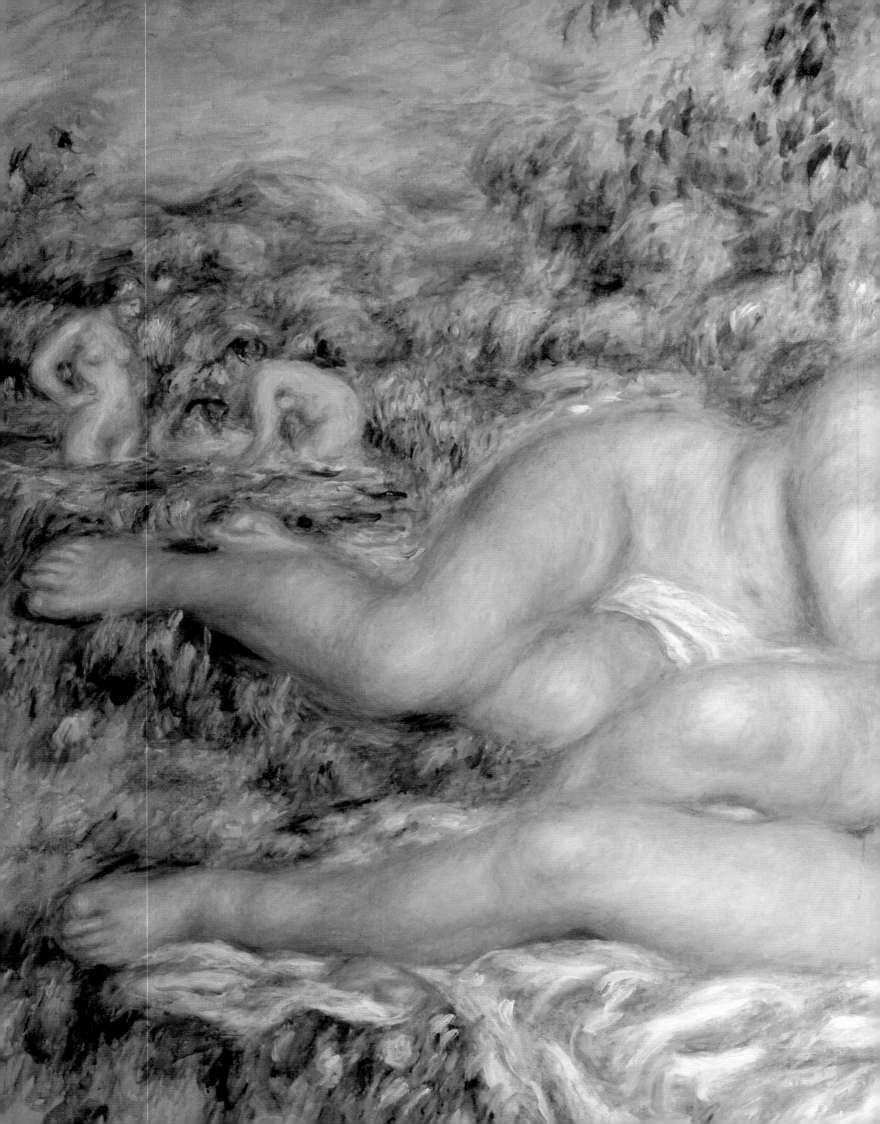

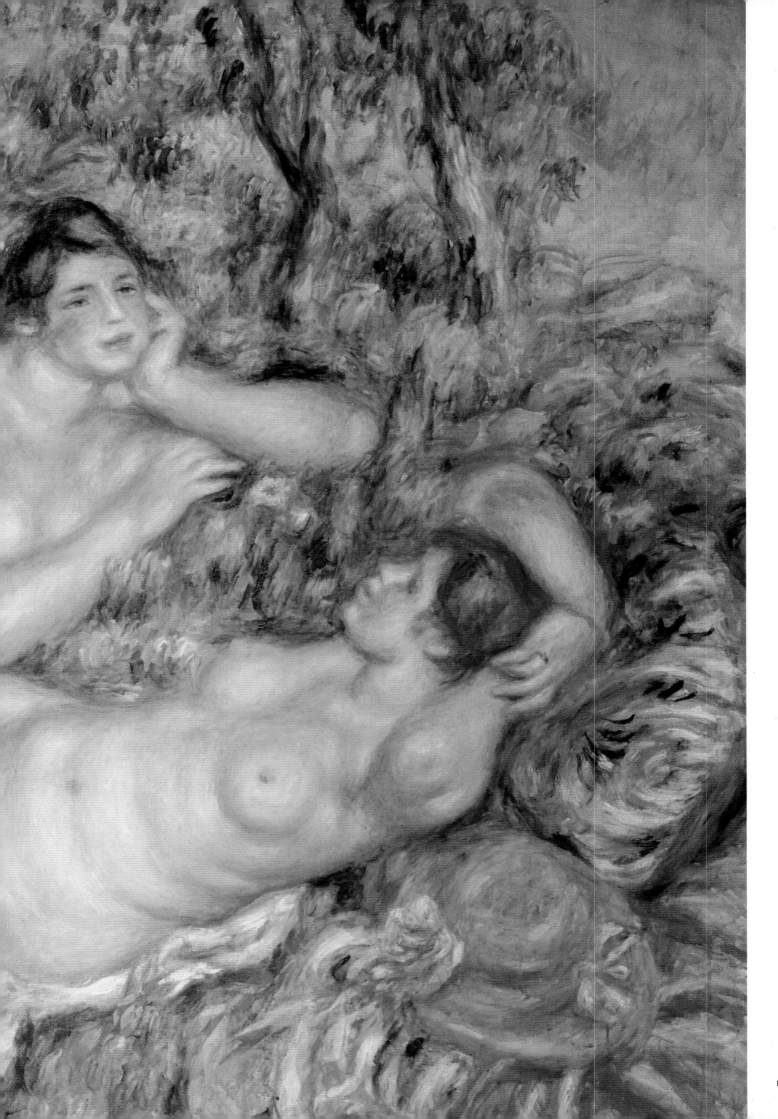

Renoir

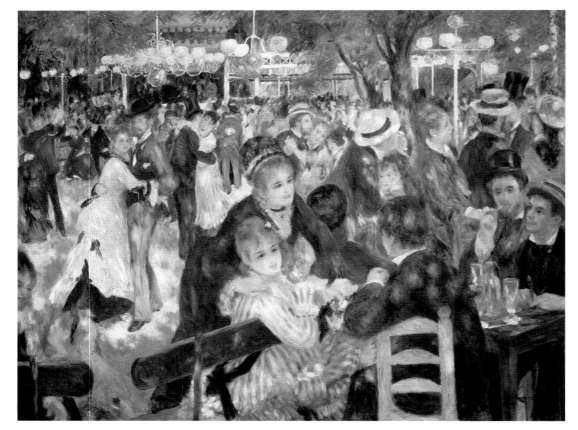

Photograph of Gustave Caillebotte
Private collection

Auguste Renoir
The Ball at the Moulin de la Galette
1876. Oil on canvas
131x175
Paris, Musée d'Orsay

Caillebotte

In his *Self-portrait with Easel* (1879-1880, priv. coll.), Caillebotte portrays himself as both a painter and a patron of the arts. The reflection in the mirror before which the artist poses recalls the image of Renoir's painting *The Ball at the Moulin de la Galette*. Renoir was the beloved friend of Caillebotte's Impressionist circle and Caillebotte must have bought the painting sometime before the third Impressionist show of 1877, along with *The Swing* and *Study: Torso, Sunlight Effect*. *The Ball at the Moulin de la Galette* was not the only work in the show that the artist acquired. He also purchased from Monet three versions of the *Gare Saint-Lazare*; from Degas, *Women on a Café Terrace*; from Cézanne, the monumental *Bathers*; and from Pissarro, the *Chemin sous bois*.

In the end Caillebotte would buy some 60 works from his Impressionist friends, putting together an exceptional collection at a time when those who appreciated such art were indeed rare. The artist bequeathed this group of paintings to the State, appointing Renoir, whom he invited to show with the group in 1876, to oversee the bequest: 'I request that Renoir be the executor of my will and testament and that he accept a painting of his choice; my heirs will see to it that he selects an important one.' Renoir chose a picture by Degas, which he sold soon after to Durand-Ruel. Degas was furious. Caillebotte would have forgiven his friend.

Renoir's task proved a difficult one and he had to show himself a firm negotiator with the French government which little appreciated the arrival of works by such controversial artists. The State's representatives declared that the tiny Musée du Luxembourg could not possibly house the collection in its entirety. Moreover, the museum's rules stipulated that no more than three works by the same artist could be shown at the same time. Renoir and Caillebotte's brother Martial, both of whom were advised by Monet, who had himself just been through a similar situation with the Olympia donation, demanded that the testament be duly carried out. The Caillebotte bequest also posed a second difficulty, namely, the collection included sketches that certain artists themselves did not care to see exhibited. Sisley, for example, wrote to Léonce Bénédite, the director of the Luxembourg, 'Among the canvases that Caillebotte owned there is one that I would not like to see in the Luxembourg…' and Pissarro pointed out: 'I have seen my paintings at Monsieur Caillebotte's—your choice is excellent save for the small gouache that seems of lesser quality to me.'

The idea of making some kind of selection thus became a necessity for both parties. Forty works were chosen for display at the Musée du Luxembourg. Among the pieces that did not find favor at the time was Cézanne's masterpiece *The Bathers* and two studies by Monet for his *Gare Saint-Lazare*. Nonetheless, the Caillebotte gallery opened to the public on February 9, 1897. Satisfied, Monet shared his impressions with Geffroy, 'It won't be too bad, but the two Cézannes are not prominent enough. I offered to place one [*L'Estaque*] that is quite beautiful in place of one of mine, but I wasn't able to.'

The Académie des Beaux-Arts addressed a letter of protestation to the minister, but to no avail. The Impressionists had now entered the museum.

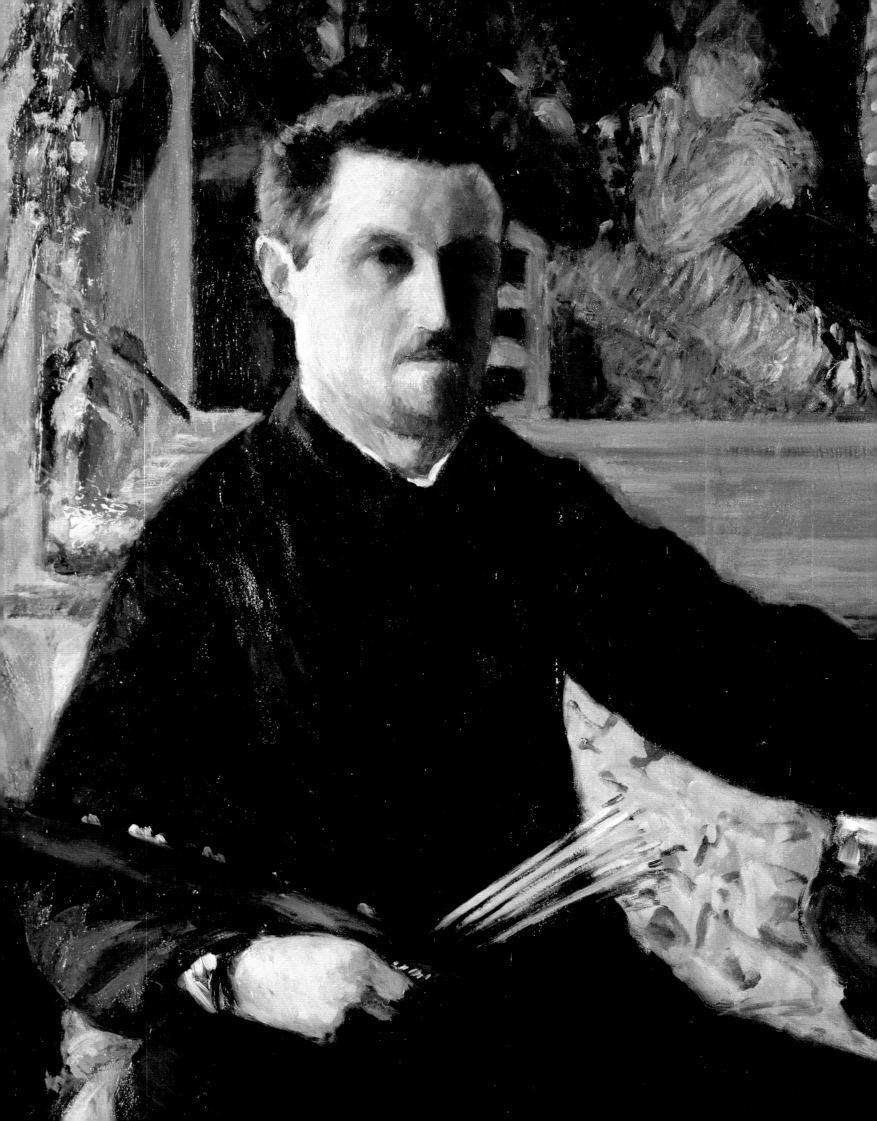

6 Caillebotte

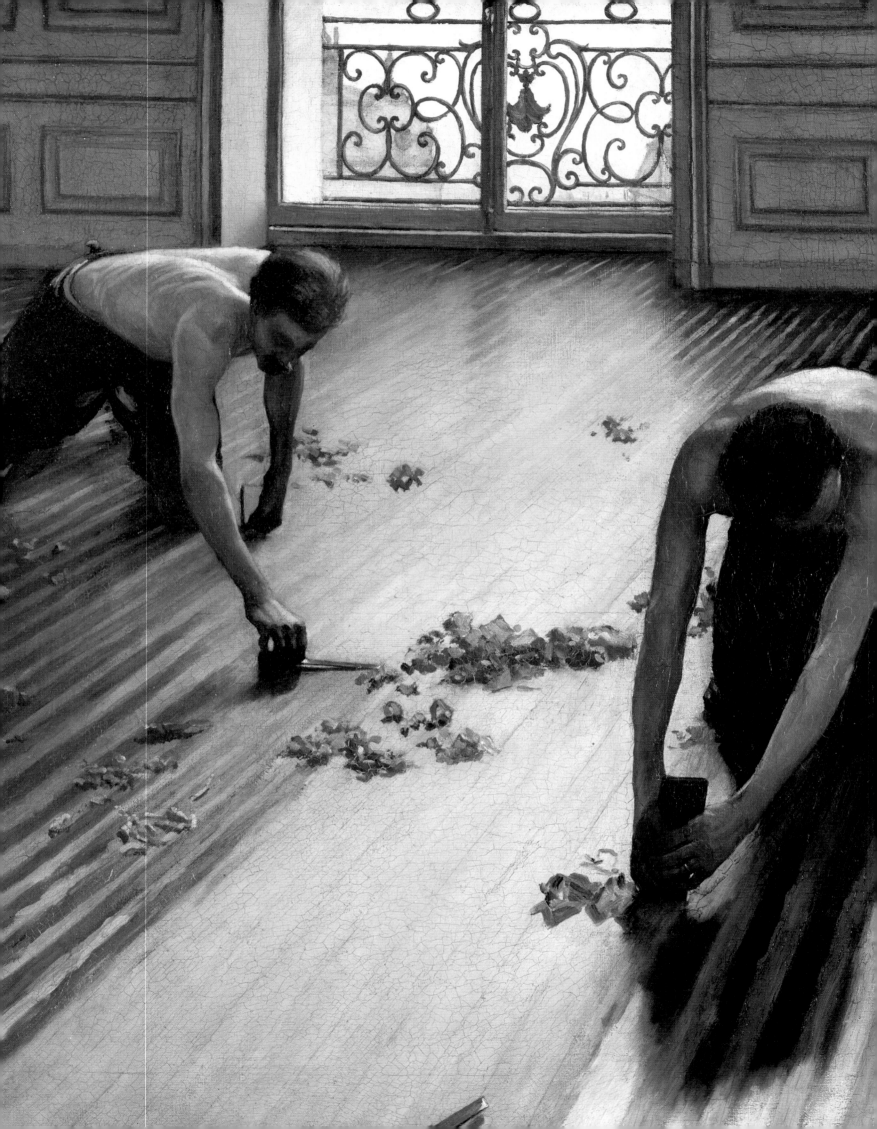

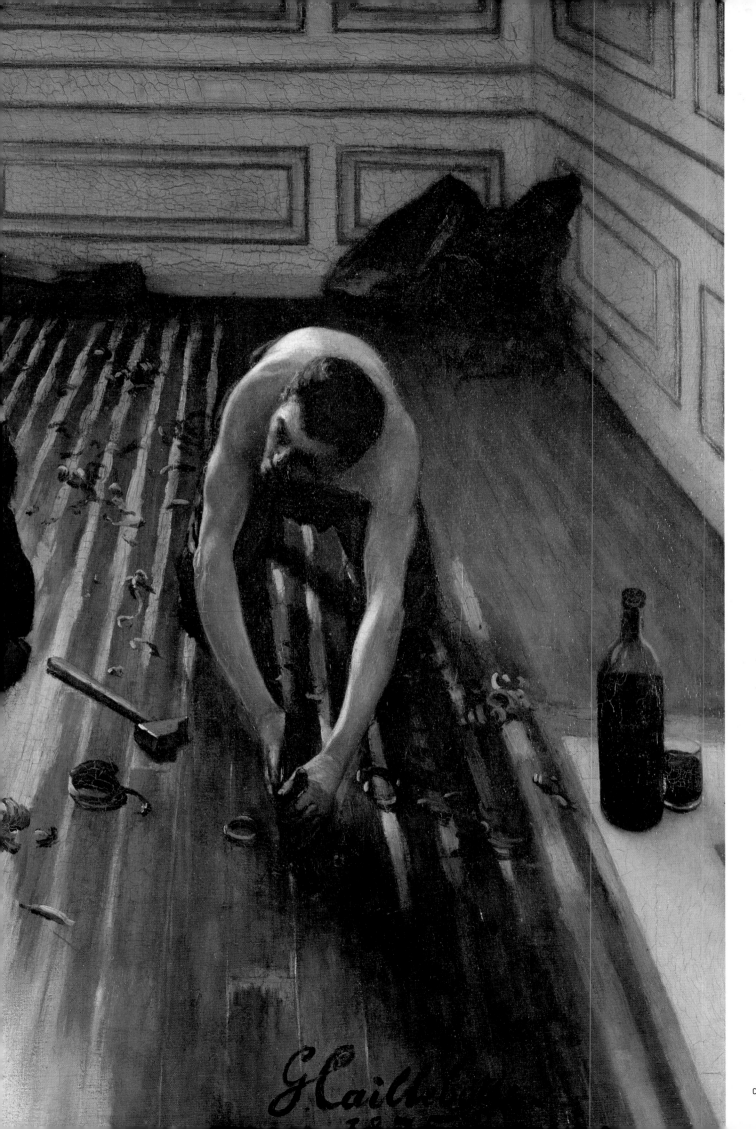

'I request that from my estate be deducted the amount necessary to mount in 1878, in the best possible conditions, an exhibition of the so-called Intransigent or Impressionist painters. It is rather difficult for me to evaluate today that amount; it could reach 30 to 40,000 francs, or even more. The painters who are to figure in this exhibition are: Degas, Monet, Pissarro, Renoir, Cézanne, Sisley, Mlle Morisot. I mention those without excluding others.

I bequeath to the State the paintings in my possession, only that, as I would like this donation to be accepted, and to be so in such a way that these paintings go neither to the attic nor to a provincial museum, but indeed to the Luxembourg and later to the Louvre, it is necessary that a certain amount of time elapse prior to executing the present clause, until the general public, I wouldn't say understands, but accepts this painting. The amount of time may be twenty years or more…'

Signed on 3 November 1876, Gustave Caillebotte's last will and testament reveals the particular attachment the artist felt for Impressionism, a movement that had formed only several months before. His was a militant commitment that led him to look to both the immediate survival of the movement, by seeing to the organization of a show in the near future, and its long-term existence, by assuring it a place in the Louvre. It was also a fervent one, prompting him to acquire painting that was selling quite poorly at the time. Yet the words of his testament leave out an essential part of his ties to Impressionism, his own personal body of work. For Caillebotte's oeuvre represented a strong and exciting element. As in his role as a collector and energetic promoter constantly seeking to bring together small coteries within the movement, through his own painting he seeks to reconcile Impressionism's major pictorial trends, that is, painting out of doors and urban modernity.

'Mr. Caillebotte, we thought it would be a good idea to renew our common attempt to mount a special exhibition… We would be very pleased to see you join with us in this new undertaking.' With this letter dated February 5, 1876, Renoir and Ernest Rouart, a friend of Degas's whom Caillebotte knew as well, invited him to take part in the Impressionists' second show. His contribution immediately makes plain his originality: *The Floor-Scrapers* combines a cool, polished treatment—inherited from Caillebotte's apprenticeship with Bonnat, an academic painter and childhood friend of Degas's—with a subject that is bursting with reality and burning with social consciousness. More important, Caillebotte sent *Man at the Window*. This painting raises the question of Caillebotte's relationship with the critic Edmond Duranty, whom Caillebotte saw repeatedly at the dinners organized by his friend Giuseppe de Nittis, and attended also by Degas and Manet.

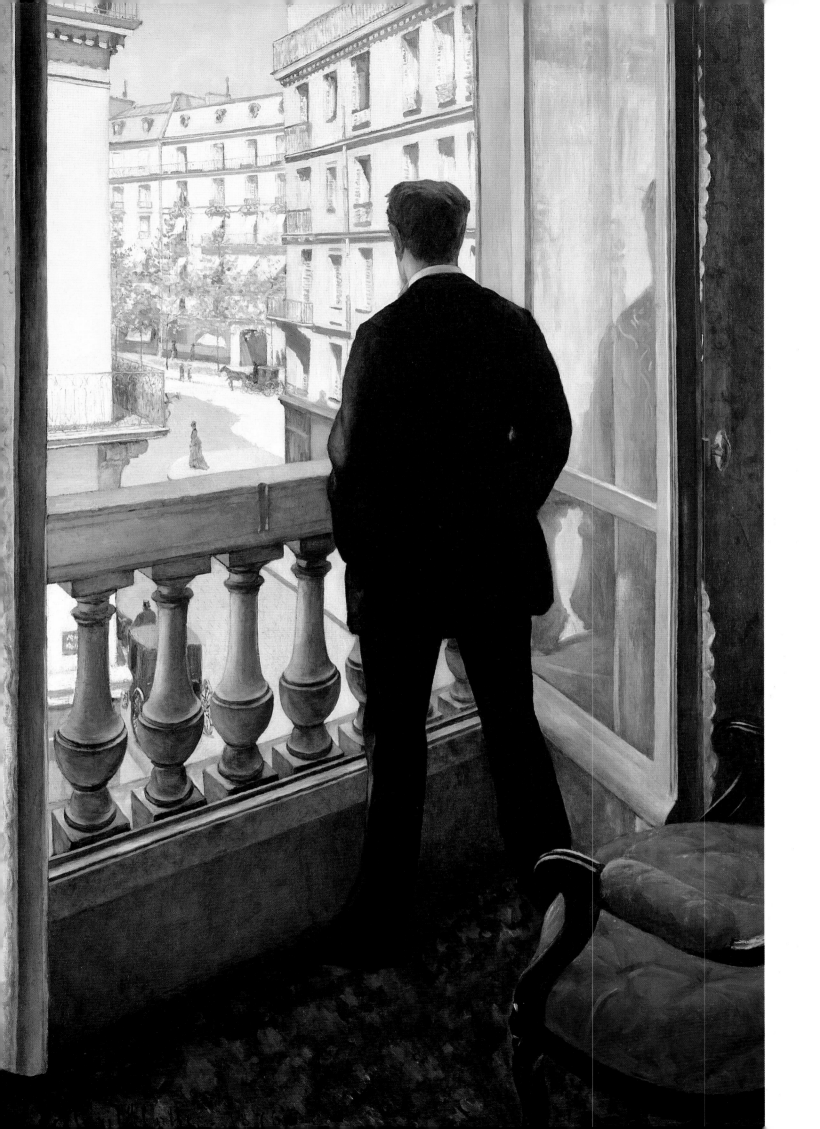

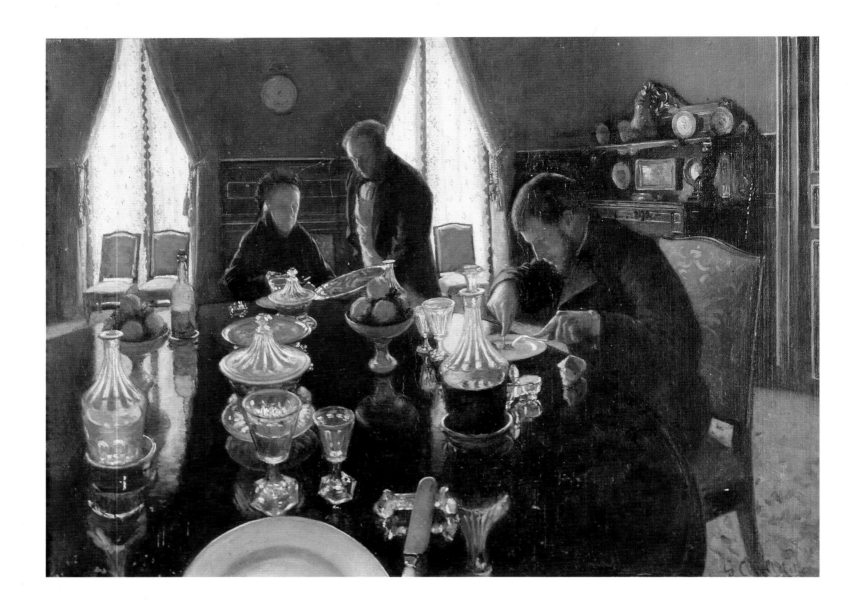

In 1876 Duranty, who had been defending the cause of realism since the mid-1850s, published a brochure entitled *La Nouvelle Peinture* (The New Painting) in which he defined the points of view that the modern painter should adopt. Between 1876, when Caillebotte first took part in the group shows, and 1882, the final year of his participation, the program articulated in *La Nouvelle Peinture* can be seen to inform his production throughout. His works from this period are both precise and carefully thought out. Caillebotte is trying his hand at all of painting's classic themes, from portraiture and the nude to still lifes. And one wonders whether Duranty didn't refresh his own ideas by discussing with the painter. When the latter presented *Man at the Window*, Duranty wrote, 'From the inside, it is through the window that we communicate with the outside; the window is still a frame that accompanies us endlessly, throughout the time we spend at home, which is a considerable amount of time. The window frame, depending on whether we are near or far, sitting or standing, carves up the spectacle outside in the most unexpected, variable way, providing us with eternal variety, the impromptu that is one of the great pleasures of reality.' Similarly, *Lunch* and *Young Man Playing the Piano* are perfectly echoed in another of Duranty's texts: 'And since we

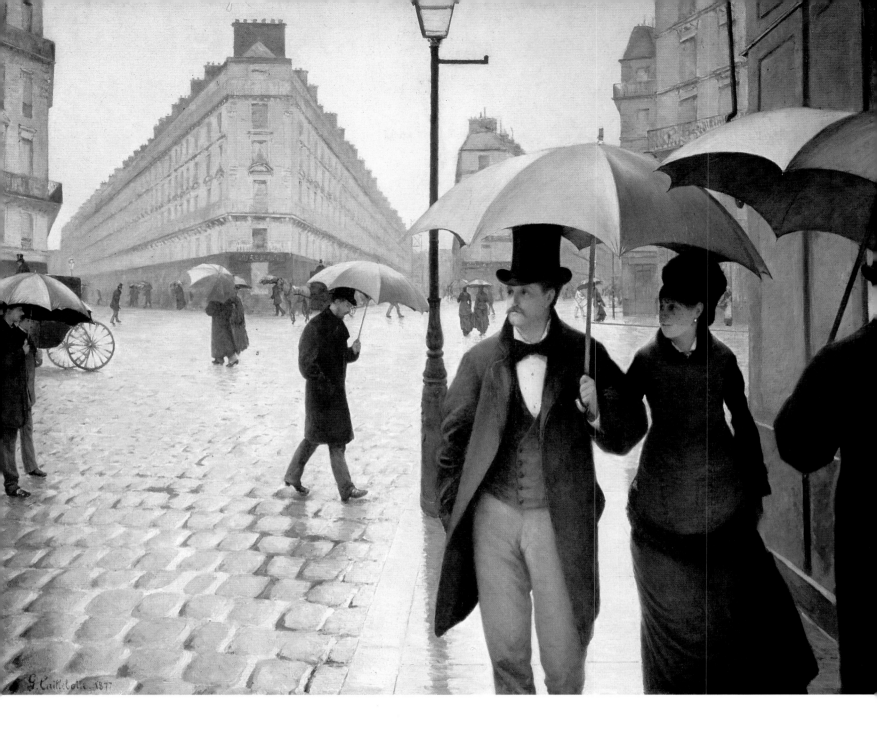

Gustave Caillebotte
Lunch
1876. Oil on canvas
52x75
Private collection

Gustave Caillebotte
A Rainy Day in Paris
1877. Oil on canvas
212.2x276.2
Chicago, Art Institute

stick closely to nature, we will no longer separate the figure from the background of the apartment or the street. The figure never appears to us, in life, against backgrounds that are neutral, empty or vague. Rather, around and behind it are pieces of furniture, fireplaces, wall coverings, a wall that expresses the person's fortune, class, profession: they will be at his piano, or examining a sample of cotton in his office, or waiting behind the scenery for the moment to go on stage, or wielding an iron on a trestle table, or dining with his family…'

The following year, Caillebotte's contribution to Impressionism proved even more incisive. First of all, with Monet he threw himself into organizing the exhibition, hunting down a venue and helping with the hanging of the paintings. His pictures, including in particular *A Rainy Day in Paris*, *The Pont de l'Europe*, *Portraits in the Country* and *The House Painters*, were those of an ambitious artist who was looking to catch up with his comrades, who had started off on their careers before him.

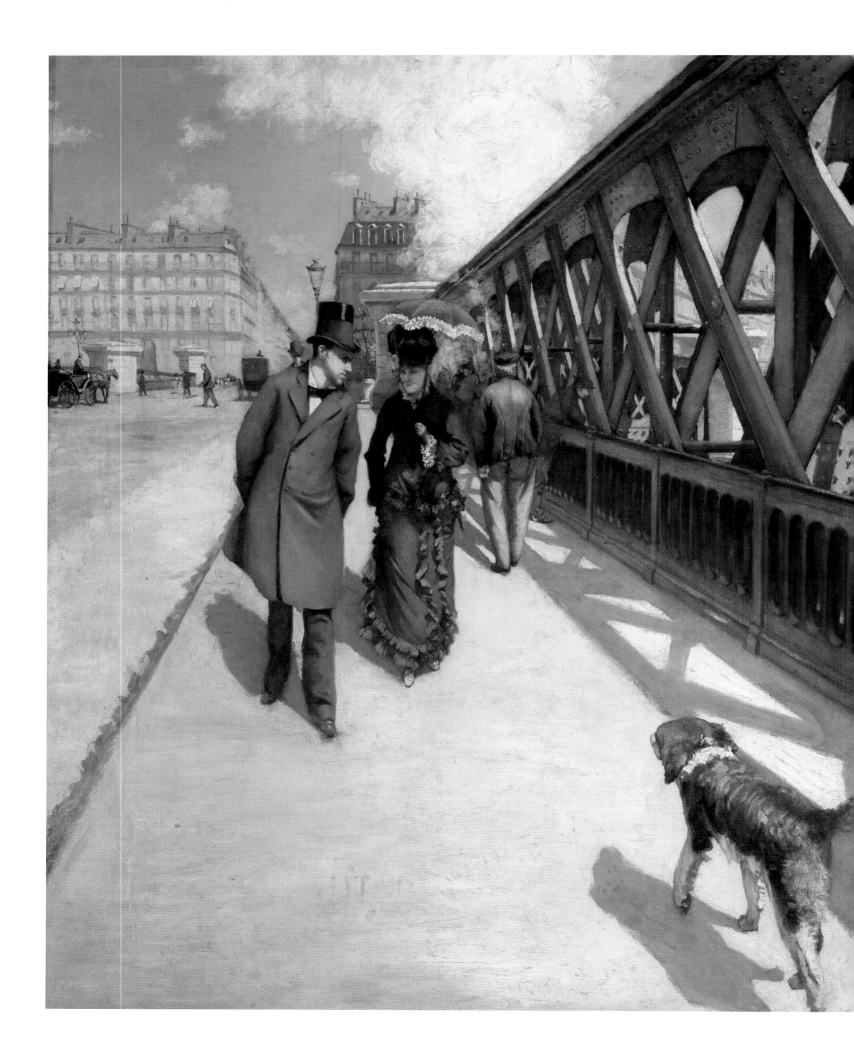

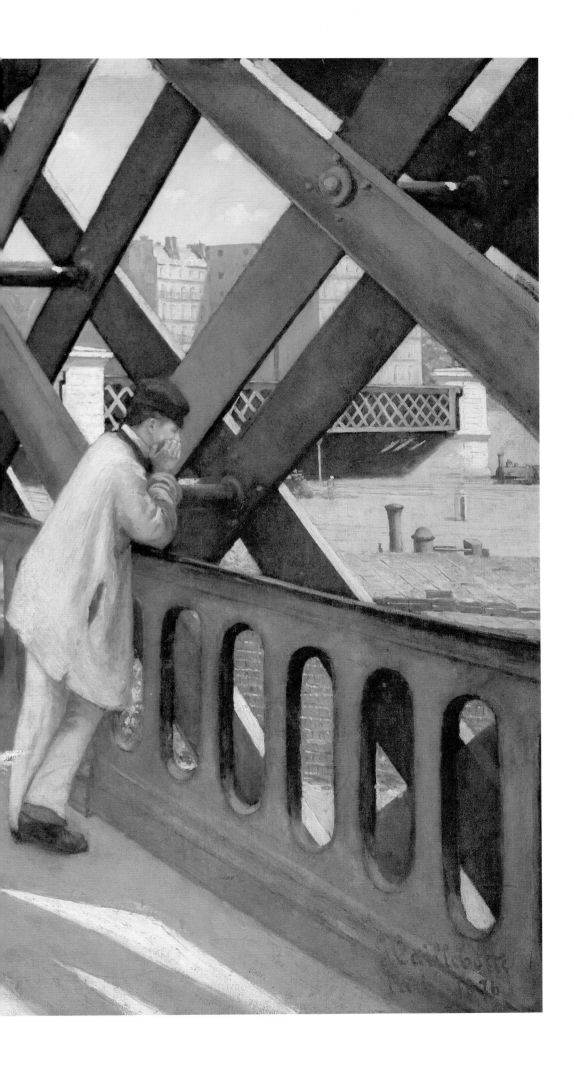

Gustave Caillebotte
The Pont de l'Europe
1876. Oil on canvas
124.7x180.6
Geneva, Musée du Petit Palais

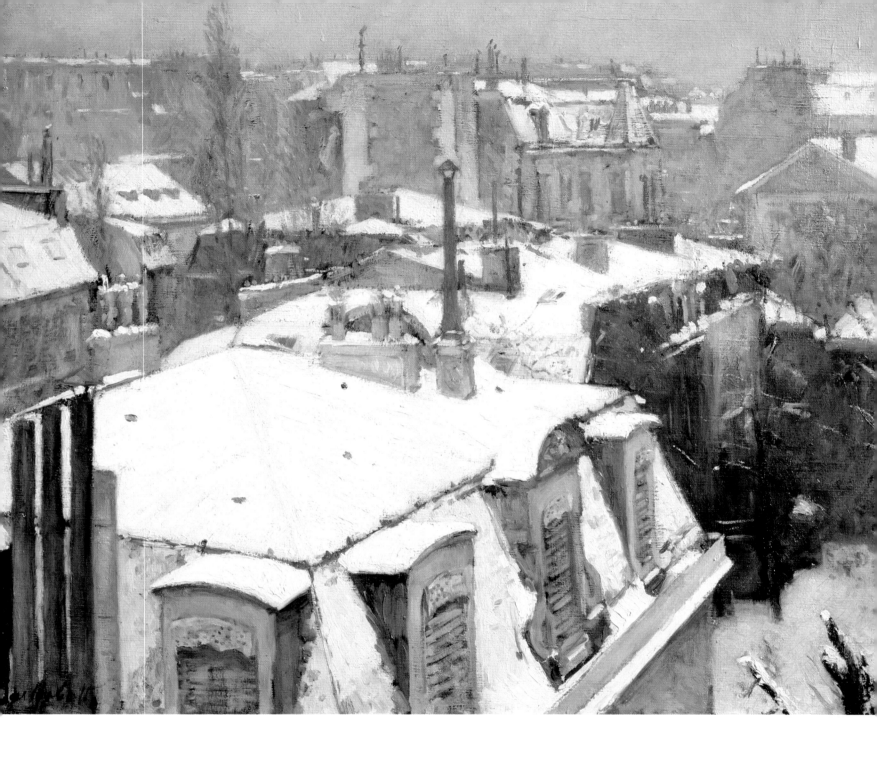

Besides a collective family portrait done in a garden which is not without a certain likeness to Bazille's portrait of his family on the terrace, Caillebotte offered views of the modern city as it had never been shown before. This was the Paris of the town planner Georges-Eugène Haussmann, with straight-as-an-arrow boulevards and never-ending perspectives. It is modern Paris, with its grey stones and metal guardrails, the Paris whose denizens are busily moving about their new metropolis or simply taking it in, by turns curious and passive. He studies the capital in the rain, when everything is grey and glossy, paving stones, sidewalks, umbrellas; and in the sun, when everything is dazzling, dry and dusty. Zola wrote: 'Finally, I shall mention Mr. Caillebotte, a young painter with the finest courage who doesn't shy from life-size modern subjects. His *Rainy Day* in *Paris* features passers-by, especially a gentleman and a lady in the foreground, that show a fine artistic truthfulness. Once his talent has

loosened up some, M. Caillebotte will surely be one of the most daring of the group.' As Zola points out, Caillebotte's technique lacked the suppleness of his comrades. His touch, although less polished than in *The Floor Scrapers*, remained stiff, but the painter's interest in classic studies in both perspective and especially the definition of the pictorial frame constituted a fundamental contribution. It allowed him to reconstruct the city with an absolute rigor that goes beyond the rigor of town planners while remaining faithful to what he saw. Caillebotte manages to lend the city an epic dimension. In the middle ground of *A Rainy Day in Paris*, a painter is passing by with his white work clothes and his ladder. Perhaps he is on his way to join his fellow painters, whom Caillebotte portrays in *The House Painters*, the other large canvas he devoted to the world of work, an exceptional image as the critic Burty emphasizes: "A curiosity, rare nowadays, strictly professional fellows and occupations." The coherence of Caillebotte's vision invites us to make such links.

While in 1878 Caillebotte failed to mount a group show of the Impressionists that would have been a response to the World's Fair (the Fair had refused to admit the representatives of the New Painting), he did manage to organize the fourth show in 1879. The defections, however, were many and serious: Cézanne, Sisley and Renoir preferred the official Salon. Monet was deeply discouraged and Caillebotte struggled to lift his spirits, "Try not to lose heart like that… If *Flags* is lacking a frame, I'll take care of the frame. I shall answer for everything… Put in as many canvases as you can. I bet that you will have a superb show. I'll spend the week running about for you if you like." Despite his discretion and abnegation, Caillebotte appeared everywhere in the exhibition, presenting 24 works of his own which delighted the caricaturists, and lending ten other paintings from his private collection. His own pictures offer a perfect balance between the two poles of Impressionism, featuring modern, urban subjects on the one hand, and outdoor scenes on the other. The paintings displayed in the 1877 show had already revealed the originality of his view of the city. Those in the 1879 show, as well as the following year, confirmed that like Degas he was the painter of modern life. He continued to play on the interior/exterior views strongly recommended by Duranty with *Roofs under Snow* and *Rue Halévy, View from the Sixth Floor*, going so far as to reduce the window, that obligatory vector between the intimate space of the apartment and the public space of the street, to a purely decorative, quasi abstract motif with suggestions of Japanese art (*View Across a*

Balcony). Caillebotte's *In a Café*, a complex composition that probably influenced Manet's *A Bar at the Folies-Bergère*, gives us the portrait of an essential 19th-century locale with a candor hailed by the naturalist critic Huysmans: 'Behind the table, a bench of reddish-purple velvet fading to wine red because of the wear produced by the continuous friction of backs; to the right, a fine flash of light tempered by a pink-striped twill blind; in the middle of the canvas, stuck above the bench, a large gilt-framed mirror flecked with fly specks reverberates the shoulders of the gentleman standing there and reflects the whole interior of the café. Here again, no precaution, no arrangement.' Caillebotte also explored modern life as seen in the countryside. Designed as decoration, the three panels shown at the 1879 exhibition (*Angling*, *Bathers* and *Périssoires*) take up certain traditional themes of the Impressionist painting being done in the 1860s and early 1870s, but with Caillebotte's usual rigor in framing the image. They effect a synthesis of Monet's and Renoir's research, notably in figures depicted out of doors and modern leisure, and the experiments carried out by Degas, who took a steely, realist view of his contemporaries. By daring to paint male nudes, moreover, Caillebotte was the only artist to respond to the long studies Degas devoted to women in their bath. His *Man at His Bath* shows in a nutshell his calm and quite modern daring.

Despite Caillebotte's and Degas's aesthetic affinity, the two painters were not on the best of terms. Caillebotte lived for the group, for the ideal Impressionism of the group's initial dreams and manifestations, and remained true to the friendship that bound him to both Renoir and Monet. Degas, on the other hand, turned his thoughts to defining a school that was strictly realist and resolutely intransigent. The disagreements were endless and Caillebotte decided to sit out the 1881 show. To Pissarro he wrote, 'Degas is bringing disorganization among us [...] He has immense talent, it's true, and I am the first to proclaim myself a great admirer. But let's leave it at that.'

While still passionately fond of the city, Caillebotte began to turn his attention increasingly to life outside the narrow, confining limits of his milieu. Moreover, in 1881 he bought a house located in Petit-Gennevilliers, an acquisition that offers further proof of his attachment to Impressionism. Not only was he drawn to this village along the Seine because boat racing, a passion of his, was beginning to enjoy considerable development there; he also found in Petit-Gennevilliers the open spaces where Monet and Renoir once painted when the former was living in Argenteuil—located on the other shore of the Seine—and where Manet also stayed several times. The paintings *The Bridge at Argenteuil*, *Regatta at Argenteuil* and *Richard Gallo and His Dog Dick at Le Petit-Gennevilliers* evince this geographic and stylistic appropriation of Impressionism. In Petit-Gennevilliers, Caillebotte drew closer and closer to Monet's art. With his participation in the 1882 show (yet again he proved to be the mainstay of the exhibition, which took place without Degas, moreover), Caillebotte presented more landscapes and seascapes than views of the city. He also exhibited a surprising still life, *Fruit Displayed on a Stand*. Taken with other equally astonishing pictures like *Display of Chicken and Game*, the work completely renewed this timeless theme by opening it up to the modern reality of commerce and consumption of fruit in the late 19th century.

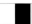

Gustave Caillebotte
Perissoires
1878. Oil on canvas
155x108
Rennes, Musée des Beaux-Arts et d'Architecture

Thanks to boat racing, Caillebotte also discovered the coast of Normandy, following once again in the footsteps of Monet in Trouville, Etretat and Honfleur, sites that are now part of the movement's history. His paintings, in which the human figure remains important, witness *Man in a Smock*, now focus increasingly on the landscape.

In 1887, he left Paris to settle in Petit-Gennevilliers. He gave up painting. He tended his garden, looked after his boats. As generous and considerate of others as always, he was elected to the municipal council of the small town. Yet for all that he didn't forget Impressionism. He saw Monet regularly, exchanging plants with his fellow gardener. He attended the dinners held at the Café Riche. And, in 1889, he confirmed the terms of his will from 1876.

Upon his death in 1894, Pissarro soberly declares, 'Here is one we can mourn. He was a good and generous man, and what is surely no blemish, a talented painter.'

Gustave Caillebotte
In a Café
1880. Oil on canvas
114x153
Rouen, Musée des Beaux-Arts

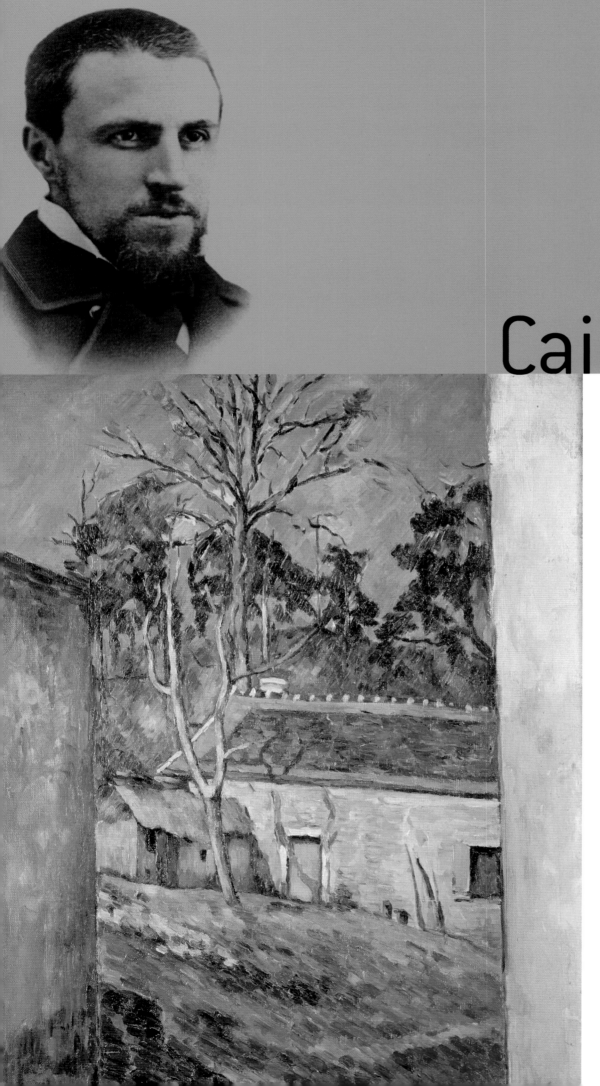

Caillebotte

Photograph of Gustave Caillebotte
Collection particulière
Photograph of Cézanne

Paul Cézanne
Farmyard at Auvers
1879-1880. Oil on canvas
65x54
Paris, Musée d'Orsay

Cézanne

For Cézanne, it was clear that Caillebotte plays an essential role in the movement, as this note makes quite plain. Cézanne is writing to Caillebotte after the death of his mother in 1878, 'Please accept in your grief both this token of my gratitude for the services you have rendered to our cause, and the assurance that I share your sorrow... My dear Caillebotte, affectionately I extend my hand to you and beg you to devote your time and your care rather to your painting now, this being the surest way to take your mind off your sadness.' And Cézanne knew what he was talking about, for Caillebotte was one of the first art lovers to take an interest in his pictures, with a self-assurance that only a true painter can possess. He purchased not only landscapes (*L'Estaque*, *Farmyard at Auvers*), and a still life (*Flowers in a Rococo Vase*), but also the *Bathers*, one of the first works—so impressive in fact that Degas made a sketch of it—in which Cézanne treated this theme without the tragic, Romantic and impassioned allusions of his early attempts. It is moreover a theme to which the painter would return again and again throughout his career. The picture was presented at the third Impressionist exhibition of 1877 in which Caillebotte, who took care of hanging the paintings, had devoted an entire wall to Cézanne, demonstrating the respect he felt for a painter who was still very much disparaged. At the same show, Cézanne also presented a portrait of Victor Choquet. Choquet, along with Caillebotte and the strange Count Doria, was one of Cézanne's first and most ardent admirers. At first a great lover of Delacroix's work, Choquet next turned his attention to Renoir, who recounted, 'As soon as I knew M.

Choquet, I thought I would get him to buy a Cézanne! So I took him to Père Tanguy's where he picked up a small *Study of Nudes*.' Renoir also introduced Monet to Choquet. At his death in 1899, this modest employee of the customs administration possessed more than 30 Cézannes, some 10 Monets and as many Renoirs. For the glory of their cause and their painting, the Impressionists well knew how to share their rare collectors.

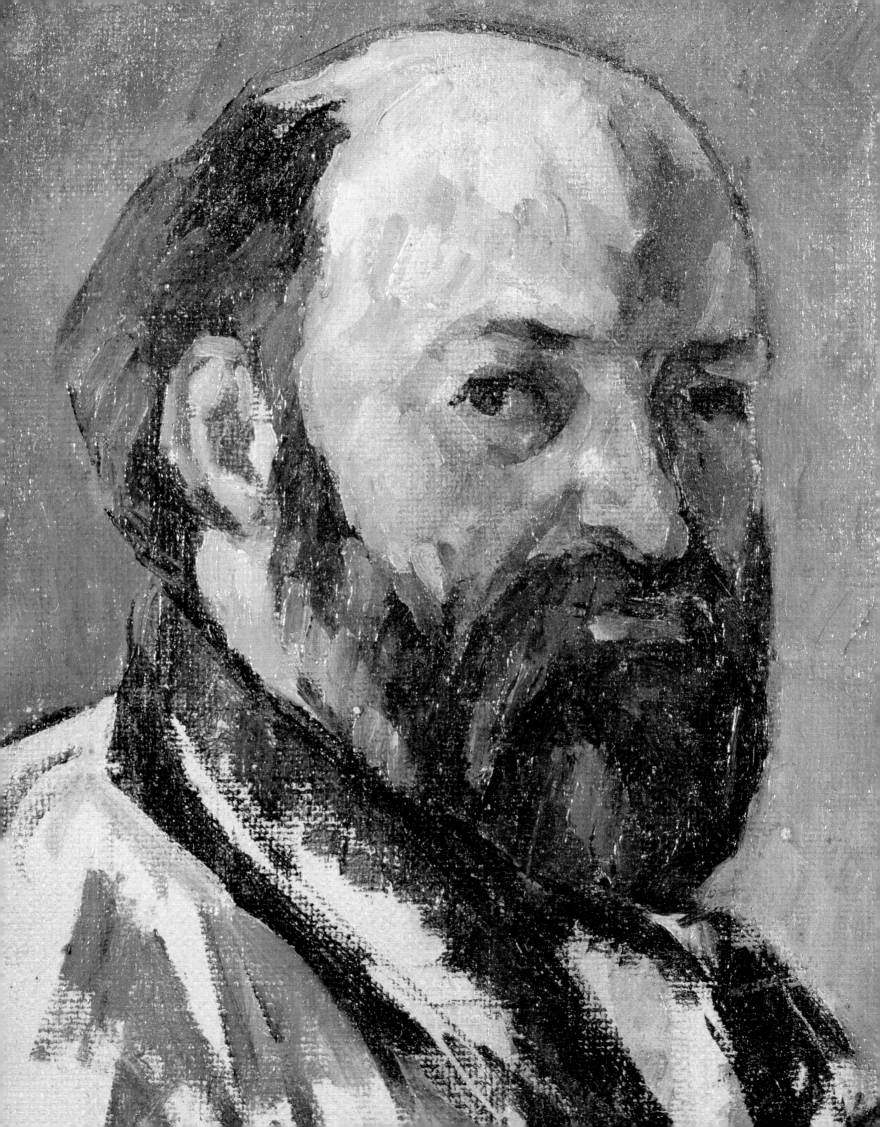

Cézanne

In 1894, Monet wrote his friend the critic Gustave Geffroy, who had just published an article on Cézanne: 'I hope Cézanne will still be here and that he will join us, but he is so peculiar, so afraid of seeing new faces, that I fear he will fail to appear, despite his great desire to meet you. What a pity this man has not had more support in his existence! He is a true artist who has come to doubt himself too much…'

That was indeed Cézanne in 1894, a figure who had retreated to his native city of Aix-en-Provence and had few ties to the art milieu of Paris, which in any case had heaped more ridicule on him than on any of his Impressionist comrades. He was unsociable because he was not understood and because he himself was wary of everyone. Cézanne, who was able to find what he continued to call throughout his life 'a small sensation,' something that was difficult to capture, difficult to render on the canvas, but no less genuine, feared that certain artists like Gauguin wanted to get hold of that discovery in order to 'trot it about on every steamer' (Cézanne). This was the same Cézanne who was to enjoy in a few months time the first tokens of his eventual recognition, thanks to the show the daring art dealer Ambroise Vollard was preparing to devote to him at his Parisian gallery. Pissarro, sharing his impressions of the show with his son, has this to say: '… while I was admiring that odd, bewildering side of Cézanne's that I've sensed for years now, in comes Renoir. My enthusiasm, however, is small beer beside Renoir's. Degas himself, who has come under the charm of that refined and wild character, Monet, everyone… Are we all mistaken? I don't think so.'

The 'odd, bewildering side of Cézanne's' that Pissarro is trying to analyze, and which makes him an artist apart in the Impressionist movement, may go back to his youth, one that was wholly given over to nature and the love of art. A childhood friend of the writer Emile Zola, he developed a keen interest in literature. Zola described those heady years in this way: "We had books in our pockets or in our game-bags. For a year Victor Hugo reigned over us like an absolute monarch […] Then one day one of us brought along a volume of Musset […] Reading Musset was for us the awakening of our own hearts. We stood there shaking." Yet it was painting that Cézanne devoted himself to, leaving literature to his friend. Their friendship was essential, and for many long feverish years one did not advance in his field without the other. Zola, for example, confided to Cézanne in 1860, 'I had a dream the other day. I had written a beautiful book, a sublime book that you had illustrated with beautiful, sublime engravings. Our two names shone in gold letters, united on the first page and in that fraternity of genius they passed, inseparable, into posterity.' For the passage from the dream of making art to the reality of the craft,

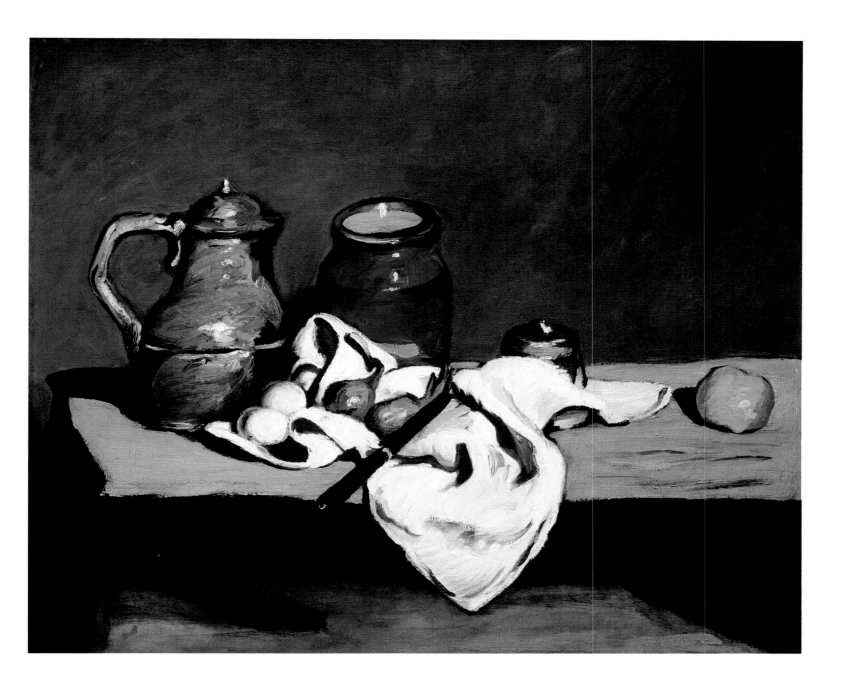

Paul Cézanne
Still Life with Kettle circa
1869. Oil on canvas
64.5x81.2
Paris, Musée d'Orsay

however, each was on his own. Cézanne had a hard time convincing his father, an honorable banker in Aix, to let him study painting in Paris, where Zola was already living. Finally, with great difficulty he obtained a small sum with which to study. He joined his friend in 1861 and registered for courses at the Académie Suisse, where he met Pissarro and Monet. He copied many paintings at the Louvre and took the competitive examination to enter the École des Beaux-Arts, but without success.

Throughout the years of his training, Cézanne interrupted his stay in Paris with long visits to Provence. Like his Impressionist friends, he endured repeated rejection by the Salon jury and felt very much a part of their ostracism of the young artists who had already formed a group. In 1867, the year of the initial hopes for an independent exhibition, he wrote to his parents, 'Annoyed by my "Salon," the jury has shown the door to all those who are following the new way.' Like his friends, he was an habitué of the Café Guerbois. Monet recalled that there Cézanne affected the

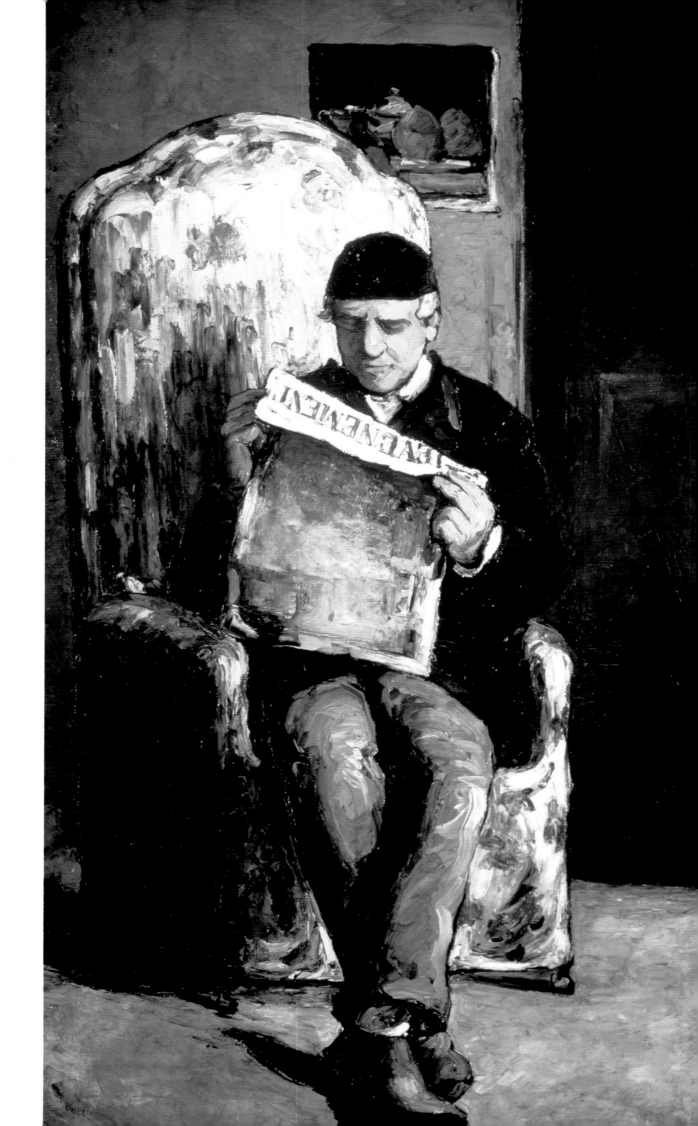

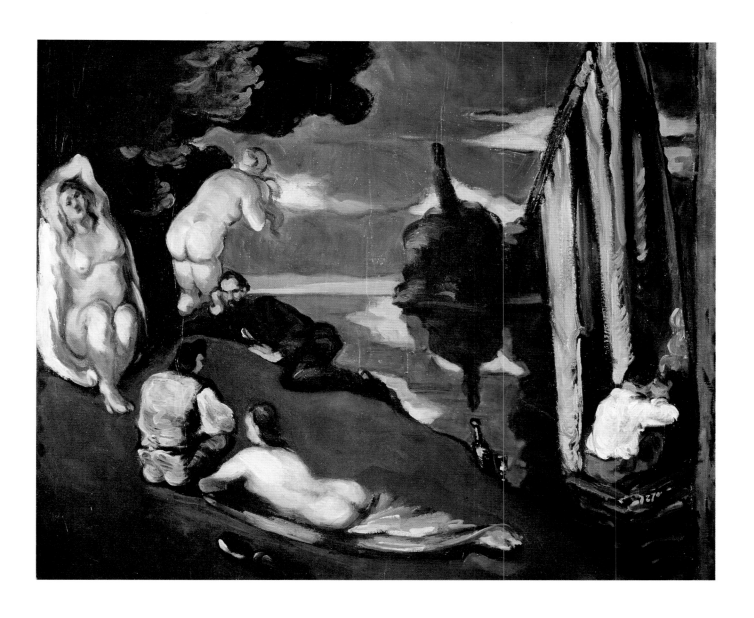

Paul Cézanne
**Portrait of Louis Auguste Cézanne,
the Artist's Father**
1866. Oil on canvas
200x120
Washington, National Gallery of Art

Paul Cézanne
Pastoral
1870. Oil on canvas
65x54
Paris, Musée d'Orsay

manner of the *zingueur*, the café regular, announcing to Manet in his southern French accent, 'I won't shake your hand, Monsieur Manet, I haven't washed in a week.' Behind this attitude, which Cézanne maintained to the end of his days, lies all of the painter's honesty with regard to his art. His attitude is seen in this letter he sent to Zola: 'Inside the artist there are two men, the poet and the workman. One is born a poet, one becomes a workman. And you who have the spark, who possess that which cannot be acquired, you complain when you need only work your fingers, need only become a workman, in order to succeed.' The same sentiment is found in a note he himself wrote to the superintendent of the Beaux-Arts in 1866 to protest the organization of the Salon and demand a juryless show 'open to all serious workers,' as well as in these words at the end of his life: 'You have to be a workman in your art [...] To be a painter by way of the very qualities of painting. To make use of unrefined materials.' There is also the timidness inspired by Manet, who was defended by Zola with such brilliance, and whom he sincerely admired, even if he judged that Manet hasn't enough 'harmony and temperament.' His early paintings, moreover, evinced that same admiration. Witness the still lifes, solidly built up with intense blacks and greys (*Still Life with Kettle*); the

massive, monumental portraits that are full of color (*Portrait of Louis-Auguste Cézanne, the Artist's Father, Portrait of Achille Emperaire*), and above all the scenes and fantasies (*Pastoral, A Modern Olympia*). Although inspired by the *Déjeuner sur l'herbe,* these last-mentioned pieces go far beyond their model thanks to an exaggerated Romanticism that does not exist in Manet's work, a Romanticism that turns even violent in *The Murder* and *Abduction*. Cézanne also executed, quite in keeping with the new painting, several group portraits that express all the hopes and dreams of friendship (*Paul Alexis Reading a Manuscript to Emile Zola*), and the passion for books and music (*Girl at the Piano*).

Cézanne spent the years 1870-1871 (the years of the Franco-Prussian War) in the small village of l'Estaque near Marseille in the company of Hortense Fiquet, a relationship that he took pains to conceal from his father. Later he would say of that time: 'During the war I worked a great

Paul Cézanne
The Murder
1867-1870. Oil on canvas
64x81
Liverpool, Walker Art Gallery

Paul Cézanne
Girl at the Piano (Overture to Tannhaüser)
1869-1871. Oil on canvas
57x92
Saint Petersburg, Hermitage Museum

deal directly from life in l'Estaque… I divided my life between landscape and studio painting.'

In 1872, Cézanne began anew with Salon refusals and petitions calling for change. At the same time he discovered the village of Auvers-sur-Oise, where he settled in August of that year with Hortense and their son Paul. He spent two years there and returned in 1879, staying until 1882. Encouraged by Camille Pissarro, he worked increasingly from life. Everyday he went on foot to join Pissarro in Pontoise and from there the two set off together into the countryside. In these moments of working together, he calmed his tormented brushstrokes and brightened his palette, but above all he gained greater confidence in himself. He wrote to his mother, 'I know Pissarro has a good opinion of me, who have a good opinion of myself…' He also acquired the definitive conviction that a painter must work from nature, which he would repeat to the end of his life: 'But I always come back to this: The painter must devote himself entirely to the study of nature […] One cannot be too scrupulous, or too sincere, or too subject to nature…' (to Emile Bernard, 1904). Despite working closely with Pissarro, he kept his originality. He did not divide his brushstrokes, a technique that the other painter readily practiced, but continued to lay down large grainy strokes that gradually build up and overlap one another, creating relief and underscoring several of the composition's prominent lines. He persisted, moreover, in painting the Romantic scenes—dark, passionate, enigmatic—of his first canvases (*Afternoon in Naples* and *The Eternal Female*), only now his work was

becoming brighter and more fluid, benefiting, despite its purely imaginary character, from his new-found fondness for light.

Cézanne's double originality—a thick, structuring brushstroke and imaginative subjects—was brilliantly revealed in the work he submitted to the first Impressionist show of 1874. He presented *The House of the Hanged Man* and *A Modern Olympia*. No other painter was attacked as much as he. In the eyes of one critic he appeared to be 'like some sort of madman, agitated while painting *delirium tremens*.' Another writes: 'Shall we speak of M. Cézanne, who has his legend, moreover? Of all the known juries, none has ever, not even while dreaming, glimpsed the possibility of accepting any picture by this painter, who came to the Salon bearing his canvases on his back like Jesus Christ carrying His cross.' The image is not far from the truth.

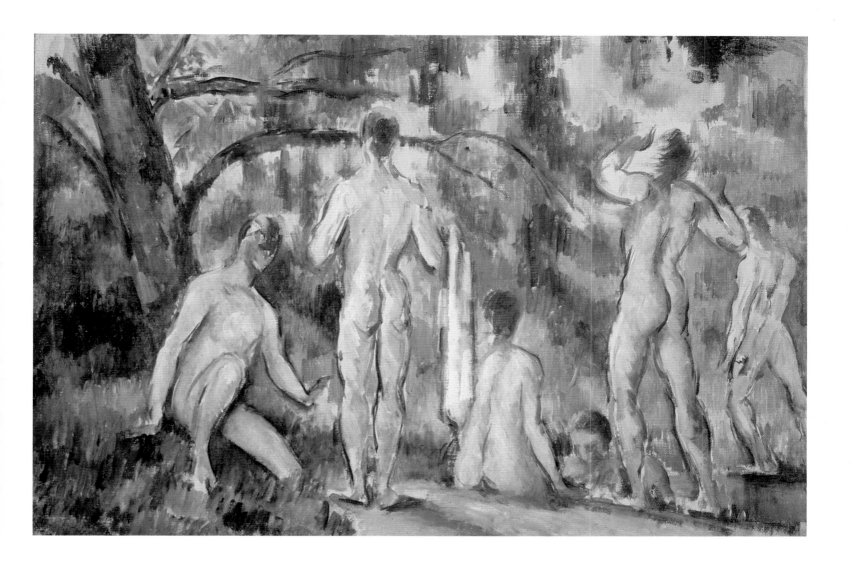

Paul Cézanne
The Bathers Resting
1875-1876. Oil on canvas
82x101.2
Merion, The Barnes Foundation

Paul Cézanne
Study of Bathers
1890. Oil on canvas
26x40
Moscow, Pushkin Museum

The following year, Cézanne abandoned the Impressionists and returned to the Salon, where his work was refused yet again. No matter, it was at the 'Bouguereau Salon' that Cézanne was eager to prove himself. Nevertheless, he made one last, magnificent appearance at the third Impressionist show of 1877, the exhibition at which Caillebotte was keen to display Cézanne's sixteen paintings to advantage. These included several landscapes of course, some of which were executed in l'Estaque over the preceding months. *The Bathers* also figured in the show. Springing from the pastorals and the *déjeuners sur l'herbe*, the 'luncheons on the grass,' being done at the start of the 1870s, this theme gained its independence and for a time shed its pathos and obscure literary allusions. The theme seems to point back to childhood memories, but only in part. Male and female bathers were one of the ways Cézanne intended to 'make Impressionism a solid art like the art of museums.' Nudes and landscapes, classic elements of the art of painting, were tirelessly revised—and reworked directly from nature—by Cézanne, who was looking to capture, not the fleeting as Monet does, but the permanent and the immutable. This approach can be seen in a landscape like *The Château at Médan* (1879-1880), which once belonged to Gauguin. In this composition, Cézanne lends the trees, river and sky the very same tactile force he imparts to the houses (including Zola's—Cézanne was the novelist's guest

Paul Cézanne

The Château at Médan

1879-1881. Oil on canvas

59x72

Glasgow, Art Gallery and Museum

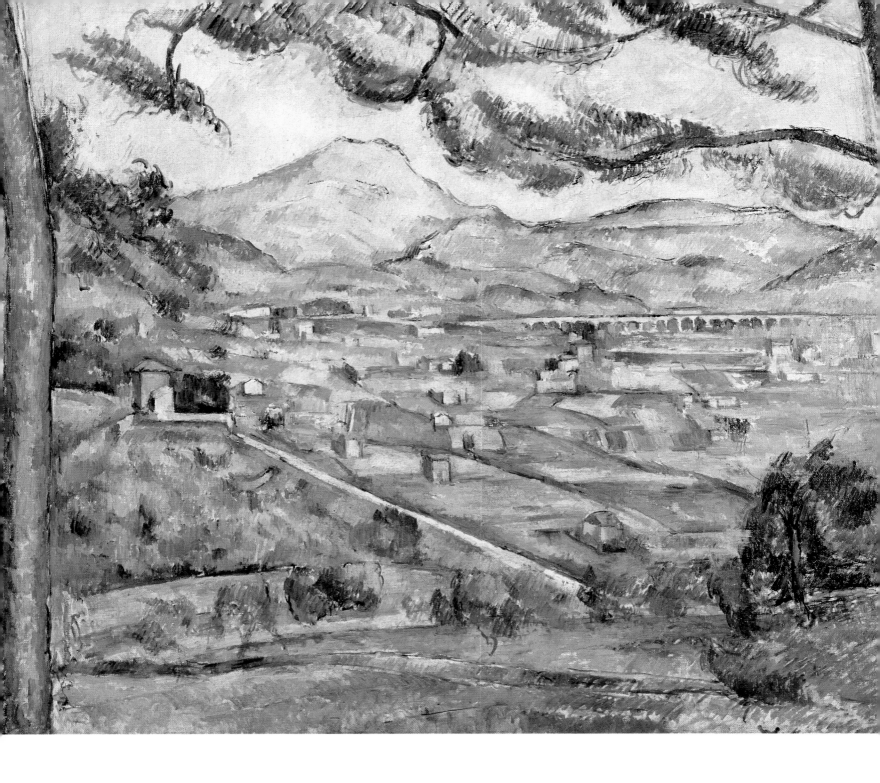

at the time) while letting the air freely circulate in the work's compact and profoundly balanced space.

That is probably why Cézanne quickly turned away from the Impressionist shows and stubbornly tried his luck with the Salon. He wanted to place his art within a tradition other than the one embodied by the Academy of his day and age, the tradition of Poussin's and Le Brun's era. From 1879 to 1881, every one of the canvases he submitted was rejected. In 1882, however, the painter Guillemet dug up a picture that had been refused earlier and which can now be shown. Zola relates this episode in his 1886 novel devoted to the art milieu, *L'Œuvre*. The story's two heroes, Claude Lantier, the painter, and Pierre Sandoz, the writer, are based upon Cézanne and Zola: 'It was a custom, the members of the jury were allowed an "act of charity," each of them could choose from the pile

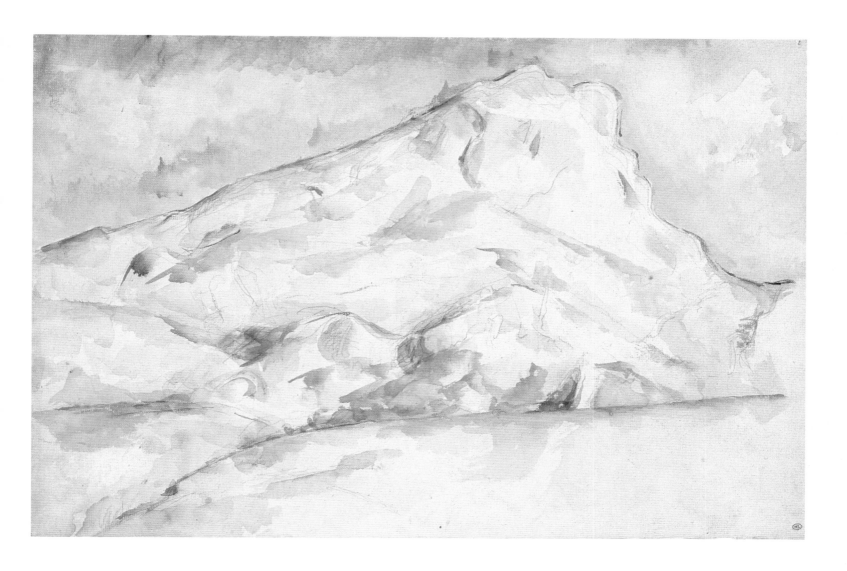

Paul Cézanne
Mount Sainte-Victoire with Pine Tree
1885-1887. Oil on canvas
60x73
Washington, Phillips Collection

Paul Cézanne
Mount Sainte-Victoire
1900-1902. Pencil, gouache and watercolor on paper
31x47
Paris, Musée du Louvre, D.A.G. (Fonds Orsay)

one canvas, however execrable, which was thus accepted without being examined. Ordinarily, the charity of this admission went to the poor. Those forty individuals who were rescued at the eleventh hour were the beggars at the gate, those who were allowed to sidle up to the low end of the table, hunger gnawing at their gut.' Cézanne would not forgive Zola this betrayal of their friendship, this public admission of his lack of faith in the painter's art, this inability in the end to understand painting. It was a betrayal that reinforced his wish to be alone.

In 1886 Cézanne's father died. The artist inherited Jas de Bouffan, the family residence, and a comfortable sum that forever placed him above all material constraints. He now put in place the artistic experiments he would pursue until his death: the landscape painting, dominated by Mount Sainte-Victoire; the portraits, which he doggedly had his wife, Hortense, and a few friends sit for over and over; the still lifes, modest or elaborately developed like baroque compositions; the male and female bathers; the card players. Only a few stays in the Ile-de-France region and Switzerland occasionally interrupted the dialog that the painter maintained day in and day out with the landscapes around Aix.

Mount Sainte-Victoire, which fills the horizon to the south of his native town, had already appeared in the background of the 1877 *Bathers*. It now became an independent motif, observed for its

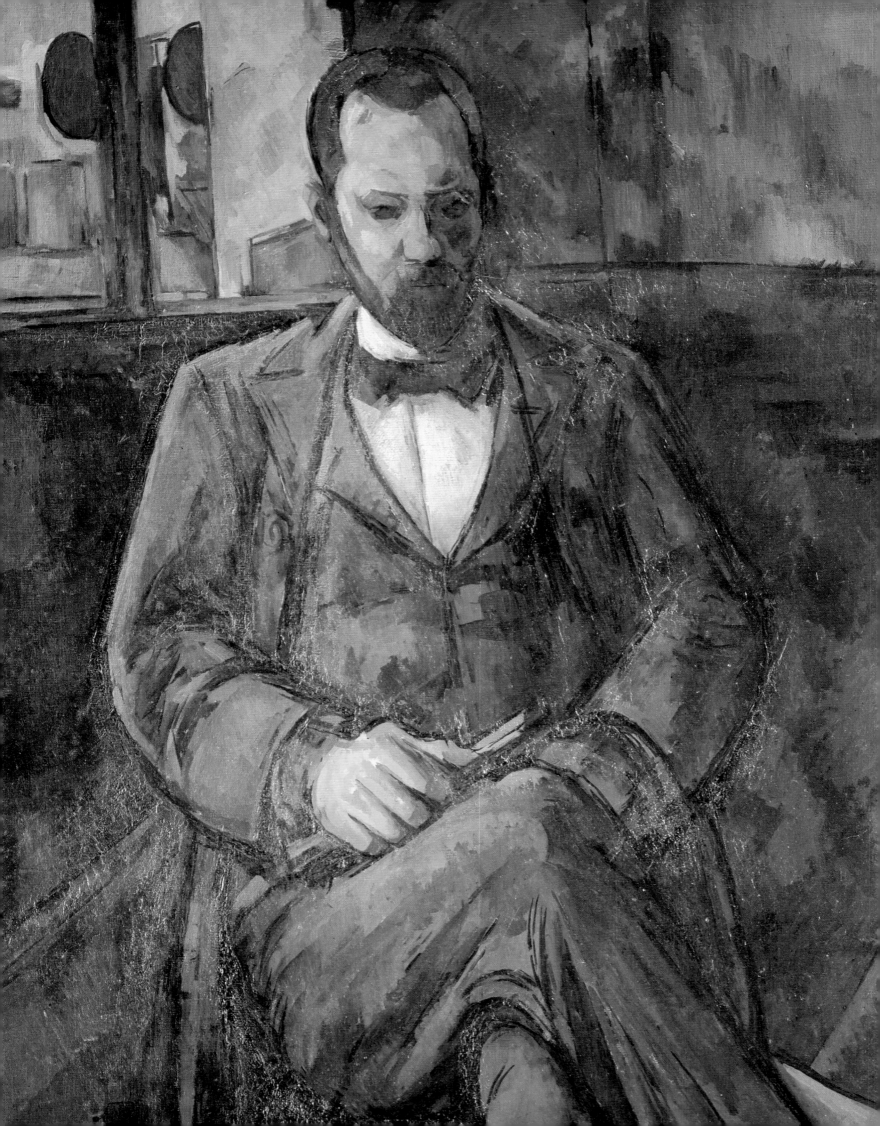

grandeur alone. Over time, as Cézanne devoted himself to the motif, he eliminated all the narrative elements from the landscape. The road, viaduct, houses and figures of *Mount Sainte-Victoire as Seen from Bellevue* (1882-1885) are absent from *Mount Sainte-Victoire with Pine Tree* (1886-1887). And soon the trees themselves will disappear, leaving room for that mysterious swelling of the earth's crust, that construction that is always uniform and inaccessible in the endless play of its myriad facets. Moreover, as Cézanne reworked his motif and drew closer to it (he even had a studio built on the hills above the town in order to be more quickly in front of the mountain), color disappears, too, in favor of the white surface of the canvas or paper (*Mount Sainte-Victoire as Seen from Les Lauves*). However, before limiting his world to the environs of his studio in Les Lauves, Cézanne continued to wander on foot about Aix's surroundings. He settled for a time in Gardanne, a small place with stiff upright houses marshaled about the town church, lingered around the pigeon house of Bellevue and Château noir, returned to l'Estaque, forsook the sea to concentrate on the shore rocks, and searched the quarries of Bibémus to find the same rockslides, the same massive chance constructions that expressed the mute power of nature.

Cézanne's portraits are subjected to the same rigorous construction in which each stroke of the brush seems to have its importance, contributing to the overall balance of the work. The art dealer Vollard posed for him in 1899. Maurice Denis noted the torture of those sittings, 'Vollard has been posing every morning at Cézanne's for ages. As soon as he moves, Cézanne complains that he has made him lose his *line of concentration*. He also speaks of his lack of *optical qualities*; of his powerlessness to work like the old masters (Poussin, Veronese, Le Nain, he also likes Delacroix and Courbet), but he thinks he has *sensations*. To train himself to paint in the morning, he strolls around the Louvre or the Trocadéro in the afternoon and draws stat-

Paul Cézanne
Portrait of Ambroise Vollard
1899. Oil on canvas
100x81
Paris, Musée du Petit Palais

Paul Cézanne
Man Naked
1895. Graphite
13.3x21.7
Paris, Musée du Louvre, D.A.G. (Fonds Orsay)

ues, either ancient ones or Pugets, or he does a watercolor out of doors. He claims that in this way he arranges everything in order to see well the next day. If the day is sunny, he complains and does little work: He needs a *grey day*.' The term 'sensation' defines the whole significance of Cézanne's work, a definition that holds for the landscapes as well as the portraits. Over and over the artist told the growing number of individuals making their way to his door, 'To read nature is to see her beneath the veil of interpretation through patches of color that come one after the other according to a law of harmony... To paint is to record her colored sensations.'

We might see in this relentless effort to create a sensation of color Cézanne's forsaking of the subject, which had become obsolete with respect to the act of painting. Yet concealed in the permanence of his themes, and the doggedness with which he came back to them again and again without end, were the same dramas and questions of his youth. He struggled to find an adequate pictorial language for rendering the fears that had plagued him since his earliest days, not a literary language, which is what Zola no doubt blamed him for, but a painterly one. Thus his piles of skulls were as much the recording of a visual sensation by the eye and the mind, as a translation—already sketched out in his first still lifes—of the fear of death. And the *Bathers* of his last years, which are neither male nor female, and appear calmer than those painted in his youth, express the desire to live, the ideal fusion of man in nature.

Cézanne said, 'You must... know early on your method of working,' and 'to work without worry of anyone and become good, such is the aim of the artist... The artist must disdain opinion that is not based on intelligent observation of character. He must fear the literary mind...' In that regard, beginning in the late 1860s, he was beyond Impressionism and its concerns, he was in another, vaster story, one to which he devoted a life of doubt, experimentation and hard work. A few weeks before dying from the pneumonia he contracted while painting out of doors, he wrote, 'I work doggedly, I have glimpsed the Promised Land. Will I be like the great leader of the Hebrews, or will I be able to enter there?'

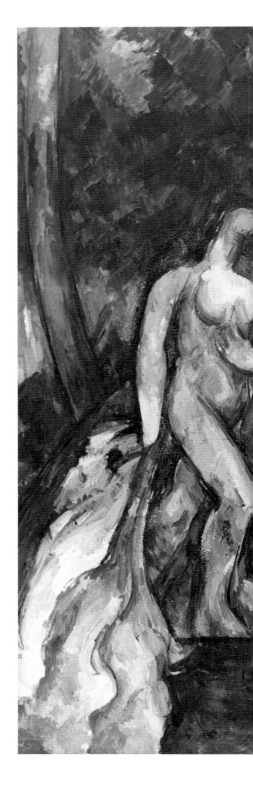

Paul Cézanne
Big Bathers
1900-1905. Oil on canvas
82x101.2
Merion, The Barnes Foundation

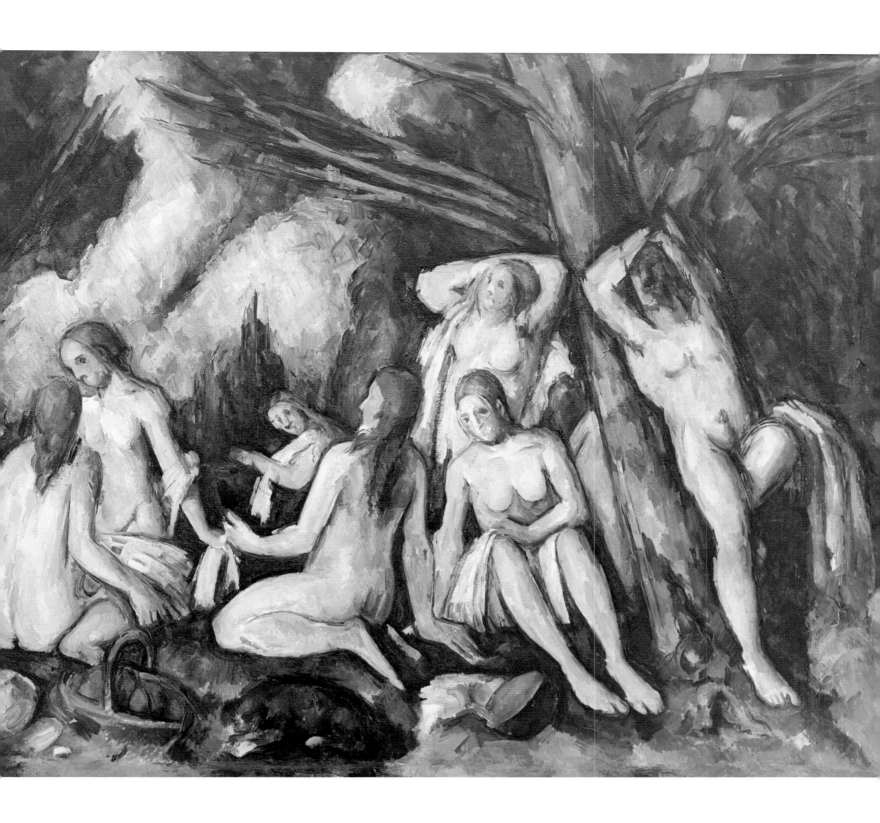

Cézanne

Pissarro

'As for old Pissarro, he was a father to me. He was a man to consult and something like God,' wrote Cézanne, and indeed, in the course of two two-year periods, the two men shared a great number of their motifs near Auvers-sur-Oise and Pontoise. Photographs show them all kitted out and harnessed up as they set off together for the countryside. They chose this region west of Paris because of its differences with Argenteuil, that other stronghold of Impressionism where Monet was living. Pontoise, where Pissarro settled in 1866, Auvers, where Cézanne lived and worked from 1873 to 1875, and later from 1879 to 1882, and their surroundings offer landscapes untouched by industrialization and the expansion of leisure activities while remaining not far from Paris thanks to the railroad. There they found landscapes that were preserved, still quite rural, with little farmhouses built of traditional tuff stone, dales, orchards, fields and twisting lanes. The place names in French, Côte de Jallais, L'Hermitage, La Maison du pendu and so on, smack of that rustic flavor that also seems to permeate Pissarro's and Cézanne's very canvases with their balanced, dense compositions and heavy, thick brushstrokes.

It was probably that rural aspect, along with the presence of the painter Daubigny and a desire to flee all the dangers to health that attended modern urban life, that convinced Doctor Gachet to live in Auvers. And it was probably Doctor Gachet who commended the area's charms to Pissarro in turn. A passionate admirer of painting and prints, he readily drew the region's artists to his home. Cézanne and especially Pissarro first tried their hand at printmaking with him, for example. Vincent Van Gogh decided to settle in Auvers in 1890 because Gachet was living there. Finally, because Pissarro was in Pontoise, Gauguin came there in the early 1880s to paint the region's harsh, modest nature. With these two artists, at several years distance, Impressionism gained a heritage.

Photograph of Pissarro and Cézanne

Paul Cézanne
Portrait of Doctor Gachet
1872-1873. Charcoal, stump drawing
on brown/gray paper
32x21
Paris, Musée du Louvre D.A.G. (Fonds Orsay)

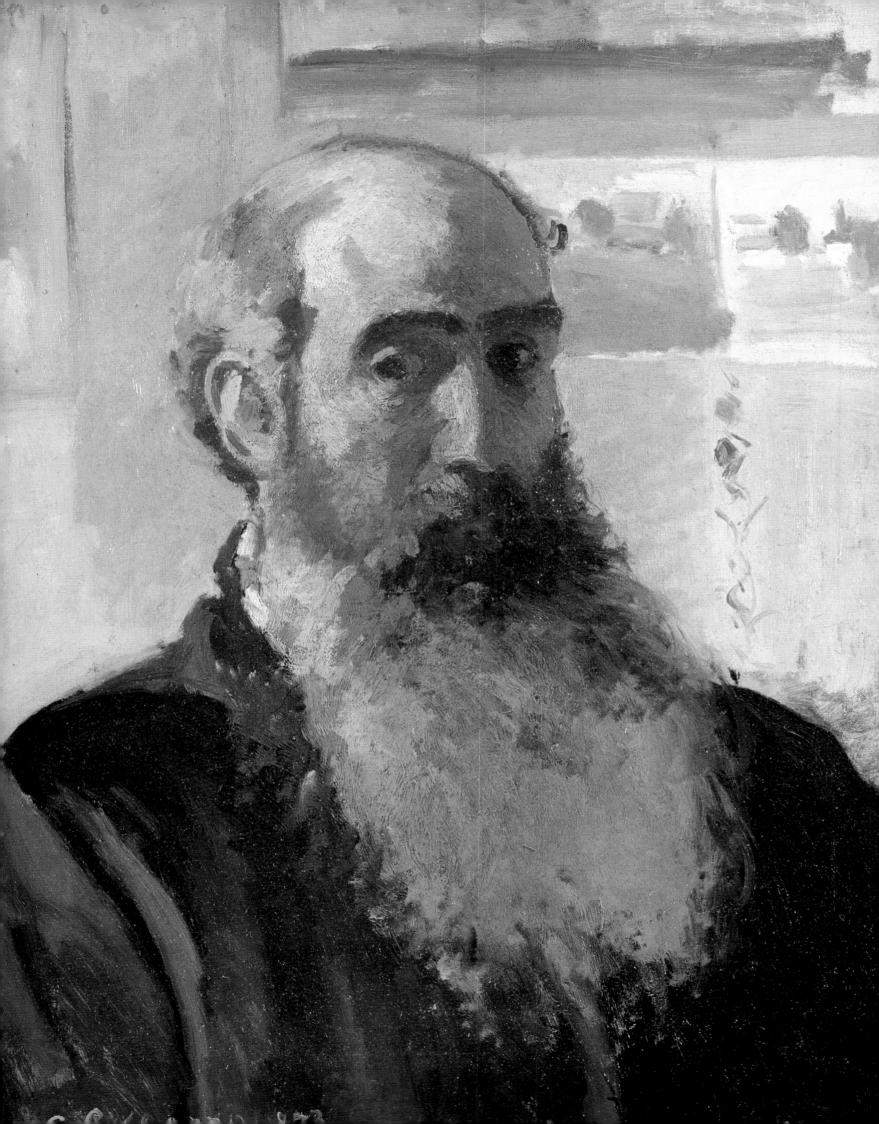

8 Pissarro

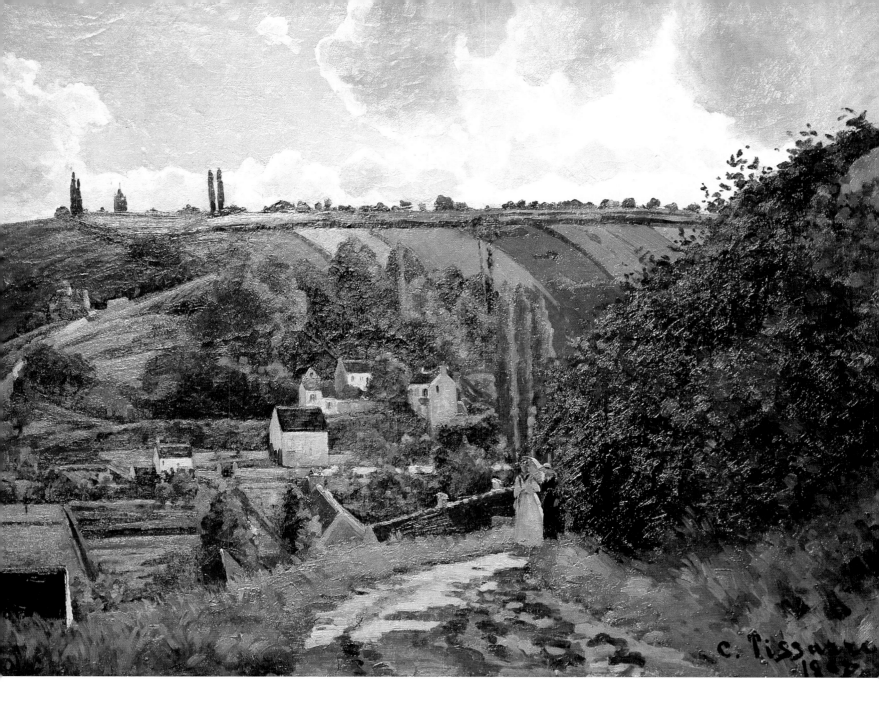

Born in 1830, that is, two years before Manet and ten years before
Monet, Pissarro came to Impressionism in a roundabout way, taking the
time to practice landscape painting in a good number of styles. He was to
experience the Romantic landscape and the Naturalist landscape, which
appeared in the 1830s with Corot (whose student Pissarro long pro-
claimed himself to be and who advised the young Pissarro to paint directly
from nature) and other artists of the Barbizon School like Chintreuil. In
1859, although he was just shy of his 30th year and had already shown a
few works at the Salon, he entered the Académie Suisse. Was landscape
painting not enough for the artist? Did he feel the need to renew his style,
which at the time was still somewhat somber and lacking in breadth?

For Pissarro was not merely a landscape painter, even if landscapes
make up the lion's share of his repertory. There is always in his pictures a
human dimension which he tends to allow more space for. Above all he
questioned his work, sought new avenues, experimented, never consid-
ered a method or skill as definitively mastered. He was on the lookout for

Camille Pissarro
Self-portrait
1873. Oil on canvas
56x46.7
Paris, Musée d'Orsay

Camille Pissarro
Hillside at l'Hermitage, Pontoise
1873. Oil on canvas
61x73
Paris, Musée d'Orsay

Camille Pissarro
Jallais Hill, Pontoise
1867. Oil on canvas
87x114.9
New York, Metropolitan Museum of Art

new things and was always happy to see young talent bloom. At the Académie Suisse, he met first Monet and then Cézanne, and was soon part of the group of artists who come together at the Café Guerbois to question the organization of the Salon. In 1866, he presented at the Salon *Banks of the Marne, Winter*. Unlike every one of his works submitted until then—all completely ignored—this painting was written up by Zola and Castagnary, the two critics of the new movement. Zola wrotes in particular: '… You should know that you are pleasing no one and that people find your painting to be too raw and too dark. And why the devil do you have the glaring clumsiness to paint solidly and study nature frankly! Consider this, you choose winter weather; you have here a simple stretch of avenue, then a hillside in the background, and empty fields as far as the horizon. Not the least treat for the eye. An austere, grave painting, an exacting concern for truth and accuracy, a will that is harsh and strong." Despite his warm fellow feeling, Zola only managed to make this landscape an otherwise remarkable work of art thanks to its absolute austerity.

Nevertheless, Pissarro's works very quickly took on the breadth and power they lacked. In Pontoise, he seemed to discover the bright monumentality that had escaped him until then. *Jallais Hill, Pontoise, The Hermitage at Pontoise* and *The Hermitage* (N.Y., Guggenheim), executed

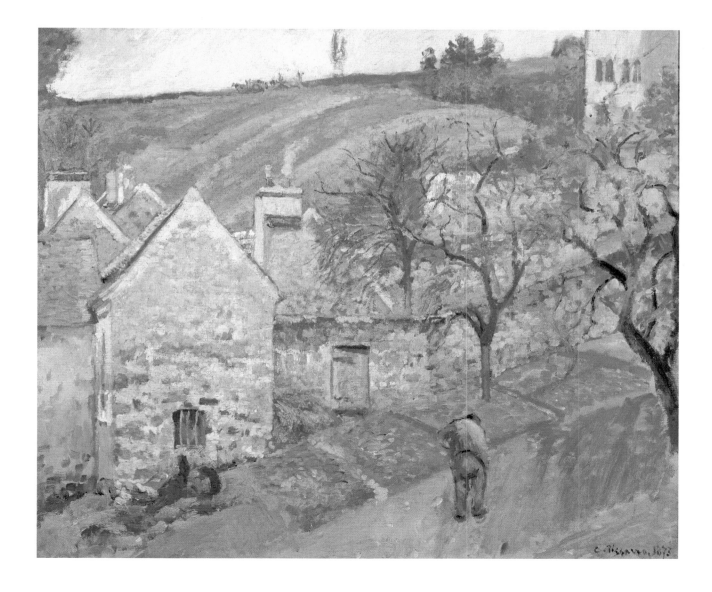

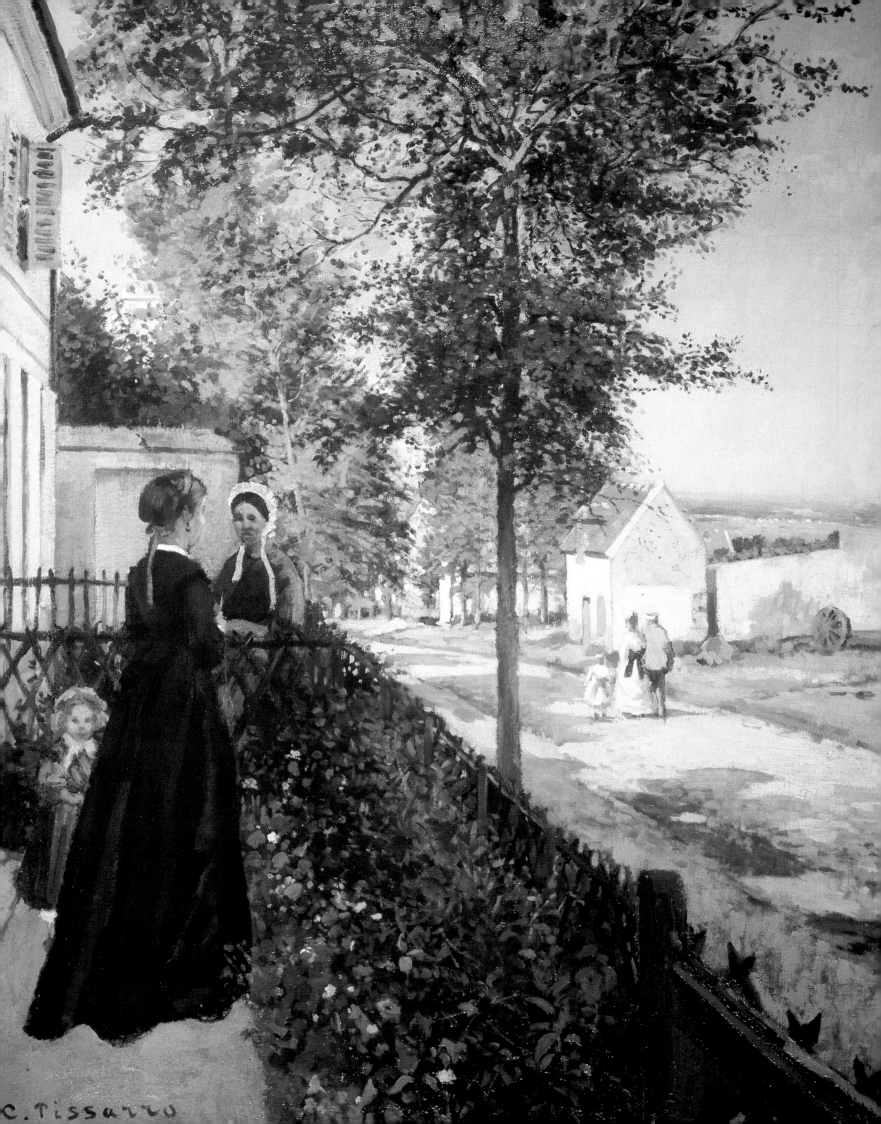

between 1867 and 1868 and shown at the Salons of 1868 and 1869, offer compositions that are both solid and more daring, and colors that glow at last. Pissarro enlivens his scenes with the silhouettes of peasants, some of whom possess the grace of Monet's figures. In fact he was coming under the influence of Monet, which was further reinforced by his settling in Louveciennes in 1869—witness *The Road from Versailles to Louveciennes* (Zurich, Bührle). Despite this lighter inspiration and interest in the transience of the moment, Pissarro kept his remarkable ability to structure his pictures. This was probably due to his systematic use of drawings done from nature, a device he inherited from the Barbizon painters, and employing the technique helped him to construct his paintings. Zola at last found his bearings in this 'modern countryside. It feels as though man has been through here, digging around in the ground, carving it up, lending the skyline a mournful aspect. And this dale, that hillside show a true simplicity and heroic candor. Nothing would be more banal if it were not so grand. The painter's temperament has drawn from ordinary truth a rare poem of life and power.' Thus Pissarro was endowed with all the qualities of an Impressionist.

In 1870 the painter, a Dutch national who already had a wife and two children in tow, could not join the French army and had to go into exile in London. There he was in contact with Durand-Ruel and studied the English landscape artists Constable and Turner in Monet's company. Following his return to France in 1871, he had to abandon Louveciennes, his house having been pillaged during the war, and settled in Pontoise. He was joined by Cézanne, with whom he would work practically everyday for two years. Neither of the two is a student of the other, even if Cézanne declared himself to be 'Pissarro's pupil' in his final years. Pissarro, for his part, had a high opinion of Cézanne's art. He even recommended his comrade to the art critic Duret, 'As soon as you begin looking for rare birds, I think Cézanne should satisfy you, because he has quite strange studies and views that show a unique treatment.' It is that feeling of equality and respect that dominates Pissarro's 1874 *Portrait of Cézanne*. The piece constitutes a response to Manet's own *Portrait of Zola*. Behind Cézanne hang caricatures of Thiers and Courbet and a small painting by Pissarro. The artist is posed in the clothes he wears as an outdoor painter. In their face-to-face encounter, Pissarro and Cézanne seem to offer us their common vision of what painting is: no pose, no discourse, but modesty and honesty on the artist's part with respect to nature. Through his contact with his younger friend, Pissarro does transform his style somewhat. He uses a thicker brushstroke, which he occasionally applies with the palette knife. And like Cézanne, he concentrates once again on the lasting aspect of the landscape and its ruggedness. Summing up this artistic marriage, Pissarro wrote to his son Lucien in 1895 that Cézanne 'came under my influence and I his.'

It was with one of those paintings, *Hoarfrost*, a spare, grating work, that Pissarro caught the attention of Louis Leroy during the 1874 show. The newspaper critic continues his dialog with Impressionism, writing, 'So these are furrows, this is frost? These are palette scrapings evenly posed on a dirty canvas. You can't make head or tail, or front or back, of it.' In fact, the picture is particularly daring, a compact work with its horizon line placed so high it seems to tip the composition over and a technique that is

Camille Pissarro
The Road from Versailles to Louveciennes
1870. Oil on canvas
100x81
Zurich, Bührle Collection

Camille Pissarro
Avenue de l'Opéra: Sunshine, Winter Morning
1880. Oil on canvas
73x91
Reims, Musée Saint-Rémi

literally one with the subject. The other paintings by Pissarro were more classically organized and the artist was generally hailed by the Naturalist critics, who nevertheless criticized him for the vulgarity of his subjects and the fact that he does not 'shy from any representation of cabbages and domestic vegetables' (Castagnary). Pissarro had been quite involved in mounting this event, and he would be the sole Impressionist to take part in the eight shows, preaching along with Degas complete intransigence with respect to the Salon and the absolute independence of the artist. He is the link then between Degas's group and the more fluid one that had formed around Monet.

In 1877, Pissarro contributed a large canvas, *Le Jardin des Mathurins*, to the group's third show. Quite balanced and filled with light, the painting manifests once again Monet's influence, the latter artist having just presented various views of his house in Argenteuil at the preceding exhibition. The brushstrokes, however, show greater delicacy and attention paid to the complementarity of colors. Yet despite this attempt to produce a gentler, more graceful and delicate painting, Pissarro continued to struggle with a lack of success and the perpetual shortage of money. In 1878, he wrote to his friend the critic Théodore Duret, 'Business is also pitiful. Soon I shall be old, my eyesight weakened, I shall see myself as far along as I was twenty years ago.' It was perhaps these difficulties that led him to change his painting. Already in 1875 Duret was encouraging him to paint figures and animals. He no doubt wanted to nudge the painter along the path left vacant by Millet (an artist with whom certain critics were already comparing Pissarro). Millet had just died and his work was enjoying a runaway success after the artist himself had led a hard, impoverished existence. We must also read in this significant evolution the dual influence of Degas, whom Pissarro had grown closer to in the late 1870s, and Gauguin, who had come seeking his advice in 1878. In the early 1880s then, Pissarro was painting large peasant figures that totally overwhelm the bits of landscape or the interiors that set them off. Solitary, as in *Shepherdess* (1881), *Rest* and *The Little Country Maid*, and grouped in twos, as in his picture of peasant women keeping the cattle, Pissarro's figures multiply innumerably in *The Market at Gisors* of 1885. At the same time, he tightened his brushstrokes, which now completely speckle the canvas and reinforce the figures' lines. This new, realist approach over-

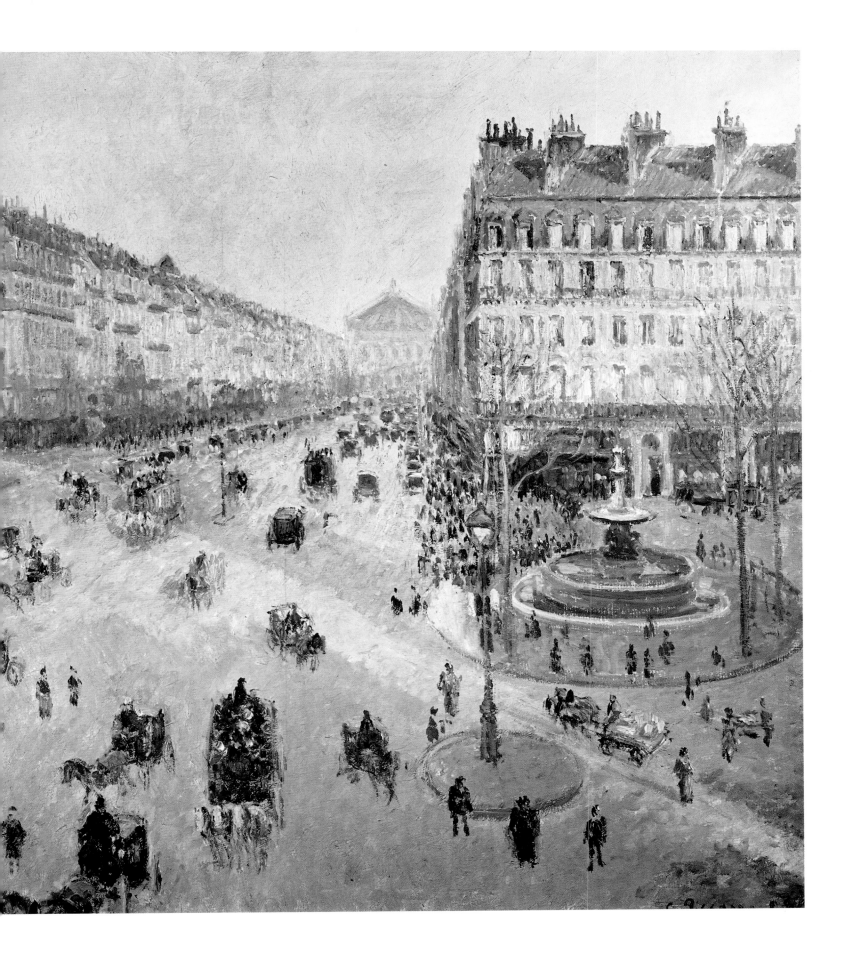

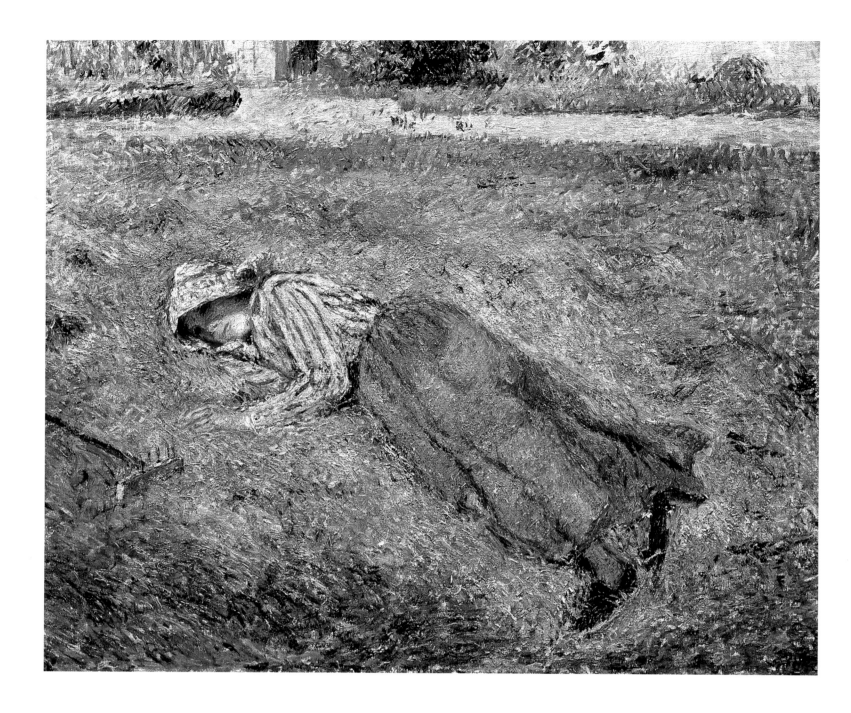

joyed the critic Huysmans at the 1881 show: 'Mr. Pissarro can now be classed among the remarkable and daring painters that we possess. If he can keep that eye of his, so perceptive, agile and discerning, we shall certainly have in him the most original landscape artist of our age.' But it was especially the year 1882 that revealed the full extent of Pissarro's work with the human figure. That year he exhibited, for example, *Study: Outdoor Figure, Sunlight Effect, Young Peasant Woman Taking her Morning Coffee*, and *Peasant Girl with a Straw Hat*, which Ernest Chesneau hailed in the following terms: 'Since Millet, no one else has observed and depicted peasants with this forceful vigor and precise and personal vision.'

Pissarro's evolution explains his adherence to neo-Impressionism in late 1885. He was attracted by the ideas of his young friends Signac and Seurat, whom he met in the fall of that year. Not only did he adopt their way of working brushstrokes and color, and recognize the need to lend

Camille Pissarro
Young Peasant Woman Lying on the Grass, Pontoise
1882. Oil on canvas
64.5x78
Bremen, Kunsthalle

Camille Pissarro
The Little Country Maid
1882. Oil on canvas
64x53
London, Tate Gallery

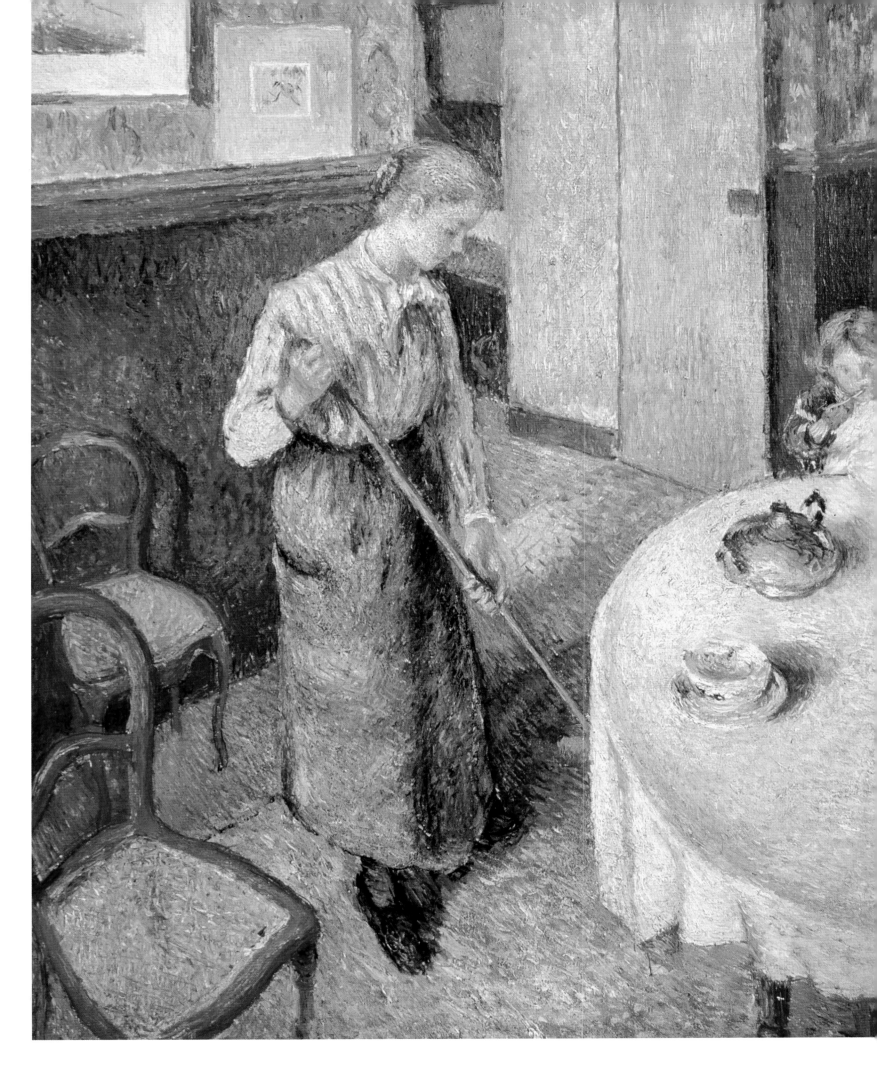

greater force to drawing, but like them he now believed in the importance of the subject. Finally, he embraced their anarchist ideas. The neo-Impressionists were overjoyed with this recruit for he confirmed their theory that neo-Impressionism was the logical and inevitable continuation of Impressionism, which they saw as marred by a threefold shortcoming: it was not scientific, it dissolved drawing and along with it the human figure, and it generated a blameworthy individualism. In 1886, Pissarro, the new convert, opened Impressionist shows to his friends. He himself presented his Divisionist canvases, *Apple Picking at Eragny-sur-Epte* and *View from the Artist's Window at Eragny*. Fénéon showed himself favorable to this new style, but Pissarro's allegiance to neo-Impressionism was poorly understood and met with little acceptance. His new loyalties provoked stormy debates in the Impressionist group, which no longer formed a single entity, moreover. The rare admirers of his work balked at his latest experiments, and these took so long to carry out, moreover, that his output abruptly slowed down, diminishing by the same token the number of works he could sell.

Bitter, he changed direction— 'having tried out that theory for four years and having given it up with no little trouble and grinding work in order to regain what I had lost and not lose what I had managed to learn,' as he explains his disaffection in 1896. Yet Pissarro's Divisionist works figure among his most beautiful creations—solid, radiant, harmonious and inspired by a Symbolist feeling that lends them a poetry his work had never previously achieved.

Thus, Pissarro returned to the Impressionism in the early 1890s, taking up one of the major themes of the 1870s, the urban landscape (*Avenue de l'Opéra: Sunshine, Winter Morning, Rue de l'Epicerie, Rouen, Place du Carrousel,* etc.), with a technique likewise dating from the 1870s.

Pissarro, a painter's painter, remains the artist who opened up Impressionism opening up and shared it with others. Gauguin, one of those he guided and imparted the lesson of Impressionism to, affirmed that very judgment: 'He watched everyone else, you say, and why not? Everyone else watched Pissarro, too, but disowns him.'

Camille Pissarro
The Market at Gisors
drawing
19.9x14,1
Paris, Musée du Louvre D.A.G. (Fonds d'Orsay)

Camille Pissarro
Apple Picking at Eragny-sur-Epte
1888. Oil on canvas
60x73
Dallas, Museum of Art

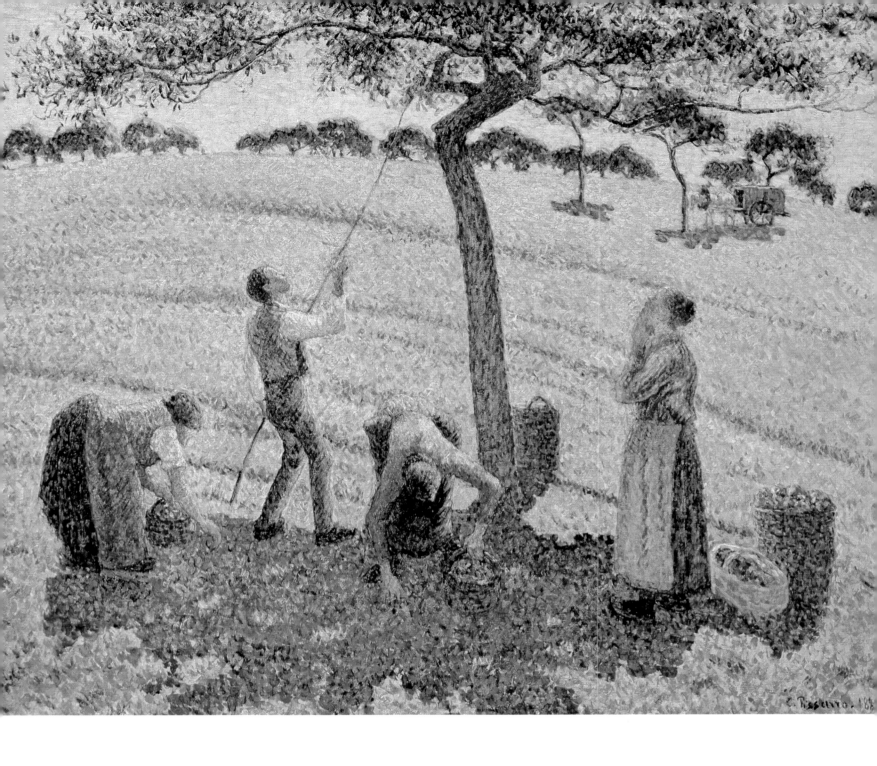

Camille Pissarro
View from the Artist's Window at Eragny
1888. Oil on canvas
65x81
Oxford, Ashmolean Museum

Pissarro

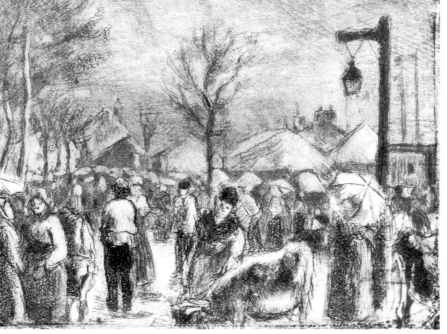

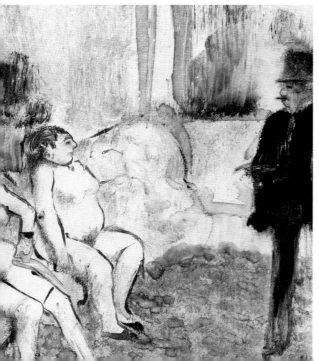

Photograph of Pissarro

Albert Bartholomé: **Photograph of Edgar Degas sitting in a garden, circa** 1889-1890
Paris, Musée d'Orsay

Camille Pissarro
Fair at Saint-Martin, Pontoise
1879. Print
16x11.9
Paris, Bibliothèque Nationale, Cabinet des Estampes

Edgar Degas
The Client
1879. Monotype with black ink on white paper
22x16,4 cm
Paris, Musée Picasso

Degas

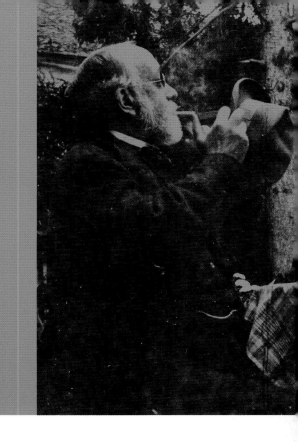

At first glance, it is difficult to find points in common between Pissarro, a Jewish anarchist, and Degas, an anti-Dreyfusard. No doubt they shared a certain esteem for each other's work, as a few declarations on the part of both artists make clear. Pissarro, for example, said, 'I am on the best of terms with him. He is a dreadful man, yet frank and loyal… He would be prepared to give me a leg-up just as he has already done on many an occasion.' And Degas, who purchased a landscape by Pissarro in 1873 for his personal collection, had this to say, 'Pissarro's peasants look like angels on their way to the market.' Above all, they shared an interest in printmaking that took concrete form between 1879 and 1880 with their joint work on a review devoted to the technique, *Le Jour et la Nuit*. The publication, which the Impressionist movement was lacking until then, was conceived in these terms: '*Le Jour et la Nuit* will have no text; it will offer a booklet containing drawings more or less, which will be accompanied by a brief profile of the artist' (*Le Gaulois*). Degas and Pissarro, as well as Cassatt, Forain, Rouart and Bracquemond, all experienced printmakers who were close to Impressionism to one extent or another, had a hand in the venture. Caillebotte bankrolls the enterprise in part.

Unfortunately, despite the talent of the participating artists, who provided several original prints, *Le Jour et la Nuit* never becomes a reality. Mary Cassatt, for one, gave way to despair and blamed Degas who, 'as always, when the time had come, wasn't ready, so that *Le Jour et la Nuit*, which might have been a great success, hasn't seen print yet. Degas… made them miss a great opportunity.' Nevertheless, this undertaking remains one of Impressionism's finest stories despite its failure. Common ground for artists who were quite distant from one another, the aborted review was a locus of feverish experimentation for Pissarro and Degas, a poetic moment, and a fleeting hope to win over new art lovers and take the movement in new directions.

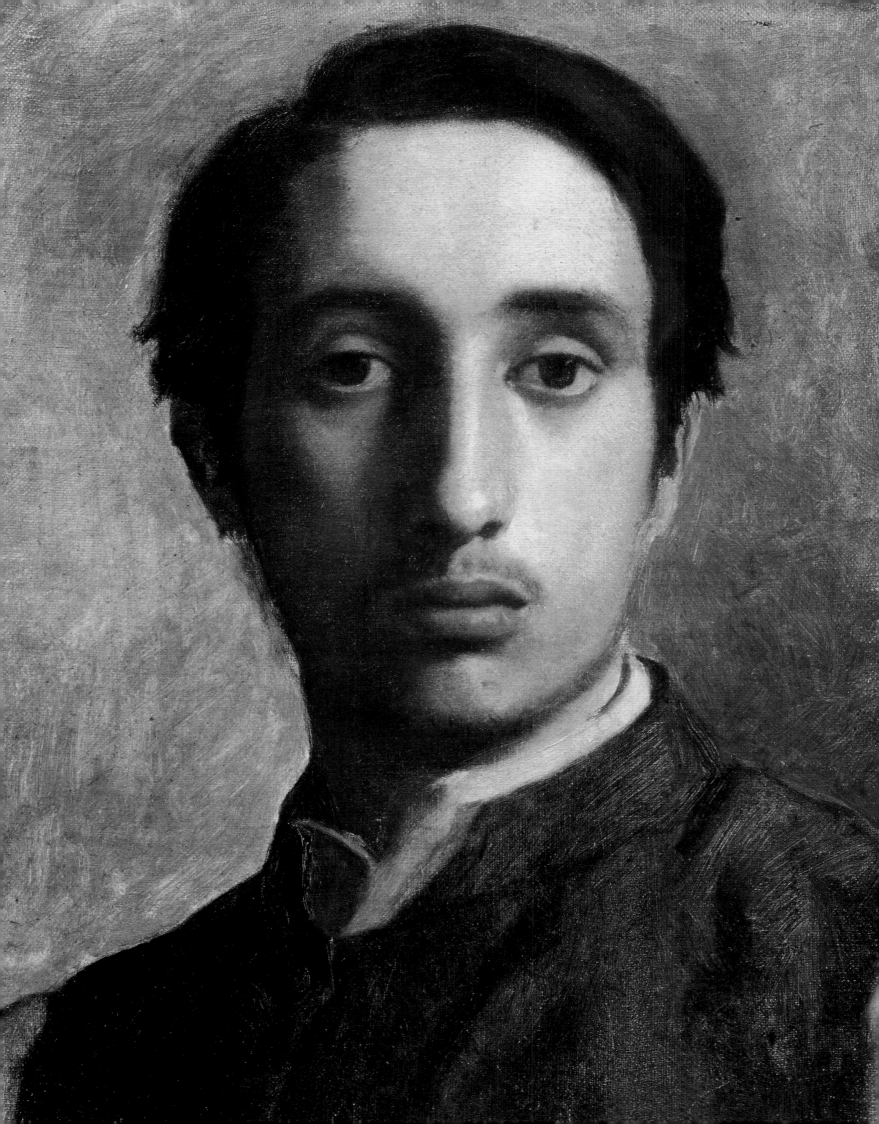

9
Degas

Previous pages:
Edgar Degas
Degas in a Green Waistcoat
1856. Oil on canvas
40x31
Private collection

Edgar Degas
Portraits in a New Orleans Cotton Office
1873. Oil on canvas
74x92
Pau, Musée des Beaux-Arts

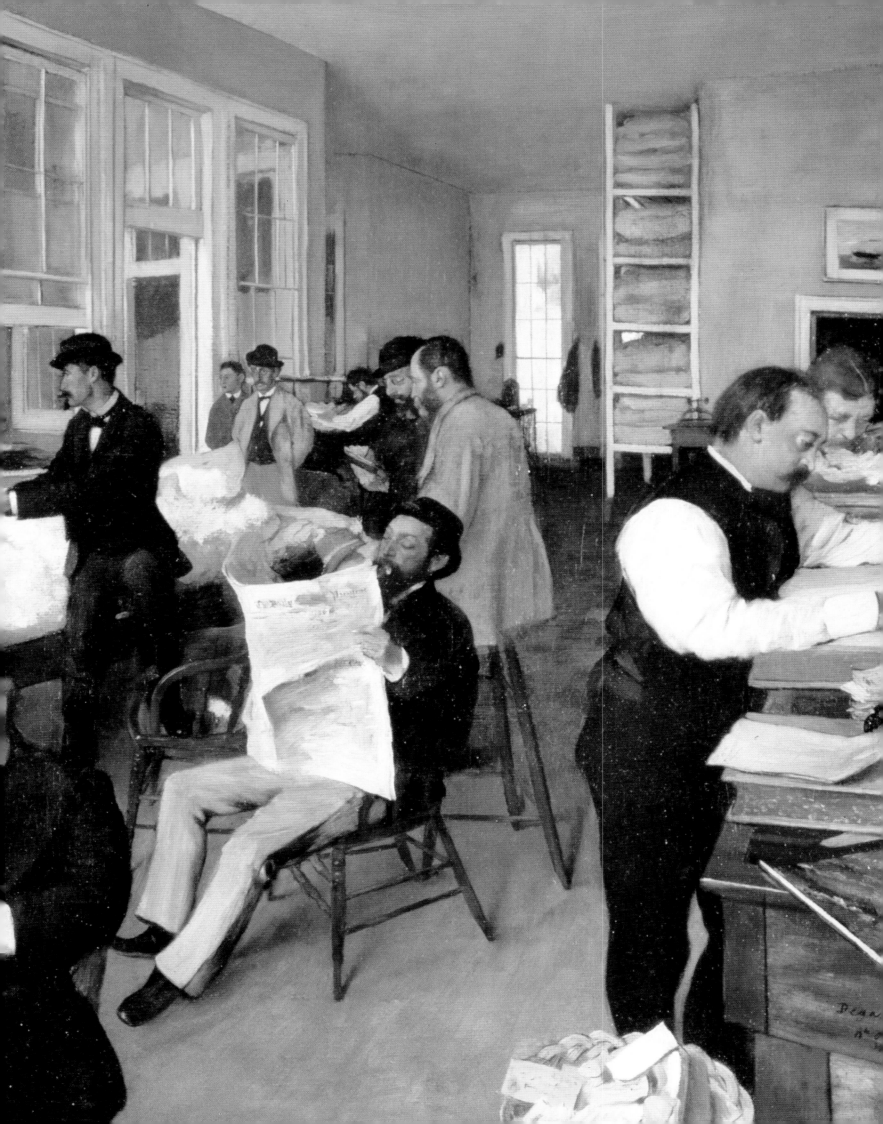

Degas, with respect to Monet—Cézanne left the movement too early on—embodies the other pole of the Impressionist movement, i.e., modernity and those who do not consider landscapes to be painting's major concern but rather hold that the figure is its main object, who refuse to lose the line in favor of the impression. Degas likewise represents those who demand intransigence vis-à-vis official art.

Between these two poles, each of the Impressionists shifted back and forth, coming under the influence of one or the other depending on the artist's own aspirations. Even Manet was situated somewhere between the two, close to Monet, whose experiments he immediately picked up on, and Degas, who is nearly his contemporary and who shared with him a passion for modern humanity. Degas and Manet, who came from family backgrounds that were quite close, met in the galleries of the Louvre in 1862. Between the two there existed a rivalry, however, Manet affirming in particular that 'Degas was painting Semiramis when [he] was painting modern Paris.' Indeed, the path toward realist, modern painting is long in coming to Degas's attention for he was slow to abandon the academic model of art. His training was more classical, even if he paid no mind to the École des Beaux-Arts, what with copying pictures at the Louvre and studying at the studio of the very sober-minded Louis Lamothe. He ended his art studies, moreover, with an endless voyage in Italy that closely resembles the study trip traditionally taken by winners of the Grand Prix

Edgar Degas
Semiramis Building Babylon
1861. Oil on canvas
151x258
Paris, Musée d'Orsay

Edgar Degas
Spartan Girls Challenging Boys
1860-1862. Oil on canvas
109x155
London, National Gallery

de Rome. And Degas was careful to make a holy pilgrimage to Ingres in 1855 and again in 1864.

The first major works by Degas are history paintings with subjects borrowed from Antiquity and later history, *Semiramis Building Babylon*, *Spartan Girls Challenging Boys* and *Medieval War Scene*. In each of these works, however, Degas reveals a number of contradictory interests and passions: subjects that are displaced or rarely treated in the history of painting; latent or obvious violence; the influence of Moreau (Degas's traveling companion in Italy), Ingres, Delacroix, Puvis de Chavannes and the Italian primitives; and an almost morbid passion for the human body. Degas was an artist driven by questions about his art. His brother wrote in 1864, 'Edgar is always working enormously without seeming to. What is fermenting in that head is tremendous. For my part, I think, am even convinced that he has not only talent, but genius even. Only will he express what he feels?' As for Degas himself, the artist sighed, 'Ah! Giotto! Let me see Paris, and you, Paris, let me see Giotto!' giving voice to the hard time he had in choosing between a classic heritage and the life of his day and age.

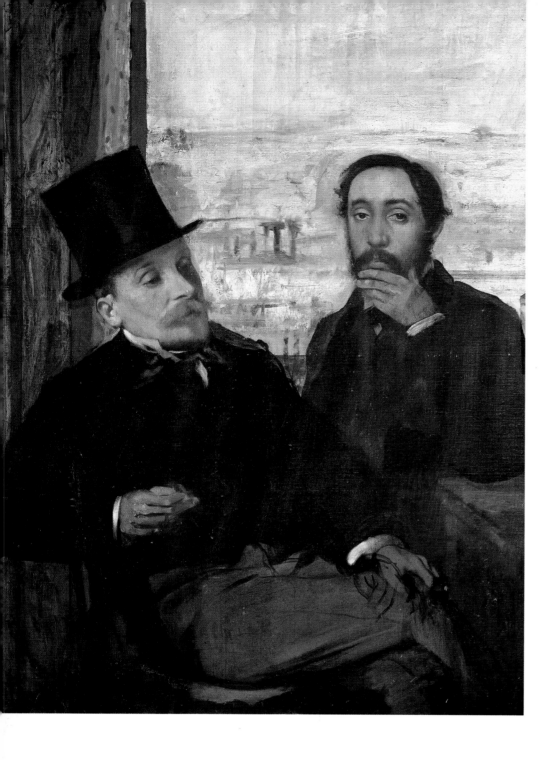

Edgar Degas
**Degas and Evariste de Valernes,
Painter and a Friend of the Artist**
1864. Oil on canvas
116x89
Paris, Musée d'Orsay

Edgar Degas
Orchestra of the Paris Opera
1868-1869. Oil on canvas
56.5x46
Paris, Musée d'Orsay

Degas was not in fact completely closed to the world around him. He executed, for example, an increasing number of portraits of his extensive family. Some of these works were treated with the breadth and monumentality of formal portraiture (*The Bellelli Family*), which does not exclude their containing the makings of possible genre scenes. Degas, who knew his models perfectly, paid particular attention to capturing their character, their physical and social surroundings (where nothing is mere anecdote), and, in the case of group portraits, the nature of the ties between them (*Degas and Evariste de Valernes, Edmond and Thérèse (Degas) Morbilli…*). Certain works blithely overstep the strict status of portrait painting to become genuine historical subjects, such as Degas's *Mlle Fiocre in the Ballet 'La Source,'* a picture that forms a bridge between history painting and portraiture. On the other hand, there are canvases that become true pictures of modern life, witness *Orchestra of the Paris Opera*, which devel-

oped around the portrait of the musician Désiré Dihau, and *Portraits in a New Orleans Cotton Office*, the first painting devoted to the conventions of modern business. These paintings clearly show how Degas mixed genres and to what extent portraiture was a driving force in his shift toward the modern world. Thus, *Sulking*, or even *The Rape* seem to have begun as portraits. On the other hand, the figures in his paintings play out a scene that the painter captures without striving to make us grasp it. Clearly, by the end of the 1860s, Degas seems to be putting into practice the system of exploring the world that Duranty will explain a few years later, 'With a back, we want a temperament, an age, a social standing to be revealed; through a pair of hands, we must express a magistrate or a businessman; through a gesture, a whole series of sentiments. Physiognomy will tell us that this one is for sure a steady, spare and meticulous man, while that one is the very embodiment of carelessness and disorder. Attitude will inform us that this figure is off to a business meeting while this other one is returning from a tryst… If we consider in turn the figure either in his room or in the street, he is not always equidistant from two parallel objects, in a straight line; he is more cramped on one side than the other by the space; in a word, he is never at the center of the canvas, the center of

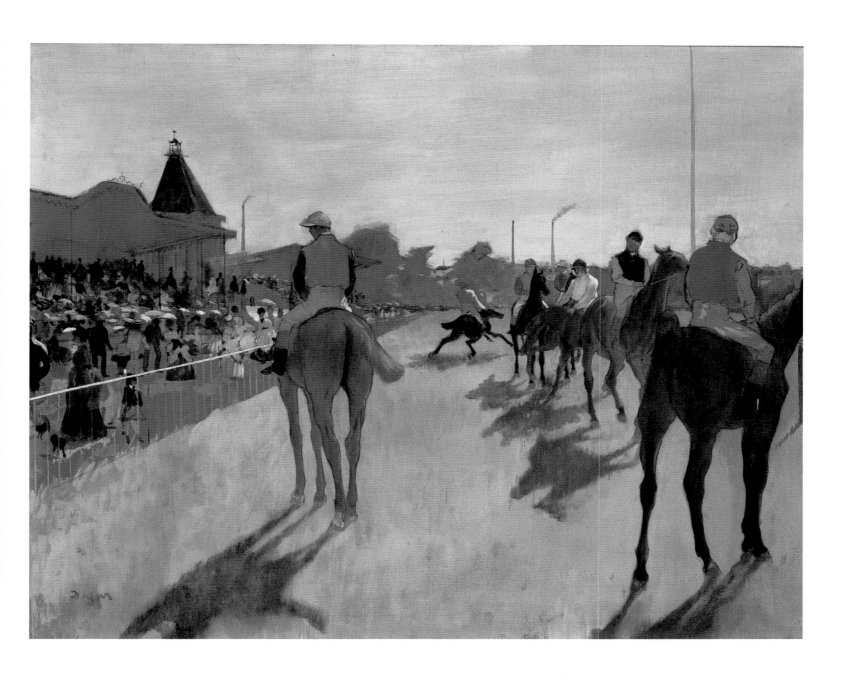

Edgar Degas
The Rape
1868-1869. Oil on canvas
81x116
Philadelphia, Museum of Art

Edgar Degas
**At the Race Course, Horses
Before the Stands**
1866-1868. Oil on canvas
46x61
Paris, Musée d'Orsay

the setting. He does not constantly show himself in his entirety; sometimes he appears cut off midway up his legs or at the waist, or sliced longitudinally.' The artist does not deviate from these rules throughout the 1870s (*Diego Martelli*) and 1880s when he continues to execute numerous portraits. He also begins to paint his racetrack subjects in the mid-1860s (*At the Race Course*, *The False Start*...), featuring horses and riders on the one hand, and the worldly spectators crowding the stands on the other. It is also around this time that the first paintings of dancers and women ironing start to appear.

In his particular way then, Degas was wholly involved in the movement that favored the new painting when war broke out between France and Prussia in 1870. During the conflict he bravely took part in the defense of Paris. It was in his 'particular way' because he eventually made several radical choices in painting, opting for modern life and the city; because he was a latecomer to that rallying point of the future Impressionists, the Café Guerbois; and because he exhibited only very

rarely at the Salon, where his works were completely overlooked. Manet of course, but also Monet, Renoir and Pissarro had already made a reputation for themselves by this time. Thus his taking part in the adventure of exhibiting independently was probably due to both his failure to attract attention at the Salon and the organization of the event itself, which he denounced while proposing improvements to it in the same breath (greater space between works, a mix of paintings, drawings, etc.) in an 1870 letter addressed to the Salon's jury and published in the *Paris-Journal*. What was at stake for Degas was finding a way to exhibit his type of realist, modern painting in the best conditions, i.e., far from all the genres he held in contempt (academic, belated Romantic as well as naturalist). In 1874 he stated unambiguously, "The realist movement no longer needs to *struggle* with the others. It is, it exists and it must be shown apart. There *has* to be *a realist Salon*."

Thus, in 1874 Degas found himself among the exhibiting artists who had gathered at Nadar's studio along Boulevard des Capucines. He presented racing scenes (*The False Start, At the Races in the Country*...), ballet scenes (*Dance Exam, Rehearsal of the Ballet on the Stage*...) as well as a laundress (*Washerwoman*). His works were seen at last. The critic Burty shrewdly noted, 'Would M. Degas be, in his day, a classic? It is impossible to find a surer draftsman to translate the feeling of modern elegance.' Prouvaire also quite shrewdly observed that one of his paintings 'improves singularly by being illuminated by an artificial light,' while Claretie affirms that "the most remarkable of these painters is M. Degas.'

From 1874 to 1881, Degas never gave up trying both to make the Impressionist shows exhibitions of realist art, and to impose his views on the entire group of participants. He was grumpy, ironic, gruff, in a word, intransigent. He brought to the group new members who shared his realist crusade and called down eternal damnation on the heads of Renoir, Monet and Sisley as soon as they turned their attention to the Salon. He was very much involved when paintings were being hung and above all exhibited daring, forceful works of art that revealed year after year both his

Edgar Degas
Woman Ironing
1869. Oil on canvas
92x74
Munich, Neue Pinakothek

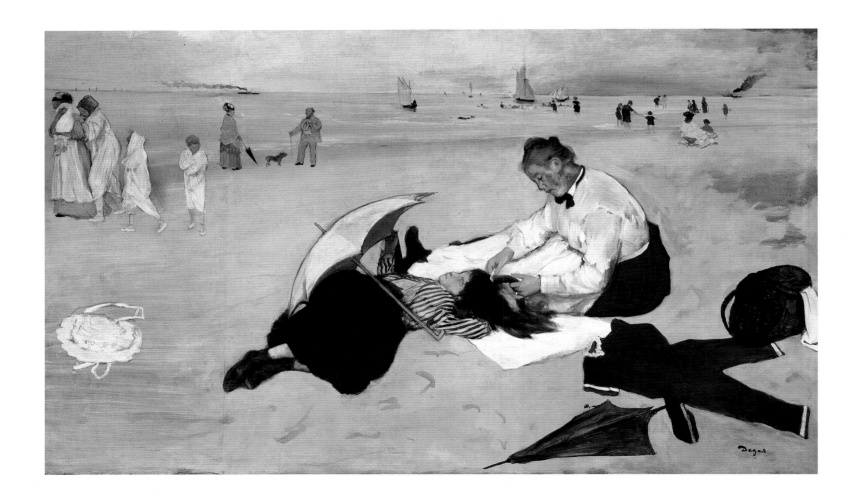

technical curiosity and his freedom with respect to the medium. In 1876, for example, he showed works as well as photographs of some of his output. In 1877, he sets aside an entire room for himself and, satisfied, explicitly stated that it is 'for me alone, filled with my things.' His 'things' were once again ballet scenes and two extraordinary beach views entitled *Bains de mer, petite fille peignée par sa bonne* and *Peasant Bathing in the Sea at Dusk*, in which he revived his fierce passion for the female body in contemporary subjects. He also included three 'drawings done in greasy ink and printed,' in other words, monotypes that sprang from his interest in technical experimentation. That same year he experimented with the use of white frames. In 1879, Degas tackled electric lighting (he was one of the first to closely observe its effects in his works) and the color of the gallery walls. In 1881, he selected a canary yellow to highlight the works he submitted. During the same exhibition of 1881, Degas unveiled a large wax sculpture adorned with doll hair, real ribbons, a real tutu and real ballet slippers, *Little Fourteen-Year-Old Dancer*. This insatiable technical curiosity, which would also lead him to take a good number of photographs, went hand in hand with his lively interest in the behavior of his contemporaries. He invented the theme of the laundress, who becomes a model of the human condition in the late 19th century; Zola, referring to his novel *L'Assommoir*, admitted to him, 'I quite simply described some of your paintings in more than one passage in my book.' He painted and drew the chanteuses of café-concerts with their faces deformed by both the artificial light and their attempt to adopt a vivid expression, the prosti-

Edgar Degas
At the Beach
1876-1877. Oil on canvas
46x81
London, National Gallery

Edgar Degas
Little Fourteen-Year-Old Dancer
1881. Wax sculpture
h: 98 w:35.2 d: 24.5
Paris, Musée d'Orsay

tutes who plied their trade along the grand boulevards, and the little dancers, tortured by the practice of their art and likewise destined for a life of prostitution. In 1879, he attended the trial of two criminals accused of three particularly violent murders and reproduced their set faces in two works in pastel, *Criminal Physiognomy*. Worthy of the theories of Cesare Lumbroso, the two pastels were exhibited at the 1881 Impressionist show. He also turned his attention to brothels in a series of monotypes, describing their customs straightforwardly and without passing judgment, but with a touch of wit. The stock exchange, the factory (*Henri Rouart*) and the matrons visiting the Louvre (*At the Louvre*) also caught his eye. If Manet claimed to have begun painting scenes of modern Paris earlier, we must allow that Degas went much further than he, discarding any hint of philosophy or poetry, and using means that were new, direct, quick, sharp, even violent to render the world with the scientific and cruel outlook he had adopted.

So it was with alcoholism. Whereas in *Plum Brandy* Manet paints a sweet young woman that you would like to save, Degas depicts a woman adrift, whom the composition in *Absinth Drinker*, all unstable and off balance, has already damned.

Degas's outlook, however, grew gentler during the 1880s. He was famous, had his regular collectors, could reimburse the large debts his father and brother left him in the mid-1870s, and now devoted himself to his work, his paintings and his collection. While he kept all his usual themes, he now lent them greater breadth and lyricism. First of all, he developed his use of pastels, which enabled him to achieve sumptuous color effects. His way of framing an image, bold, incisive and ready to cut right through the main motifs of his works, continued to be original, although the viewpoints he adopted vary. Increasingly he used *sotto insu* or low-angle views, plunging his compositions into total spatial imprecision. He also made use of formats that were almost square and which lent the canvas or sheet of paper a kind of perfection, a calm, monumental balance. He moves in closer and closer to his subjects, tightened the frame and lost himself in the spaces he created, rather like the approach used by Monet working his pool of water lilies over and over again.

All of the works that Degas devoted to milliners between 1882 and 1886 clearly show this evolution in his style. *At the Milliner's* (NY Met.) is very much a narrative painting that describes the faces and gestures a client makes while trying on her new hat, whereas the final pastel on this theme overlooks the narrative aspect and offers rather a colorful riot of ladies' hats decorated with ribbons and blooms. The composition, saturated with dense, mat colors, rises in defiance of the rules of perspective,

Edgar Degas
Women on a Cafe Terrace
1877. Pastel
54.5x71.5
Paris, Musée d'Orsay

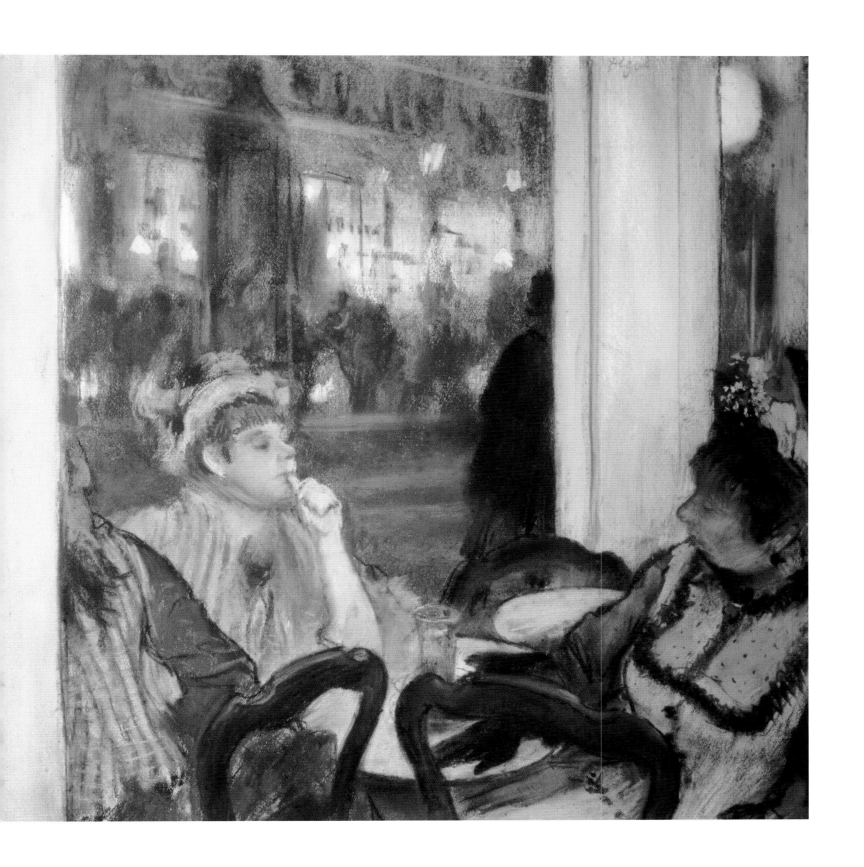

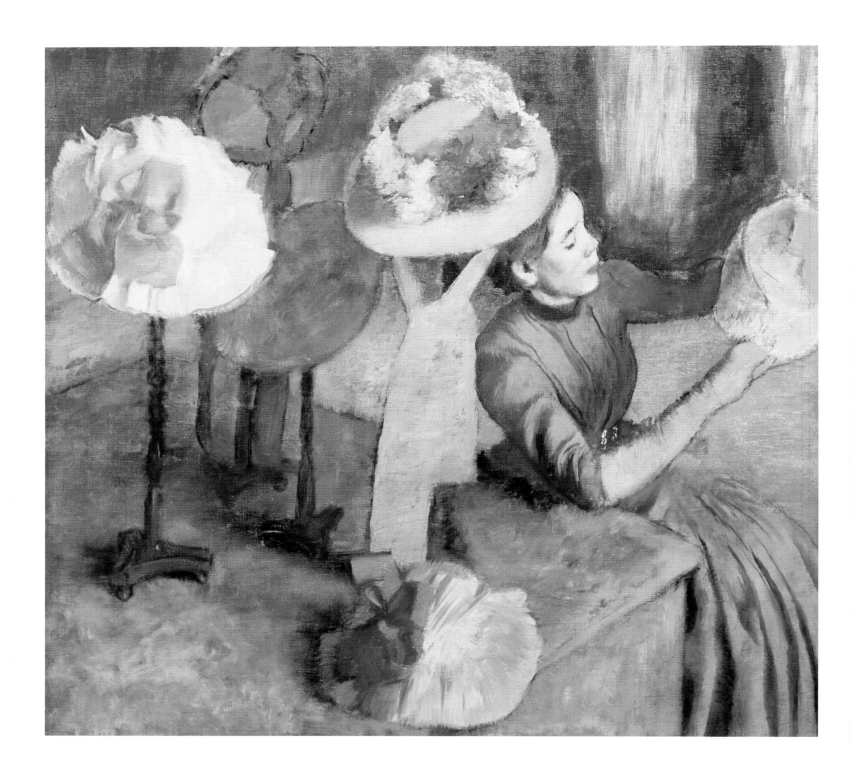

inviting us to look at an unreal space. The theme of the nude, little exploited during the 1870s, now seems to overrun Degas's oeuvre. Women are depicted at their bath, drying themselves, stretching. Here again pastel is king, with its streaks of color perfectly capturing the effects of the bathroom's steamy dampness (*The Tub, Nude Wiping her Foot, Bather Stretched Out on the Floor*). The women are naked, caught in postures that offer not the least bit of elegance. Yet Degas is neither ironic nor cruel here. He is simply an observer, readily allowing his sticks of pastel to edge towards a certain sweetness, occasionally even tenderness, with respect to his anonymous models, whose bodies in movement are all that matters to him.

Edgar Degas
At the Milliner's
1884. Pastel
100x111
Chicago, Art Institute

Edgar Degas
Nude Wiping Her Foot
1886. Pastel
53.3x52.4
Paris, Musée d'Orsay

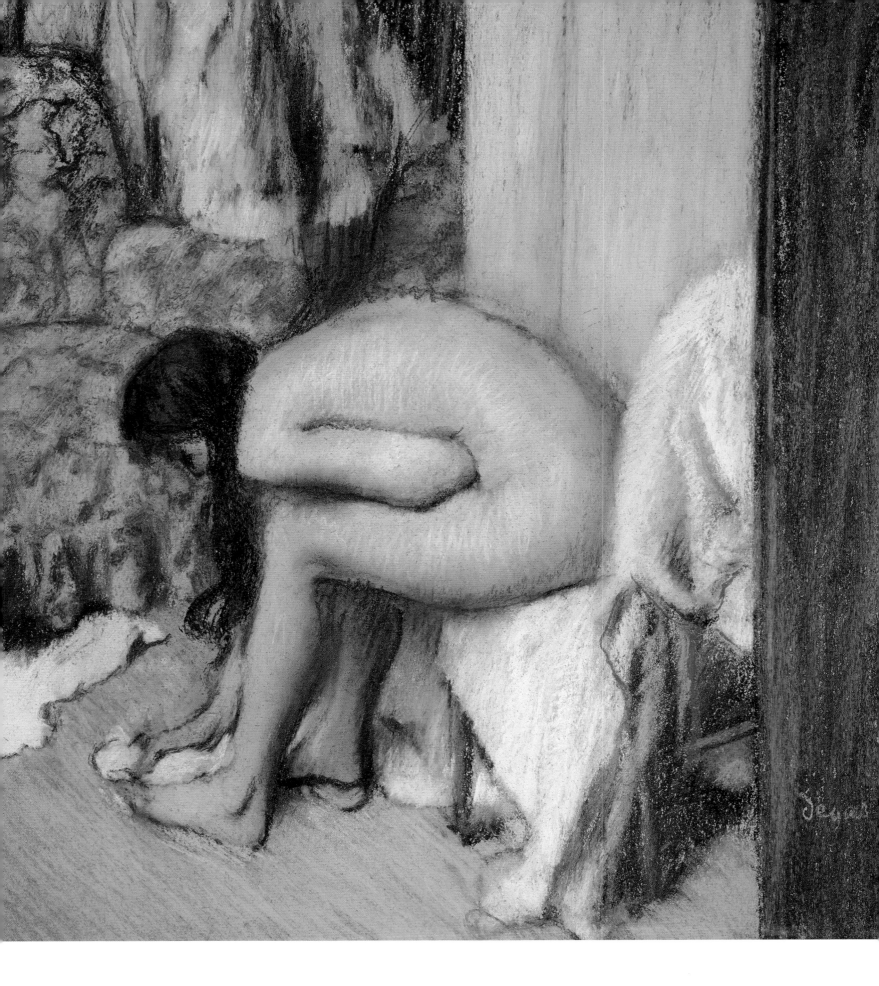

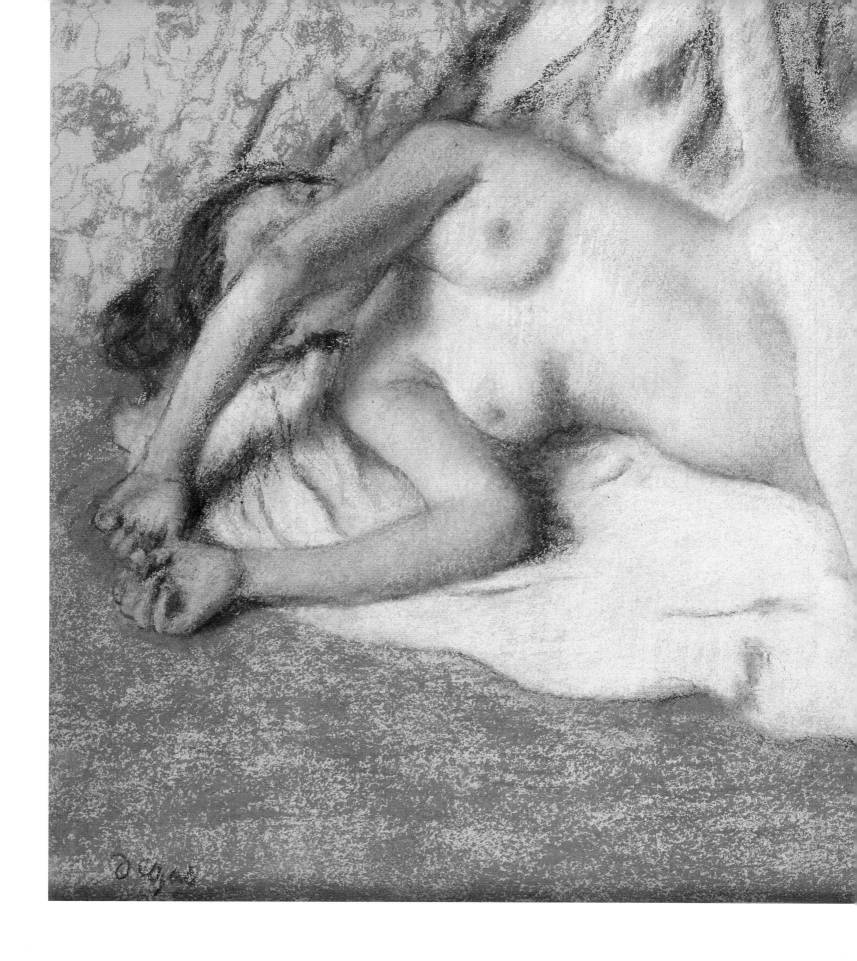

Edgar Degas
Bather Stretched Out on the Floor
1885. Pastel
48x87
Paris, Musée du Louvre D.A.G. (Fonds Orsay)

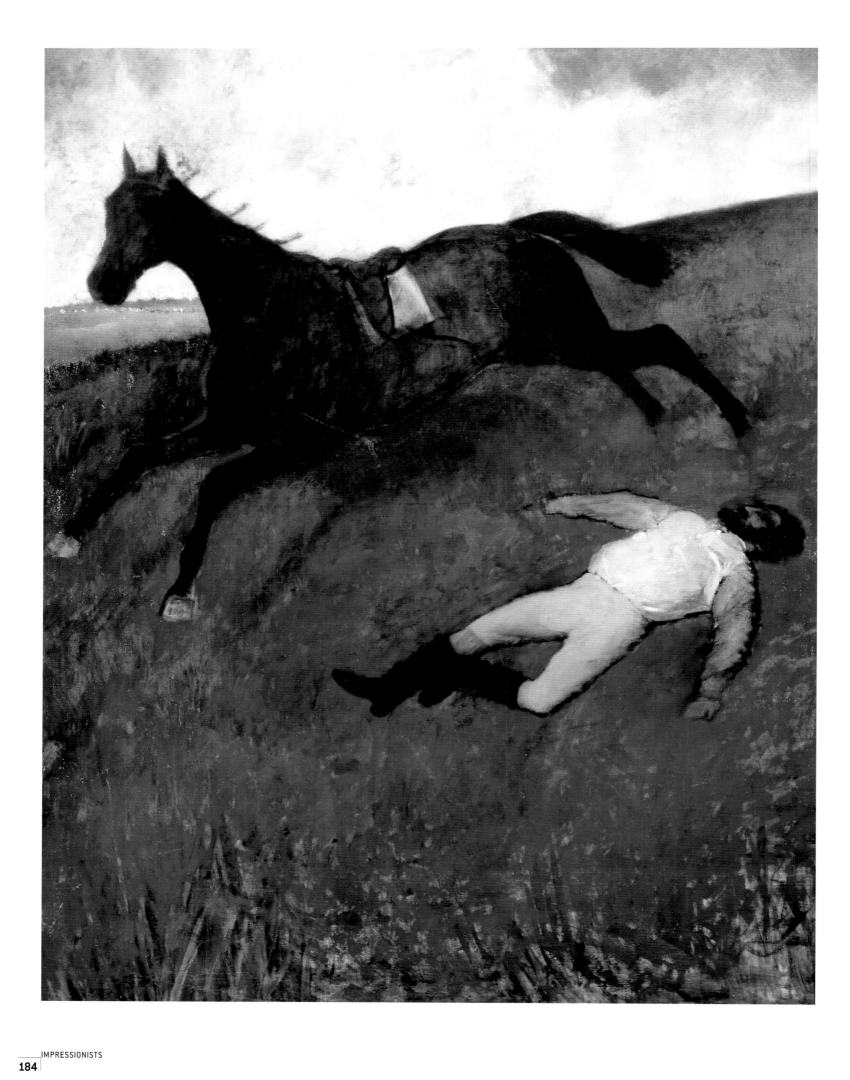

Unexpectedly for this confirmed city dweller, Degas discovered landscape painting in 1890. In fact, he had executed a few landscape studies at the start of his career, but had quickly forsaken a genre that is intrinsically Impressionist. He returned to landscapes during a trip through Burgundy, but adopted a style and technique that were resolutely anti-Impressionist. The technique he used was the monotype heightened with pastel. And instead of working outdoors, he worked from memory before a friend's press, recreating on paper his fleeting impressions in lines that are almost abstract and which he qualified as 'imaginary landscapes.' In 1898, he was painting landscapes anew but in the traditional manner, with oil on canvas, and the sites that he represents were recognizable this time.

Another reminiscence of his early years as an artist are the racing scenes that appear in his output once again. The fashionable gatherings of the 1860s and 1870s now give way to stately compositions that focus on a few jockeys and horses crossing paths (*Race Horses*). Drama both simmers and swells up in *The Injured Jockey*, where the man, thrown by his mount, sprawls in grass that is a garish shade of green.

Degas also tirelessly pursued his work on ballerinas and bathers. Viewed from afar up to this point, gathered in little clusters, sharing their daily grind or the glory of the show, the ballet dancers are now depicted increasingly alone, framed in close up, their tutus abounding in bright colors. The narrative touch, the little stories centered on rehearsal or the grand finale have disappeared. The only thing remaining is the body, enclosed in the ballerina's outfit, and the gesture, either spontaneous (adjusting a strap, for example) or repeated over and over again (*Dancers in Blue*, *Backstage*). The bathers are still presented in compositions boasting warm, violent colors over which a few streaks of garish, vivid hues occasionally roam. At such times he comes close to the shrillness Monet achieves by the edge of his water lily basin. Independently of the models' contortions, color brims and brightly glows in the work of this exceptional draftsman.

Edgar Degas
The Injured Jockey
1866. Oil on canvas
181x151
Basel, Kunstmuseum

Bathers or ballet dancers, Degas's models were also captured in wax. The artist, who had begun studying horses in the late 1860s, had been increasing his research into movement since the late 1880s thanks to the small statues that he modeled over fragile armatures. Unlike the *Little Fourteen-Year-Old Dancer*, which he exhibited at the sixth Impressionist show, these pieces would remain hidden in his studio until he passed away in 1917.

At his death Degas left behind his numerous statuettes and his private collection, which deftly balanced old masters, Ingres, Delacroix, the Impressionists, Gauguin and Van Gogh—just as he himself was able to balance his taste for museum art, his perpetual need for invention, his passion for tradition and history, and his enthusiasm, equally strong, for the contemporary world.

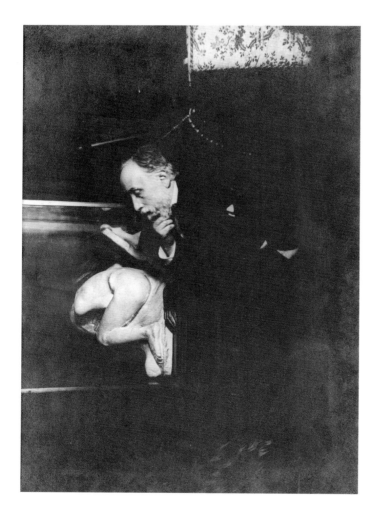

Edgar Degas
Edgar Degas,
in front of *The Young Girl Crying*
by Bartholomé,
Silver gelatin print
1895.
Paris, musée d'Orsay

Edgar Degas
Dancers in Blue
1893. Oil on canvas
85x75.5
Paris, Musée d'Orsay

Degas

Morisot

Henri de Régnier described the soirees hosted by Berthe Morisot in her 'salon-studio' in these terms, 'That evening the studio was filled with pretty women and attentive men. Ordinarily it would remain more intimate. A dinner would occasionally bring together a few friends of the house. Degas would be there in lively conversation with Mallarmé [...] Renoir would be there breaking bread with a gesture that was both rustic and working class, his hands already deformed.' Degas, a great man-about-town in his youth, could be seen only rarely in society in the early 1890s, so it must have taken all the affection he felt for Berthe Morisot for him to appear in the intellectual and artistic circle she regularly gathered at her home.

By then, Degas and Berthe Morisot had long been friends moving in the same fashionable world. Ever since settling in

Paris in 1864, Morisot's mother had had her Tuesdays when she was 'at home' for political figures (Jules Ferry), painters (Puvis de Chavannes, who would have gladly married Berthe, Alfred Stevens, Carolus-Durand), and others. A little later, Degas was also invited to join them. For a time Degas and Morisot saw each other at the gatherings hosted by Édouard and Eugène Manet's parents which Mme Morisot and her daughters started to attend beginning in 1868. It is probably in this circle that Degas became infatuated with Berthe's sister Yves Gobillard, whose portrait he painted in 1869-70, a period when Berthe—wholly committed to her relationship with Manet—and he were not overly fond of each other's company. 'I definitely do not think he has an engaging character; he has wit and nothing more,' noted the young women. She was also convinced that 'M. Degas holds everything [she does] in supreme contempt...'

Until Berthe's engagement to Eugène Manet, they continued to see one another at various events in 1871, as this letter from Mme Morisot to her daughter Yves attests. In the letter the painter's mother tells about a gathering at the Manets, 'Degas was present. I shan't say he was flitting about, he looked as if he were asleep, your father seemed younger than he.'

Yet it was Degas that Berthe listens to in the spring of 1874 when he convinced her to throw in with the Impressionists and their show. Laying out the project to Berthe's parents, he wrote, 'And we find that for our venture Mlle Berthe's name and talent are too much of a good thing for us to pass up.' Thus Degas and Morisot, beyond their social ties, became comrades in art and arms.

Albert Bartholomé: Photograph of Edgar Degas
sitting in a garden, circa 1889-1890
Paris, Musée d'Orsay

Letter from Edgar Degas to Berthe Morisot
& Photograph of Berthe Morisot
Paris, Musée Marmottan

Edgar Degas
Portrait of Madame Gobillard
1869. Oil on canvas
54x.3x65,1
New-York, Metropolitan Museum of Art

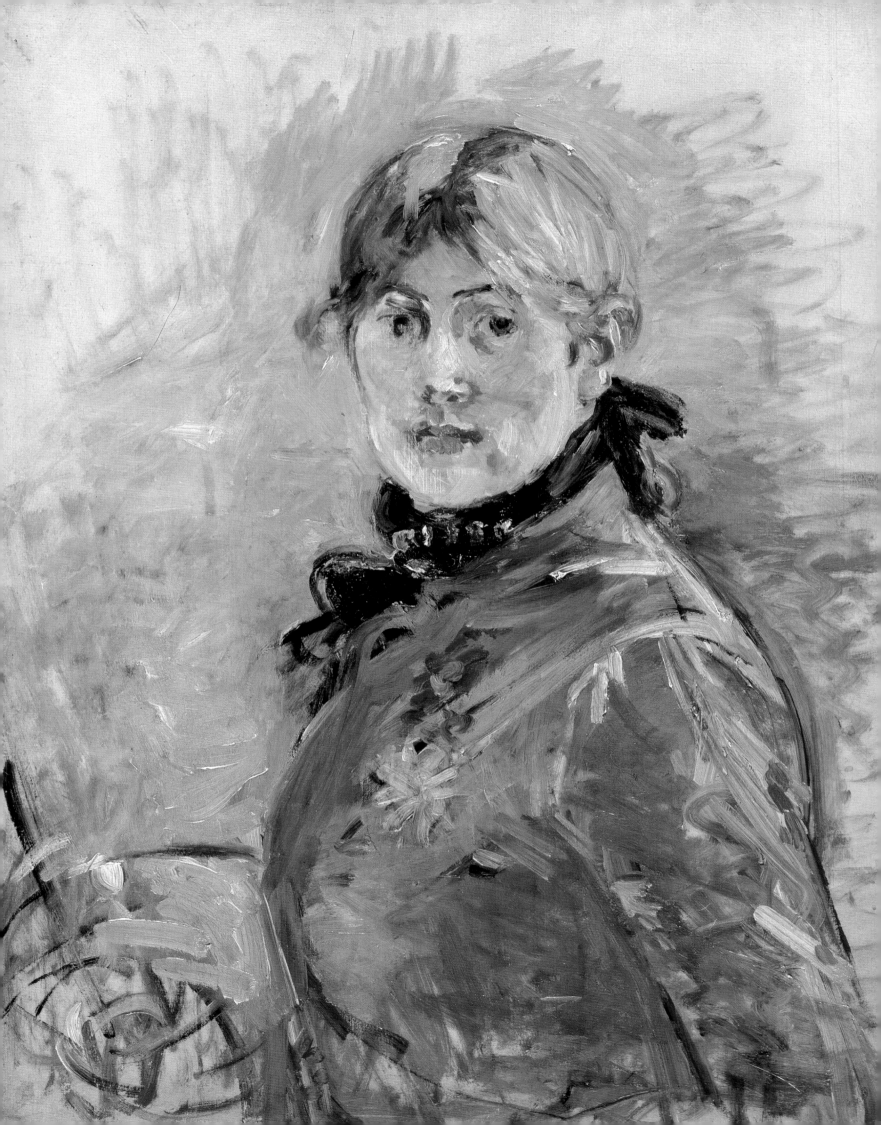

10 Morisot

Previous pages:
Berthe Morisot
Selfportrait
1885. Oil on canvas
61x50
Paris, musée Marmottan

Berthe Morisot
La Petite Niçoise
1889. Oil on canvas
64x52
Lyon, Musée des Beaux-Arts

One of the merits of the Impressionist movement was to have welcomed women into the group, seeing in them their artistic qualities and treating them as equals. Two women were wholly involved in this adventure, Berthe Morisot and Mary Cassatt.

Berthe Morisot experienced the story of Impressionism in all its manifestations—the pleasures of making art, the friendship (in 1884, for example, she confides to her sister, 'I am beginning to get quite close to my fellow Impressionists) and the bitterness of being misunderstood. Thus, a savage critic for *Le Figaro* wrote in 1876, 'There is also a woman in the group, as in every famous bunch, moreover; her name is Berthe Morisot and she is odd to watch. In her, feminine grace holds its ground amid the outbursts of a delirious mind.' Each of the group's members was devoted to her in his special way, and when she died in 1895, Monet wrote, 'It is very painful to think that she is no longer with us: She was so intelligent, had so much talent, I cannot stop thinking about it.' Renoir who 'went to paint near Cézanne in the south, as his son says, learned of Berthe Morisot's death. It was a great blow to him.' He declared at the time, 'I felt as if I were completely alone in a desert.' And Pissarro admitted to his son, 'You won't believe how surprised and affected we were by the death of that distinguished woman, who had such a fine feminine talent and did our Impressionist group honor.' Nevertheless, we must ask ourselves what was the true stature of this woman of Paris's *grande bourgeoisie*, with respect to her and to her fellow Impressionists.

With respect to her, first of all, Henri Rouart recalls that 'in Paris, where she was in the habit of painting at home, in her salon, storing her canvas, brushes and palette in a cupboard whenever she had an unexpected visit, and in the country, where she spent part of the year, Berthe Morisot often worked from the people in her circle of family and friends.' The life of the artist seemed to be subordinate to that of the mother, wife and society woman, and the field of her pictorial research was strictly limited to her family circle; she hardly ventured further than the edge of the Bois de Boulogne. Painting in Morisot's life must have been only slightly more important than what it had been in her original family milieu, where Corot, Puvis de Chavannes, Marcello and other artists were frequent visitors; in other words, it must have occupied some middle ground between the bohemian and the bourgeoise. Painting was a rampart against convention, an opening onto all the pleasures and the conquests of the soul.

With respect to her painter friends, the Impressionists admired her work as a reflection of the world of women which they had but glimpsed until then. Monet thought highly of the artist but referred to her 'talent,' a rather limited term that he would not use for Degas, Cézanne, Manet or

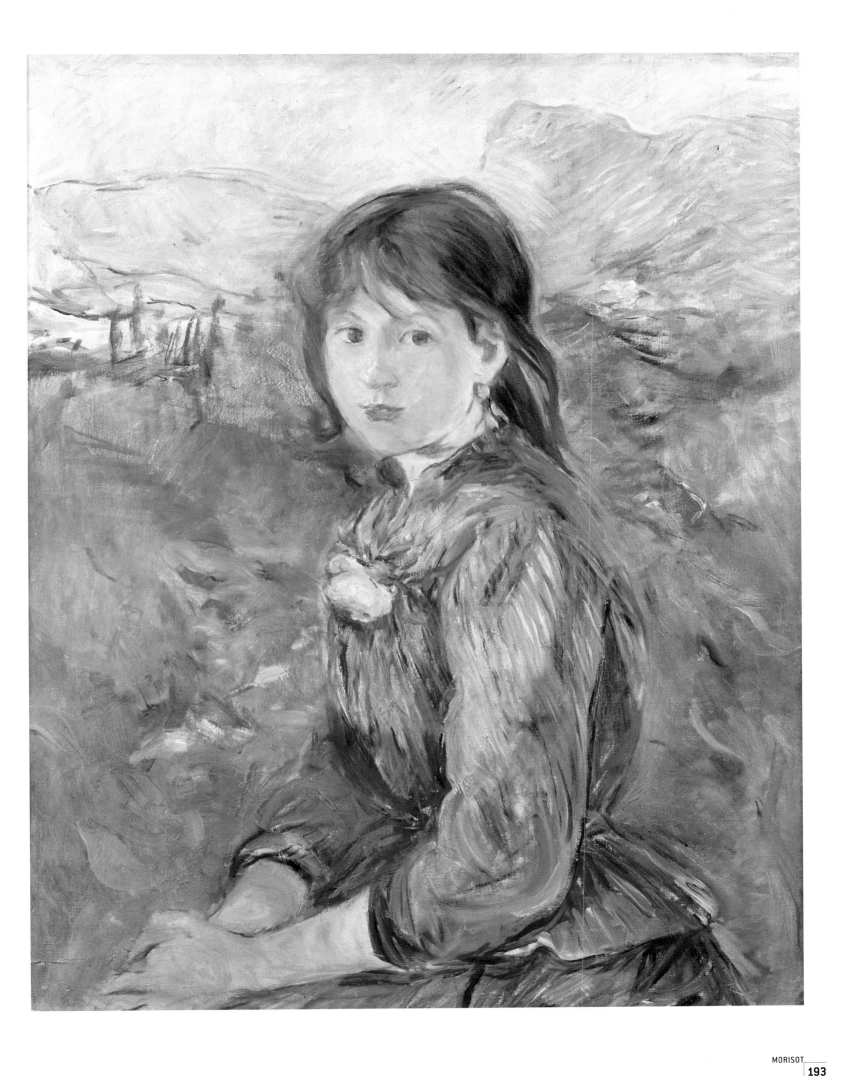

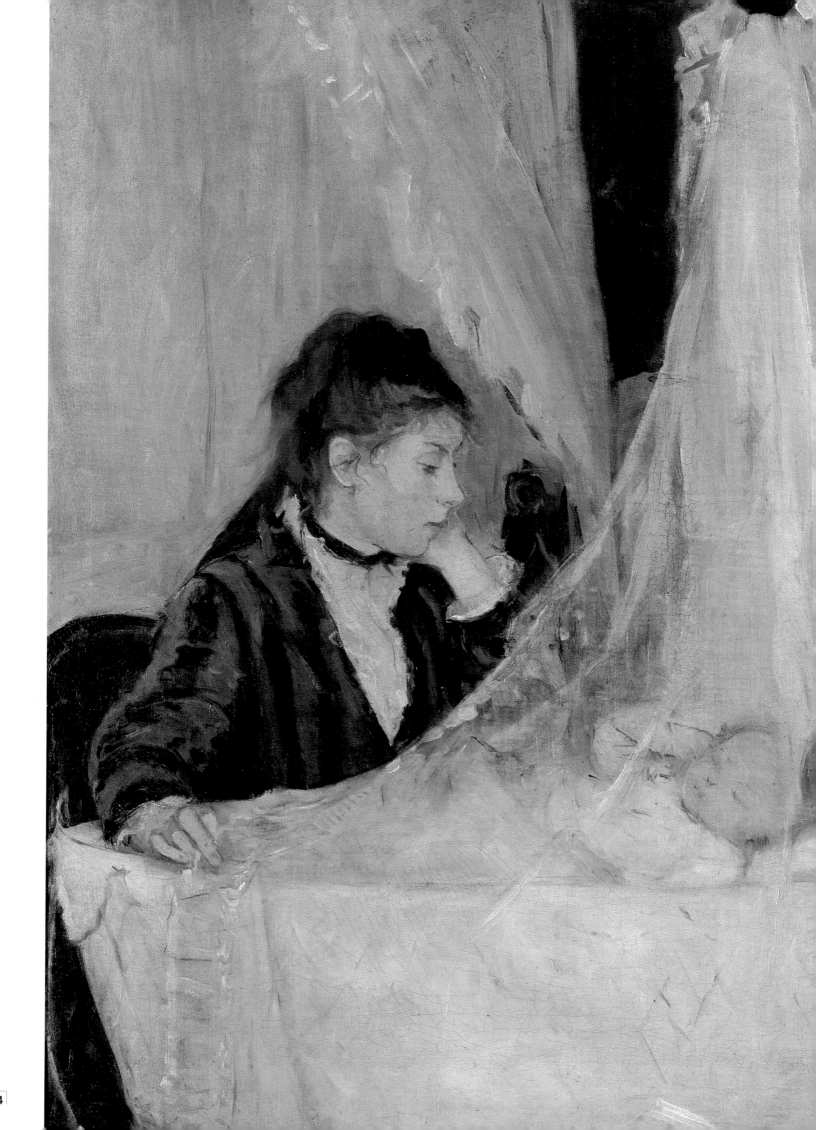

Berthe Morisot
The Cradle
1872. Oil on canvas
56x46
Paris, Musée d'Orsay

Renoir. Pissarro bluntly spoke of her 'fine feminine talent.' And Renoir mourned above all the friend to whom he had remained very close. Degas, too, declared that 'Berthe Morisot paints pictures the way she would make hats,' praising her instinct and intuition, but reducing her painterly activity to a thoroughly female occupation.

And Manet? Manet who had played such an important role in Morisot's life? It was he who had introduced her to the milieu of modern painting when she was working with Joseph Guichard, a respectable and altogether mediocre artist who wrote this to Mme Morisot in 1874: 'I have seen Nadar's Salons and I want to give you my sincere impression immediately; as I entered… I felt a pang upon seeing the works of your daughter in that harmful milieu and I said to myself, "One does not live among madmen with impunity…"' At a time when he regularly saw Berthe Morisot in the galleries of the Louvre accompanied by her mother and sister, Manet admits to Fantin-Latour in 1868, 'I agree with you. The Morisot girls are charming. It's a pity they aren't men. All the same, they could serve the cause of painting as women by each marrying a member of the Academy and sowing discord in the camp of those doddering fools.' Manet's observation was surely a joke, yet it was indeed at the Louvre, where Morisot goes to copy art and where, according to Fantin-Latour's terms, 'she is a sensation,' that Manet made her acquaintance. And eventually took her as a model for his art, too. She was not a colleague as Fantin and Degas were, but a muse. She was the incarnation of woman for Manet over several years and eighteen portraits. She was a strong, puzzling, rebellious woman to be sure, but also Parisian and alluring. He was to depict her with a fan, a muff, a veiled hat, never with a paintbrush.

In his preface to the catalog that accompanied the posthumous retrospective Durand-Ruel devoted to her work in 1896, the poet Stéphane Mallarmé avoids the question of her painting, even if he does call to mind 'so many bright iridescent pictures, here, exact, impulsive.' He lingers especially over the person of the painter, whose name, 'uttered for itself alone, or the extraordinary charm with which it was borne, evokes a figure of extreme nobility in life and personal elegance.' The poet Paul Valéry, who married one of her nieces, wrote the preface to the catalog accompanying another show in 1926. He, too, leaves aside the paintings. 'I shall not venture into the realm of art criticism,' he declares, in order to focus on 'her very person […] one of the rarest and most reserved; distinct by nature; easily, dangerously silent…'

And her painting?

It is impossible, it seems, to speak about it truly, even if more than one critic has ventured an opinion, granting her the status of painter which her friends only reluctantly acknowledged. Her painting is above all close to Manet's as in *The Petites Dalles Beach* or *On the Beach*, which calls to mind *On the Beach, Boulogne-sur-Mer*, and especially in *Vue de Paris des hauteurs du Trocadéro*, which Morisot affirmed 'looks like a Manet; I realize it and am quite annoyed.' The piece indeed is a reworking of *The Universal Exhibition*, although Morisot modifies the point of view. Instead of adopting the viewpoint of an ordinary passer-by, she takes that of two women and a little girl. The system is even more obvious in *Woman and Child on a Balcony*, where the subject, the modern Paris that so preoccupies her fellow Impressionists, is blurry presence behind the woman and child.

It was that point of view, exclusively feminine rather than universal, that dominated the pieces Morisot exhibited at the first Impressionist show of 1874, *The Cradle*, *Hide and Seek*, and *Reading*. Wanting no doubt to give notice of her independence with respect to her good friend at a time when she was preparing to marry his brother, Morisot follows the Impressionists against Manet's advice. She would subsequently confirm her choice by taking part in seven of the eight shows, nearly a record. The works she submitted were indeed praised for that graceful, feminine point of view. Castagnary declared: 'Mlle Berthe Morisot has wit to the very end, especially to the very end of her fingertips. What fine artistic feeling! You could not find more graceful, more painstakingly and delicately worked pages than *The Cradle* and *Hide and Seek*.' In 1868 Monet had treated the same theme of a child sleeping in its cradle in *Jean Asleep*, although without the mother and her unconscious mirroring of her daughter's gesture as she concentrates wholly on her baby. Monet's painting isn't devoid of feeling, but Morisot shifts the composition's discourse into an imaginary dialog, the result of motherly tenderness. Manet's influence can be seen once again in *Hide and Seek*, although it is the Manet of the period when he is in fact drawing closer to Monet in style. *The Lilacs at Maurecourt*, which depicts Edma Gobillard, the painter's sister, and her two little girls, rather faithfully borrows from the compositions that Monet, Manet and Renoir had been producing some time before in their garden in Argenteuil. *Washerwoman* echoes Manet's *Washing*, which was refused by the Salon of 1876; *Young Girl at the Mirror* and *Young Girl from Behind at Her Toilet* recall *Before the Mirror* and *Nana*, although without the historical aspect that Manet sought to impart to his compositions. A few other works, especially various women at their toilet, recall Degas's painterly research, still others evoke Renoir's experiments.

Morisot endlessly sought the advice of different artists (perhaps she had a hard time attaining the status of independent artist), and her works also partake of an aesthetic that runs parallel to the Impressionists' approach. It is the style of painters like James Tissot, a great friend of Degas's in the late

Berthe Morisot
Chasing Butterflies
1874. Oil on canvas
46x56
Paris, Musée d'Orsay

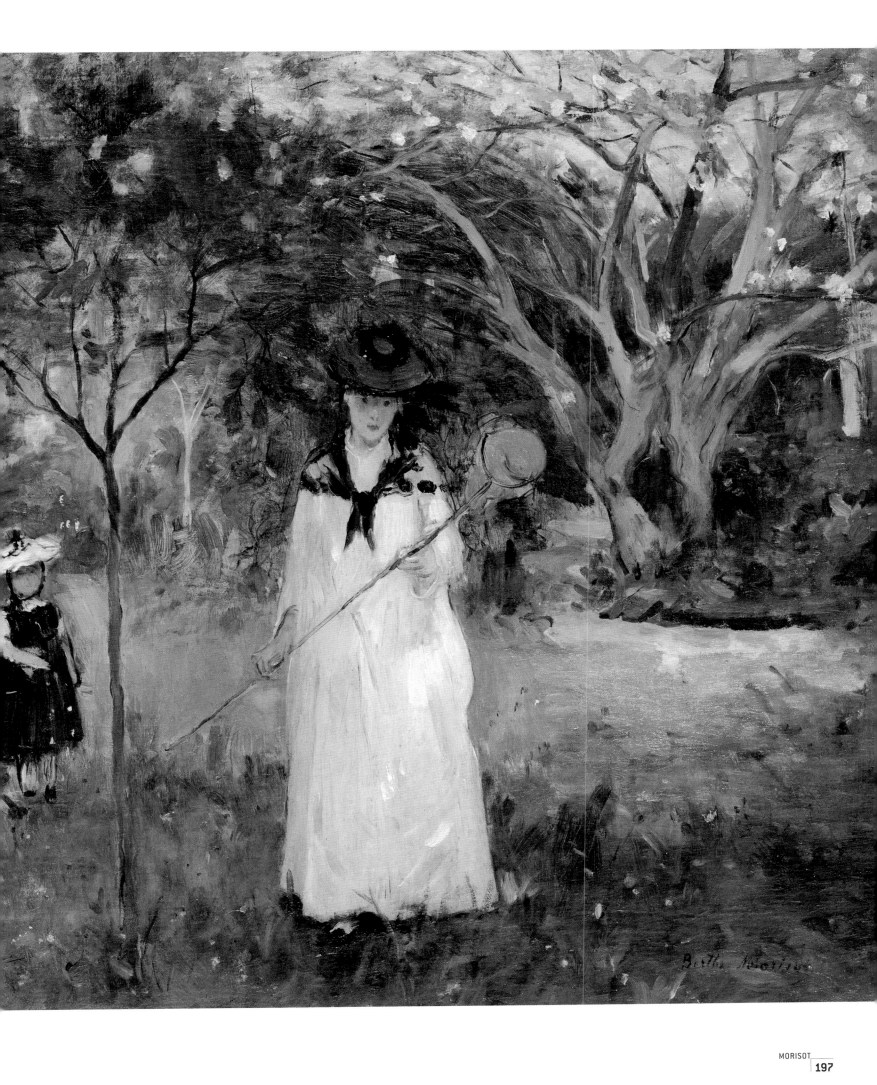

1860s and early 1870s; Alfred Stevens, a regular guest at her parents' home (in *On the Terrace* and *Eugène Manet on the Isle of Wight*, she adopts some of his solutions to framing the image); and Fantin-Latour, with his portraits of women posed amid one or another sort of woman's work or activity.

In 1878, Berthe Morisot gave birth to a daughter, Julie, who became her main source of inspiration. Numerous paintings, as well as a remarkable bust (1886), which reminds us that Morisot also studied under the sculptor Aimé Millet, follow the growth of the child, who likewise became a model for Renoir. *Eugène Manet and His Daughter in the Garden*, *The Sewing Lesson*, *On he Lake*, *Young Girl with Doll*, *Julie Manet and her Greyhound Laertes*, *Reading*, *Julie Pensive*—in the end, Berthe Morisot, despite the charm of her paintings, was more a woman painter, a female Impressionist, than a full-fledged painter in her own right.

Berthe Morisot
Eugène Manet on the Isle of Wight
1875. Oil on canvas
38x46
Paris, Musée Marmottan

Berthe Morisot
Julie Manet and Her Greyhound Laertes
1893. Oil on canvas
73x80
Paris, Musée Marmottan

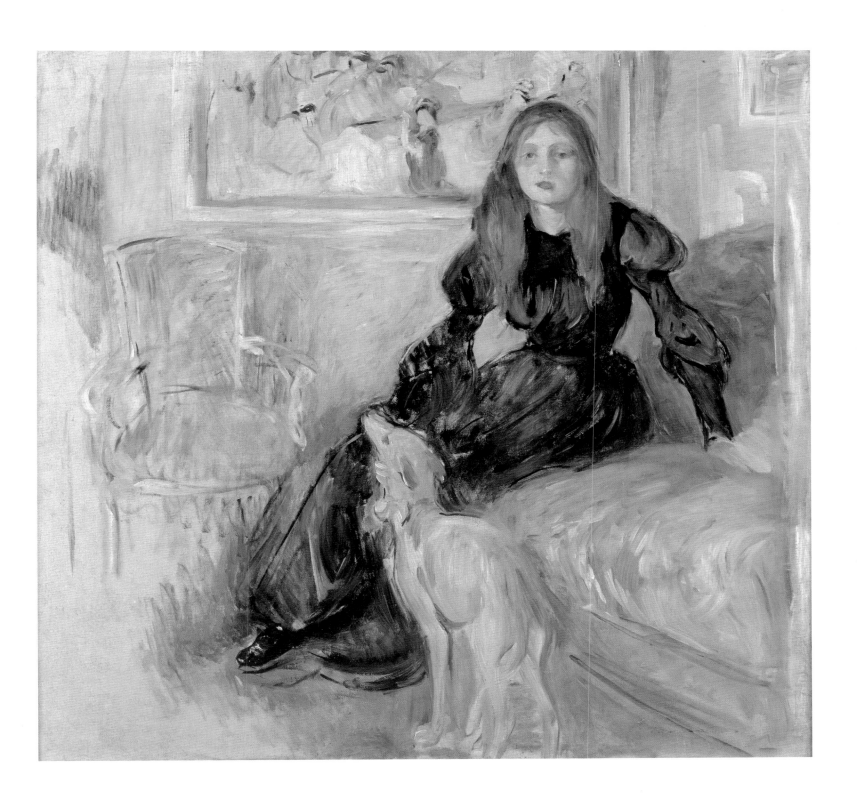

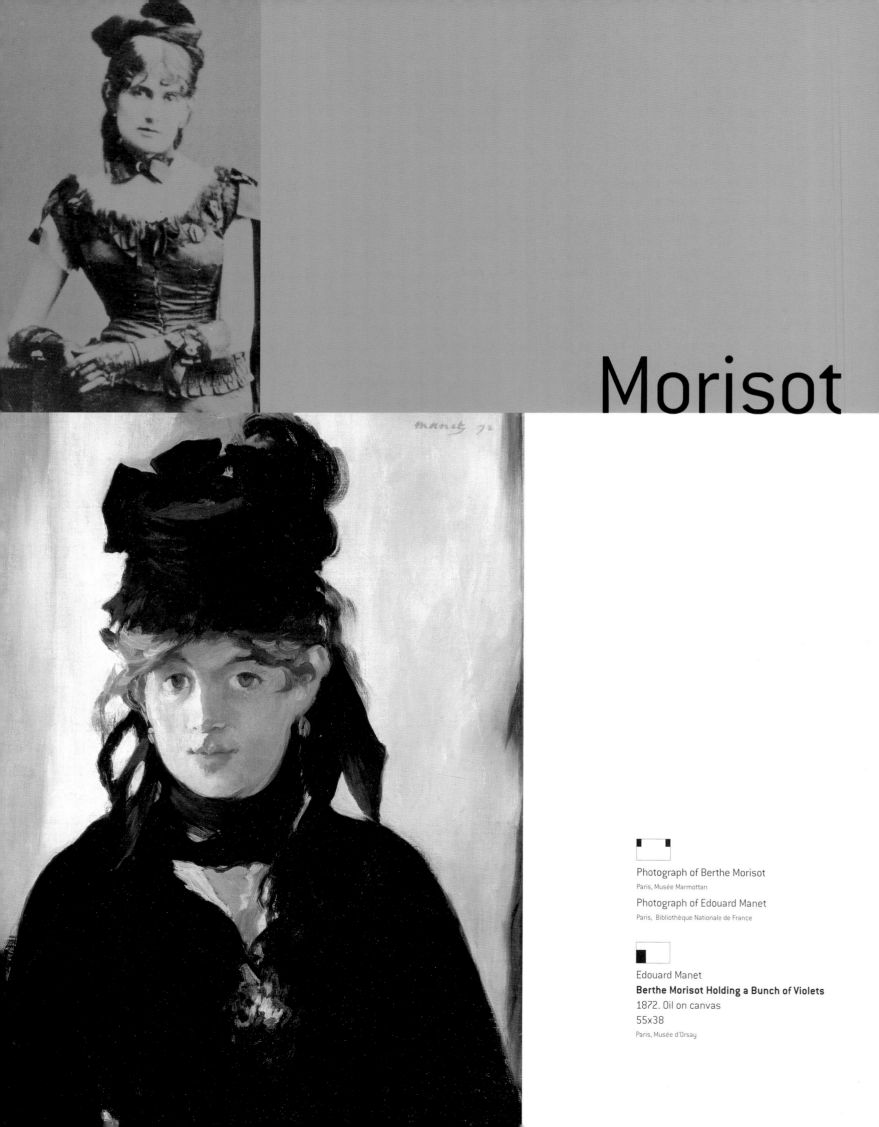

Morisot

Photograph of Berthe Morisot
Paris, Musée Marmottan

Photograph of Edouard Manet
Paris, Bibliothèque Nationale de France

Edouard Manet
Berthe Morisot Holding a Bunch of Violets
1872. Oil on canvas
55x38
Paris, Musée d'Orsay

Manet

'For that has always been my great preoccupation, to obtain regular sittings. When I begin something, I tremble at the idea that the model will fail me, that I won't see him as often as I would like. They come, they pose and then they leave, saying to themselves, He will finish on his own. Well, no, no one ever finishes anything on his own, less so in that you only finish the very day you begin, but often you have to begin over and then you need many days,' explains Manet to his friend Marcel Proust. For her part, Berthe Morisot recalls, 'I shall never forget the former days of friendship and intimacy with [Manet] when I was posing for him and his charming wit kept me alert during those long hours…' Painter and model have never been so in league as in the duo Manet/Morisot, a collaboration that produced eighteen portraits. The person of Berthe Morisot offers Manet the ideal sitter. She is young and beautiful, and has character. As a woman painter who knows the troubles that attend the profession, the difficulty of the motif that is ever on the move, she suffered the sittings without a word. She assumed the role as well as artists' wives did—Camille Doncieux, who was Monet's spouse; Hortense Fiquet, who was Cézanne's; Aline Charigot, who married Renoir; and even Suzanne Leenhoff, who became Mme Manet. Tirelessly they lent themselves to their husbands' artistic whims and lost a little bit of their own identity throughout the sittings and the finished portraits by their husbands, becoming mere models, not anonymous but nearly exhausted and absent. The phenomenon is described in *L'Œuvre* when Zola touches on the relationship between Catherine and Claude Lantier: 'And soon it became a habit, he treated her as a simple model, more demanding than if he had paid her, never fearing to misuse her body since she was his wife.'

With Manet and Morisot, nothing like that ever occurs. Morisot is not Manet's wife and has a life of her own. She sits for him, leaves, goes about her business and faithfully returns, altogether renewed by her existence as an artist and a woman of Parisian society. It was his task to capture in paint that ever-changing intensity, hers to accept the image that the artist gives her in return, granting her her nonconformism. Thus, in *The Balcony*, which was the first time Manet painted her, mysterious and unfathomable, she found herself 'more strange than ugly.' She probably knows that she exists—tremendously—through this artist's painting, which she finds for quite some time gives 'the impression of a piece of wild, even unripe fruit.' Their collaboration as painter and model came to an end in 1874 when she married Eugène Manet, the artist's brother. She had become closer, but also definitively inaccessible. She now belonged to another.

Conclusion

From 1874 to 1886, and long after that, the Impressionists so distrusted the name critics wanted to confine their painting to that we might well wonder whether the movement hadn't simply been a mirage or a misunderstanding.

Yet when Vincent Van Gogh arrived in Paris in 1886, he discovered a painting that was bursting with color. He went here and there, met the artists and talked about these works of art that stand on its head everything he had known about the art of painting until then. Sometime later, in March of 1888, he was alone in Arles, where he hoped to found an artists' community, a southern studio. To his brother Theo, the dealer who sold a few works by Monet, Degas, Pissarro and Renoir at the branch of the Galerie Goupil that he managed, he wrote, 'Maybe it would be easier to get a few dealers and collectors to agree to buy Impressionist paintings, than to get the artists to agree to share equally the price of the pictures sold. Nevertheless, the artists would do well to throw in with one another, give their paintings to the association, and share the price of the sale, such that at least the partnership can guarantee its members the chance to work.

'If Degas, Claude Monet, Renoir, Sisley, C. Pissarro, took the initiative and said, "It's now up to the five of us to give ten paintings each… and we promise to give each year the amount of… And we invite you others, Guillaumin, Seurat, Gauguin, etc., etc., to join us…"

Then the great Impressionists of the Grand Boulevard, providing paintings that become general property, would keep their prestige and the others could no longer blame them for keeping for themselves the advantages of a reputation, acquired beyond all doubt by their personal efforts and individual genius in the first place, but also, secondly, a reputation that is growing, solidified and maintained at present as well by the paintings of a whole army of artists who have worked until now in unremitting poverty.'

The utopian project laid out by the painter, who is thinking here as a former art dealer and the brother of a dealer, as well as an artist in need, clearly reveals the lesson young artists drew from Impressionism immediately after the last show to be mounted under their banner. It was the lesson of a success.

First, there was the name, Impressionist, which for Van Gogh signified all the artists of the avant-garde, Pointillists like Seurat, Symbolists like Gauguin, or unclassifiable like himself, all those who continued to refuse the official Salon even if the organization of the event had been turned over to the artists themselves since 1881 (an effect of the Impressionist secession). And to make a distinction between the original Impressionists and those who followed in their wake, he invented the term 'Impressionists of the Grand Boulevard,' i.e., those who exhibited in the beautiful galleries of the dealers Georges Petit or Durand-Ruel, or other prestigious ones, rented out specifically for a show. They contrast with the 'Impressionists of the Petit Boulevard,' those who like himself cobbled together exhibitions in the capital's outskirts, who had yet to be discovered, yet to make their mark. By this time Impressionism had become the overall term for any modernist movement.

Van Gogh, moreover, equated Impressionism with a real revolution in the system governing the fine arts. It was a revolution brought about not only in the system of exhibitions, but also in the network of ties between artists and dealers, even if he thinks that Monet and his friends did not go far enough and that the mechanism of partnerships among artists ought to be reinforced. All the same, we must recognize that by 1874 artists had achieved their autonomy. Finally, Van Gogh affirmed that the Impressionists were out of the woods, had won both critical recognition and financial security—which was true, if only to a point. Pissarro and Sisley continued to face hard times. Cézanne would have to cool his

heels in critical obscurity some time more before his genius was given its due.

Nonetheless, built up in 1867 and brought to completion in 1874, the enterprise was a success. Impressionism existed, the artists making up the movement earned a living from their art, were known and acknowledged as serious painters, and were becoming models and emblems for the younger generations. This was in 1888 and the years to come would continue to confirm and magnify their accomplishment. This achievement existed as it did thanks to their association. Artists' associations, the pooling of objectives and means, had become, throughout Europe the necessary step toward freedom from the diktats imposed on artists by the state.

Credit also goes to 'their personal efforts and individual genius,' as Van Gogh recognized. The painter hailed and admired each of the Impressionists for his particular talent, which dealers were now careful to emphasize by increasing the number of solo shows. For the artistic success of the Impressionists was as beyond dispute as the success of their careers. Even if it assumed different forms and was driven by interests that were occasionally contradictory, their project enabled them to renew our way of seeing. The Impressionists managed to shake off literature, which was still cluttering up painting at the time, for an art that does not forsake the subject, history, or humanity, but rather treats these things with resources that are strictly pictorial, and pictorial in the proper sense of the term. More important, most of the group managed to renew year after year both their quest and the form of that quest, fully participating in the nearly imperceptible evolution of Western taste and ideas without ever losing their personal style. They were the first modernists. Monet, Degas, Pissarro and Cézanne also figure among those artists who gradually came to view reality with an alienated outlook, no longer fashioning it exactly as it may have been, turbulent and triumphant, but as it was becoming, disturbing, melancholic, impenetrable—Symbolists, one might say, if they hadn't already been indelibly Impressionists.

What remains then of this history in our day and age, when artists are free to exhibit what and how they want?

Probably little of that tremendous, mechanical, liberating impulse.

Much more of the painting, however, which finally spoke of our humanity and our world straightforwardly, without metaphors or pompous, pretentious language. Vincent Van Gogh must have felt that shift. And that is surely the meaning that he, like us, especially stressed in the word 'Impressionism.'

Index

ARSÈNE **ALEXANDRE** (1859-1937)
According to the French poet Apollinaire, Arsène Alexandre was a 'writer on art whose perspicacity was a credit to its time'. Beginning his career as a critic in the early 1870s, he at once spotted Impressionism as the major movement of the age. Lacking Zola's fiery combativeness and Duranty's capacity for esthetic focus, this clearsighted historian calmly followed his characters down their chosen paths. Alert, too, to the originality of Toulouse-Lautrec and Gauguin, he acquired a fine collection of Impressionist works.

EMILE **BERNARD** (1868-1941)
Emile Bernard painted alongside Gauguin at Pont-Aven and it may have been the latter's dream of 'pinching Cézanne's fortune' that alerted him to the genius of the great painter of Aix-en-Provence. Unless, of course, he had spotted Cézanne's pictures at dealer Yves Tanguy's, the only place they could be seen until Vollard started showing them in 1895. In 1891 Bernard published a major piece on Cézanne in *Les Hommes d'Aujourd'hui* ('Men of Today'), but it was not until 1904 that he went to Aix to meet the master. Bernard tried to get Cézanne to outline his esthetic principles in their correspondence and was told, 'I owe you the truth about painting and I'll give it to you.' In *L'Occident* the same year Bernard published an important article summing up what was said in the letters.

PHILIPPE **BURTY** (1830-1890)
An admirer of the Barbizon painters, of Delacroix (whose executor he was) and of things Japanese, Philippe Burty – present at the conversations at the Café Guerbois in the late 1860s – was also an ardent defender of the Impressionist principle of exhibiting independently. 'It is not a matter of providing a refuge for those rejected by the Salon jury,' he wrote, adding that 'the jury principle itself is to be rejected as detrimental to the free expression of the personal.' His own tastes favored Manet and Degas, and he experimented with engraving.

MARY **CASSATT** (1844-1926)
This highly gifted American painter visited Europe regularly to tour the museums and study painting. In 1872 she met Degas and the two became close friends. He invited her to take part in the Impressionist exhibitions of 1879, 1880, 1881 and 1886, made her one of his favorite models – showing her at the Louvre and the milliner's – and called on her for his experiments in engraving, a field in which she excelled. Enjoying connections with rich East Coast families in the United States – notably the Haverneyers, who built up one of the finest of all Impressionist collections, later donated to the National Gallery in Washington – Mary Cassatt actively contributed to the success of Impressionism in America.

JULES **CASTAGNARY** (1830-1888)
Politically close to the left-winger Léon Gambetta, an ardent defender of Courbet and inventor of the term 'Naturalism', Castagnary sought to link Impressionism to the Naturalist school that had sprung up in the 1850s. An attentive student of the movement's philosophy, he recognized in Manet the heir to the battles of Courbet and in Monet 'a Naturalist setting out to take the future by storm'. At the first Impressionist exhibition in 1874 he took his capacity for inventing names further: 'If a single word is needed to pin them down, we need to create the new term *Impressionists.*'

GEORGES **CHARPENTIER** (1846-1901)
Publisher of Flaubert, Zola, Maupassant, Daudet and the Goncourts, Charpentier was one of the pillars of literary Naturalism. He and his wife were part of a newly emergent intellectual society mixing Naturalist writers, Impressionist painters, politicians and enlightened members of the nobility. Collectors of Impressionist paintings, the Charpentiers commissioned portraits from Renoir and arranged his triumphal return to the Salon in 1879. The couple also founded a review and a gallery – both called *La Vie Moderne* – that would back Impressionist painting, and played a decisive role in the late 1870s and early 1890s, when Renoir, Monet and Sisley could no longer count on Durand-Ruel.

ERNEST **CHESNEAU** (1833-1890)
Ernest Chesneau may have held high office in France's Imperial art education system, but the tastes he revealed as an art critic were anything but conservative. In 1865, for example, he wrote to Manet: 'Far better this wild elation than the lethal calm of the self-satisfied.' It was more or less natural, too, that someone so interested in English painting and Boudin should in 1874 see Impressionism as the logical follow-up to the 'open air school'. Doubtless his passion for Japanese art played a considerable part in his defense of Manet and an Impressionist movement whose 'tendency to extreme simplicity' matched one of the basic principles of japonism.

VICTOR **CHOCQUET** (1821-1891)
According to Renoir, Chocquet was nothing less than 'the greatest French collector since the kings; and in the world, perhaps, since the Popes' – even if it has to be said that Renoir was one of the first Impressionists to benefit from the acuity and generosity of this exceptional collector. A low-ranking customs clerk for whom art auction rooms represented an escape from a dreary life, Chocquet came into an inheritance in 1882 and was more readily able to indulge his interests, the principal of which was Delacroix. Already, in 1862, the painter had refused his request for a portrait of Madame Chocquet, a commission accepted by Renoir in 1875. Renoir in turn introduced his collector to the works of Monet and, especially, Cézanne, Chocquet becoming the latter's most faithful and passionate advocate. In 1899 Chocquet's Impressionist collection comprised 10 Renoirs, 30 Cézannes, 10 Monets and 5 Manets, together with 23 paintings and over 60 drawings by Delacroix.

MAURICE **DENIS** (1870-1943)
A member of the Nabis, Maurice Denis was also an authoritative art critic and theoretician. One of the first of the new generation to recognize the importance of Cézanne, he painted in 1900 a *Homage to Cézanne* in which painters and critics are shown gathered round a still life in the gallery of the art dealer Vollard. He followed this in 1906 with his *Visit to Cézanne*, which encapsulates the time he spent listening to the aging master's ideas on art.

PAUL **DURAND-RUEL** (1831-1922)
Heir to an art dealer who had begun to take an interest in the 1830 school – Delacroix, Descamps, Diaz, Daubigny, Daumier and Corot – Paul Durand-Ruel discovered Impressionism in London in 1870, where Daubigny introduced Monet to him in glowing terms. Sensing the commercial potential of the budding movement, he began buying works, setting up arrangements with most of the painters concerned and encouraging them in their group exhibition ventures. In 1872 he became interested in Manet, whose outrageous beginnings he had missed out on. However in 1873 he had to slow, and in some cases halt his purchases, leaving Monet, Sisley and Pissarro in dire straits. In 1882 he was hard hit by the collapse of the Union Générale, in which his main associate was a partner, and had also to cope with the competition of Georges Petit, who put his faith in individuals rather than a group of artists. Monet, Pissarro and Sisley then looked elsewhere, but Renoir and Degas remained loyal and Durand-Ruel set out to conquer foreign markets. The breakthrough came with the founding of a branch of his firm in the United States: he then got back together with Pissarro and Monet and organized numerous one-person exhibitions. In 1911 he handed the business over to his sons, proud of having succeeded – through all the ups and downs – as the Impressionists' dealer.

EDMOND **DURANTY** (1833-1880)

Initially an advocate of the Realist movement in the mid-1850s, the art critic Edmond Duranty took up the Impressionist cause as personified by Degas, whom he met in the early 1860s. A regular at the Café Guerbois, he served as an interpreter of Degas' artistic aims, but also championed Manet – with whom, nonetheless, he fought a duel in 1870. He upheld the same ideas in his pamphlet *La Nouvelle Peinture*, although scrupulously avoiding – to Monet's great displeasure – the word 'Impressionism'.

THÉODORE **DURET** (1838-1927)

The publication in 1878 of *Les Peintres Impressionnistes* made Théodore Duret the movement's first historian. This son of a wealthy wine merchant began to take an interest in painting in 1862, when his collector cousin Etiénne Baudry introduced him to Courbet and Corot. In 1865 he met Manet in Spain and became one of his earliest advocates, positing him as the founder of Impressionism. A fervent republican, he founded the newspaper *La Tribune Française* with Emile Zola, Eugène Pelletan and Jules Ferry. His political aspirations led to his conviction after the Paris Commune. From 1872 onwards, after traveling in China and Japan and helping promote japonism, he devoted himself to art criticism and his substantial painting collection. Like his friend Manet, he was firmly opposed to independent exhibitions and urged Pissarro, Monet and Sisley to return to the Salon.

FÉLIX **FÉNÉON** (1861-1944)

For many years Fénéon led a triple life, as an editor at the War Office, critic and anarchist. As an anarchist he found himself in the dock during the Trial of the 30 in 1894, having hidden detonators in his office. His critical style is studiously precious, yet incisive, biting and illuminating. Initially the neo-Impressionist movement's spokesman, theoretician and go-between, he was at pains to emphasize the shortcomings and limitations of an Impressionism he found 'summary and approximate', setting out to prove that Pointillism was the perfect, logical extension of avant-garde painting. Closely associated with the Symbolists, he was joint founder of *La Revue Indépendante* and *La Vogue* and was to become the brilliantly indefatigable secretary of *La Revue Blanche*. With the closure of the last-mentioned in 1903 he became director of the Bernheim-Jeune gallery.

PAUL **GACHET** (1828-1909)

A puzzling figure, Dr Paul Gachet had written his medical thesis on melancholy. He cultivated connections with the Impressionist movement by treating some of its painters (Renoir, Monet, Pissarro) and by inviting others (Pissarro, Cézanne) to his home in Auvers-sur-Oise, where he had an engraving press. A close friend of the engraver Meryon, Gachet himself dabbled in engraving and painting and gave anatomy lessons at a Paris drawing school attended by Seurat. In 1891 Theo van Gogh sent him his convalescent brother Vincent. Gachet's connections enabled him to build up a fine collection of works by Cézanne, Daubigny, Pissarro and Van Gogh, now to be found at the Musée d'Orsay.

GUSTAVE **GEFFROY** (1855-1926)

An associate of Clemenceau, Geffroy wrote regularly for the newspaper *La Justice*, beginning his career as an art critic just as Impressionism was gaining acceptance and so playing a part in its ultimate triumph. In 1886 he met Monet at Belle-Île en Mer, where 'The handshake between us sealed our friendship forever', and went on to become Monet's champion and more or less official biographer. Geffroy's interest in art was not limited to Monet, however, and his preface to the catalogue of the combined Monet-Rodin exhibition in 1899 gives equal attention to a sculptor he was later to write about extensively. Through Monet he met Pissarro, Sisley and Cézanne; Cézanne painted his portrait in 1895 in recognition of Geffroy's role as one of his earliest defenders.

ERNEST **HOSCHÉDÉ** (1837-1891)

A wealth fabrics merchant, Ernest Hoschédé was among the first and most unstinting patrons of Impressionism. In 1873 he sold a collection made up of paintings from the School of 1830 and the Impressionist movement; at a second sale in 1875 he rid himself of his last Romantic paintings so as to devote himself totally to Impressionism. Inviting Manet to his Château de Rottenbourg at Mongeron, he commissioned decorative work from him. Following his bankruptcy in 1877, however, his pictures were sold by Drouot, but the sale was a disaster, with the works going for less than their purchase price. Hoschédé moved in with Monet at Vétheuil, bringing with him his wife Alice and six children, all of whom he soon left in the painter's care. A passionate affair ensued between Monet and Alice and when the painter's companion Camille died in 1879, Alice took her place. She and Monet married in 1892, after Ernest Hoschédé's death.

JORIS-KARL **HUYSMANS** (1848-1907)

A fanatical Naturalist, Huysmans came late to the Impressionist battle: in 1880, at the time of the break between the landscape painters and the moderns. It was the latter group, led by Degas, that he focused on in 'Salons', a series of meticulous, caustic articles that began appearing in *L'Art Moderne* in 1883: here he homes in on pitilessly Naturalist subjects in the work of Degas, his followers and Gauguin, using them as a springboard for a denunciation of social injustice in his literary work. In a spectacular about-face, however, Huysmans wrote *Against the Grain* (1884), a thoroughgoing defense of the work of Odilon Redon, Félicien Rops and symbolism in general.

AMBROISE **VOLLARD** (1868-1939)

When Ambroise Vollard decided to become an art dealer in the late 1880s, all the Impressionists were already committed to Durand-Ruel or Georges Petit. All, that is, except Cézanne, who had never attracted anything but scorn and incomprehension from critics and dealers alike. And so Vollard took him on, organizing his first one-person show in 1895. He also worked regularly with Renoir, from whom he commissioned sculptures, and Degas. In addition, his books devoted to painters were a great success. He also collaborated with Gauguin on his second and last journey to the Pacific, and organized the first Van Gogh retrospective. Taciturn and indolent, wily and adroit, Vollard became a legendary figure, not least via the link he forged with the following generation as Picasso's first dealer.

ALBERT **WOLFF** (1835-1891)

Art critic for the Paris daily *Le Figaro*, Albert Wolff was famed for his anti-Impressionist obduracy. His bête noire was Manet, who, he wrote in 1869, 'sinks so low as to compete with house painters'. When the two actually met, Wolff acknowledged Manet's intelligence, but never accepted his painting. In 1874 Manet pleaded with him to mention the Impressionist group in his column and he did just that – but only to say that Impressionist painting reminded him of 'a monkey who has got hold of a paintbox'. His review of the 1876 exhibition was particularly violent, attacking each painter in turn and closing with the words, 'There is also a woman in the group: her name is Berthe Morisot. In her case feminine grace survives despite the excesses of a mind out of control…' Eugène Manet, the painter's brother and Berthe Morisot's husband, had to be restrained from challenging Wolff to a duel. In 1877 Manet himself began a portrait of the critic, who ultimately took a softer line on Impressionism, although without ever coming to grasp its real worth. Yet he was without doubt the most influential and most feared critic of the second half of the 19th century, as Pissarro once made clear: 'You have no idea how all the painters and dealers tremble before him. When Wolff came in, everyone rushed forward to hear the oracle speak.'

Choronology

MAJOR DATES

1830: birth of Pissarro at Charlotte-Amalie, Saint Thomas, Danish West Indies.

1832: birth of Manet in Paris.

1834: birth of Degas in Paris.

1839: birth of Cézanne in Aix-en-Provence; birth of Sisley in Paris.

1840: birth of Monet and Zola in Paris.

1841: birth of Bazille in Montpellier, Berthe Morisot in Bourges and Renoir in Limoges.

1848: birth of Caillebotte and Gauguin in Paris.

1850: Manet begins studying under Thomas Couture.

1852: Napoleon III becomes Emperor after a coup d'état. Second Empire.

1853: birth of Vincent Van Gogh.

1856: beginning of Degas' three-year trip to Italy.

1859: Pissarro and Monet meet at the Académie Suisse. Cézanne takes drawing lessons at the municipal art school in Aix-en-Provence.

1861: Degas and Manet meet in the Louvre. Cézanne meets Pissarro at the Académie Suisse. Monet, Renoir, Sisley and Bazille form a group in Charles Gleyre's studio. Manet's first success at the Salon.

1863: Salon des Refusés: Manet shows Luncheon on the Grass. Death of Delacroix. Teaching reforms at the École des Beaux-Arts in Paris.

1865: suicide of the painter Holtzapffel after being refused by the Salon. Demonstration by artists. Monet is well received at the Salon, while Manet's Olympia provokes outrage. Degas is admitted to the Salon for the first time.

1866: Zola writes on the Salon in *L'Événement*. Monet triumphs at the Salon. Manet and Monet meet.

1867: The Universal Exhibition marks the apogee of the Second Empire. A petition is organized for a new Salon des Refusés. Courbet and Manet both organize independent exhibitions. Zola supports Manet. An attempt is made to organize a group exhibition based on Bazille and Monet. Death of Ingres and Baudelaire.

1868: with landscape artist Daubigny on the jury, the Salon broadens its horizons slightly. Cézanne is still refused, however, while Renoir is acclaimed.

1870: open letter by Degas on the organization of the Salon. Millet and Daubigny resign from the jury to protest the refusal of works by Monet and Renoir. The Franco-Prussian war. France defeated at Sedan. Fall of the Second Empire. Proclamation of the Third Republic. Degas and Manet volunteer for the National Guard in Paris. Bazille killed in action at Beaune-la-Rolande.

1871: siege of Paris, proclamation of the Paris Commune. The Commune is put down by troops from Versailles. "A fearsome year" sums up Victor Hugo.

1872: only Manet shows at the Salon. Degas visits New Orleans

1873: "Discontent is rife in the artistic world," notes Paul Alexis. Creation of the "Société Anonyme" of painters, sculptors and engravers, under the aegis of Monet. Caillebotte studies under Bonnat.

1874: 15 May, opening of the first Impressionist exhibition at Nadar's. Jeers for Manet at the Salon.

1875: death of Gleyre, Millet and Corot. Sale of paintings organized at Drouot's by some of the Impressionists. The first stone is laid at Sacré Coeur.

1876: second Impressionist exhibition. Manet organizes an exhibition in his studio to protest refusal of one of his works by the Salon. Edmond Duranty publishes *La Nouvelle Peinture* (The New Painting).

1877: third Impressionist exhibition. Death of Courbet.

1878: disastrous sale of the Impressionist collections of singer Jean-Baptiste Faure and Ernest Hoschédé. Théodore Duret publishes *Les Peintres Impressionnistes*. The Universal Exhibition makes it impossible for the Impressionists to organize an exhibition.

1879: fourth Impressionist exhibition. Death of Thomas Couture.

1880: fifth Impressionist exhibition. Renoir well received at the Salon, where Sisley goes unnoticed.

1881: sixth Impressionist exhibition. Monet shows at the Salon. Manet receives the Legion of Honor. Renoir travels to Algeria and Italy. Birth of Picasso.

1882: seventh Impressionist exhibition. Cézanne admitted to the Salon for the first and last time.

1883: death of Manet, followed by a retrospective at the École des Beaux-Arts in Paris. Monet and Renoir visit Cézanne in Aix-en-Provence.

1884: publication of Jean Moréas' symbolist manifesto.

1886: eighth and last Impressionist exhibition. Gauguin leaves for Pont-Aven. Van Gogh arrives in Paris. Zola publishes *L'Œuvre*. Durand-Ruel presents "Works by the Impressionists of Paris" in New York.

1888: a Durand-Ruel gallery opens in New York.

1889: Universal Exhibition with the Eiffel Tower. Centennial Exhibition in which Cézanne, Monet and Pissarro consent to participate.

1890: subscription for Manet's Olympia launched and managed by Monet. Suicide of Van Gogh.

1891: death of Seurat. Gauguin's first voyage to Tahiti. Monet's Haystacks shown by Durand-Ruel.

1894: death of Gustave Caillebotte.

1895: death of Berthe Morisot. First major Cézanne exhibition at Vollard's. Gauguin leaves France definitively.

1897: The "Caillebotte Affair".

1898: Zola's *I Accuse* and the beginning of the Dreyfus affair. Monet, initially angered by *L'Œuvre*, renews his friendship with Zola.

1899: death of Sisley. Paul Signac publishes *D'Eugène Delacroix au Néo-Impressionnisme* (From Eugène Delacroix to Neo-Impressionism).

1903: death of Gauguin and Pissarro.

1906: death of Cézanne and a retrospective of his work at the Salon d'Automne. Manet's Olympia shown in the Louvre.

1914: beginning of the First World War.

1917: death of Degas.

1918: armistice. Monet offers his Waterlilies cycle to the nation.

1919: death of Renoir.

1926: death of Monet.

Select bibliography

Richard R. Brettel et al., *Impressionism: Painting Quickly in France, 1860-1890,* Yale University Press, 2000

Xavier Carrère, Françoise Cachin, *Treasures of the Musée d'Orsay*, Artabras, 1995

T.J. Clark, *The Painting of Modern Life,* Princeton University Press, 1999

Bernard Denvir, *The Chronicle of Impressionism: An Intimate Diary of the Lives and World of the Great Artists*, Thames & Hudson, 2000

Anne Distel, *Impressionism: The First Collectors*, Harry N. Abrams, 1990

Robert L. Herbert, *Impressionism: Art, Leisure and Parisian Society*, Yale University Press, 1991

Diane Kelder, *The Great Book of French Impressionism*, Abbeville, 2000

Laurence Madeline, *Musée d'Orsay: 100 Impressionist Masterpieces*, Scala, 2000

Michel Melot, *The Impressionist Print*, Yale University Press, 1997

John Rewald, *History of Impressionism*, MoMA New York, 1994

Meyer Schapiro, *Impressionism: Reflections and Perceptions*, George Braziller, 1997

Belinda Thompson, *Impressionism: Origins, Practice, Reception*, Thames & Hudson, 2000

Photographic credits

Printed and bound in China